# AND NOW
# ARE YOU GOING TO
# BELIEVE US

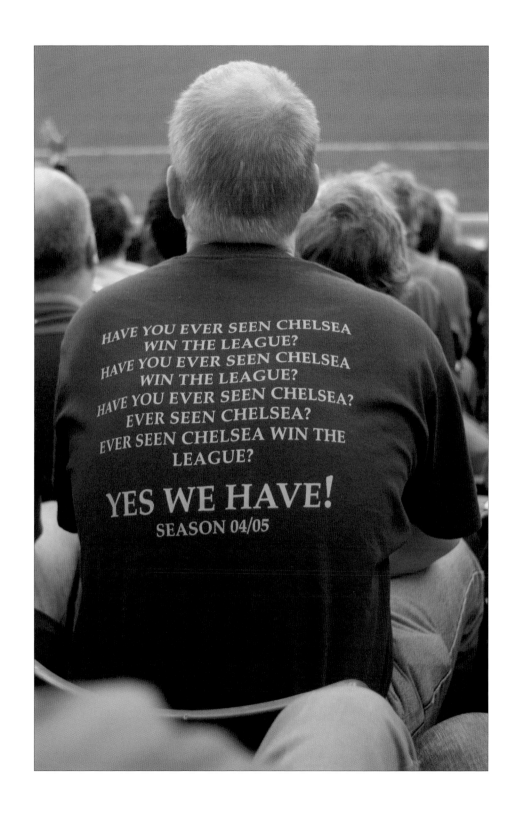

# AND NOW ARE YOU GOING TO BELIEVE US

## TWENTY-FIVE YEARS BEHIND THE SCENES AT CHELSEA FC

JOHN INGLEDEW

JOHN BLAKE

Published by John Blake Publishing Ltd,
3, Bramber Court, 2 Bramber Road,
London W14 9PB, England

www.blake.co.uk

First published in hardback in 2006

ISBN 1 84454 247 5

British Library Cataloguing-in-Publication Data:

A catalogue record for this book is available from the British Library.

Design by www.envydesign.co.uk

Printed in Spain by Artes Graficas Toledo S.A.U.

1 3 5 7 9 10 8 6 4 2

# Introduction

The first time I saw Chelsea play, it rained. This was 1976. We were a second division club then. A second division club with fourth division terraces and non-league catering facilities. I got wet walking up from Fulham Broadway beforehand, got wetter standing in an uncovered part of the Shed for the match, and got wettest walking back to the Tube afterwards. Social history would suggest that I had a Wagon Wheel at half time. Social history would also suggest that it was a wet Wagon Wheel.

Incredible to relate, it was still raining, eighteen years later, in 1994. The rain that fell on Wembley after we lost 4–0 to Manchester United in the Cup Final was – meteorologists later confirmed – the hardest rain of all. But it turned out to be the rain's last fling. Soon after, the sun was to come out and the weather over Stamford Bridge grew weirdly Californian. For those of us who took up with Chelsea in the glory years of 1970–1, this was something more like the weather we had seen in the brochure, but no less startling for that. (We booked in expectation of Peter Osgood, trophies, glory: we turned up to find relegation, the threat of electric fences, Micky Droy. Never trust the brochure.)

What I needed, back in those days, while sloshing up the Fulham Road, or trying to keep dry under a police horse, was for someone to bend down and say, 'Don't worry. Give it thirty years or so, and the club you love will be champions of England, under the benign patronage of the world's seventh richest man and the management of the world's greatest coach, and you'll be sitting comfortably in a hand-crafted all-seater stadium, enjoying a fine range of quality snacking opportunities.' But nobody did. They never do. And I wouldn't have believed them anyway.

It still rains now, of course, every now and again. But nowhere near as hard. Which means, among other things, that the history of Chelsea Football Club over the last quarter of a century amounts to the most convincing evidence yet produced for the existence of climate change.

Which is like any kind of change: things are gained, things are lost, and you just get carried along, at a pace you don't control, with little time to freeze the moments. It's like with my family: I wish I'd taken more photographs. But actually it doesn't matter. John Ingledew took plenty.

Giles Smith

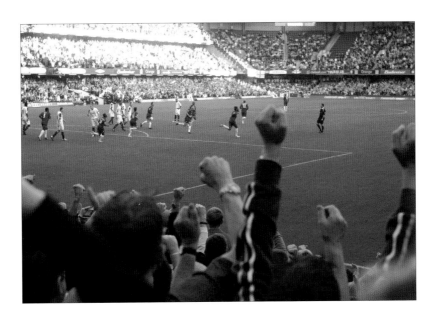

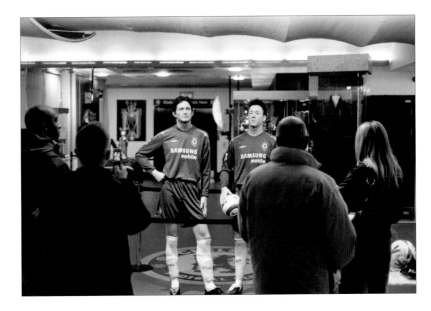

# the bridge

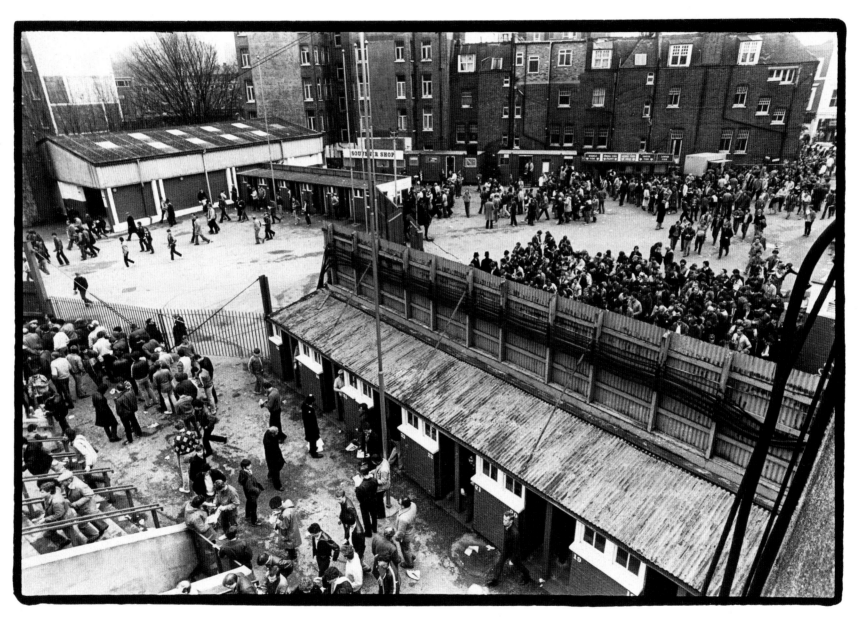

The Shed End turnstiles. Chelsea vs Fulham, May 1984.

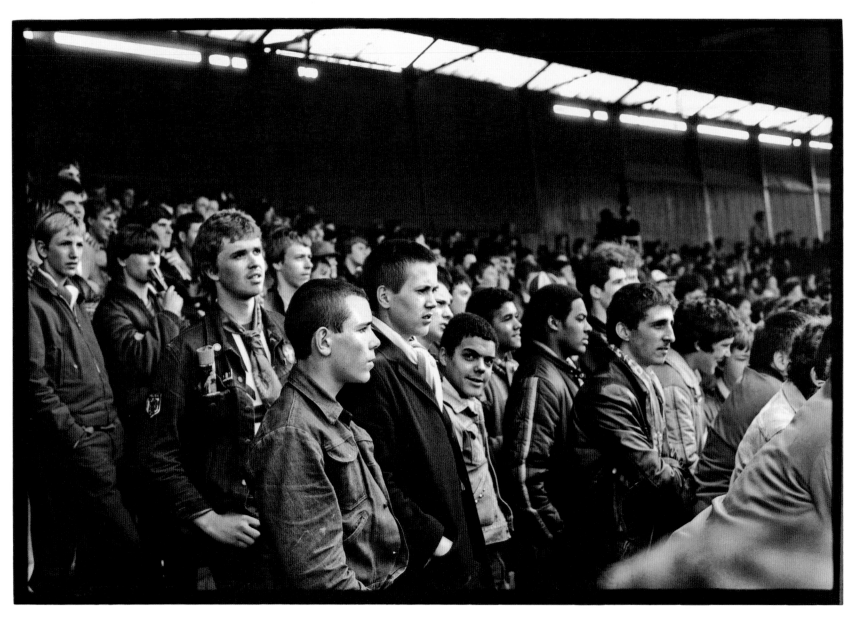

The Shed End. Chelsea vs Oldham Athletic, 1982.

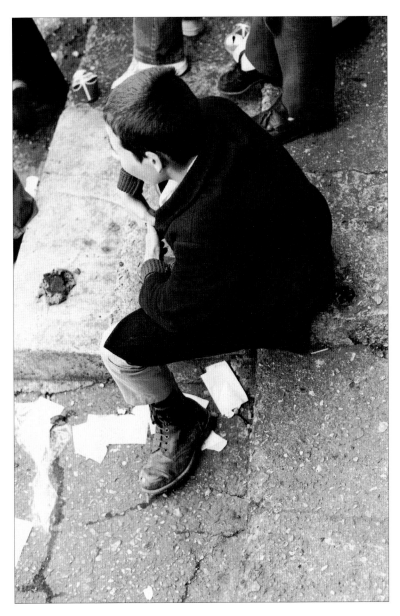

The Shed Terrace, 1980.

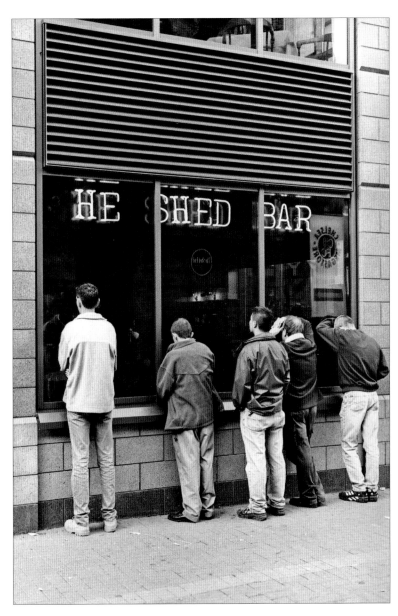

Ticketless fans find a way to watch the Chelsea vs Arsenal game, September 2001.

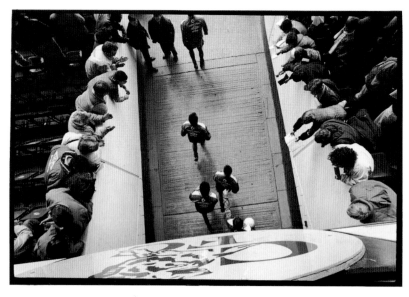

Tunnel vision. Chelsea run out against Liverpool, May 1991.

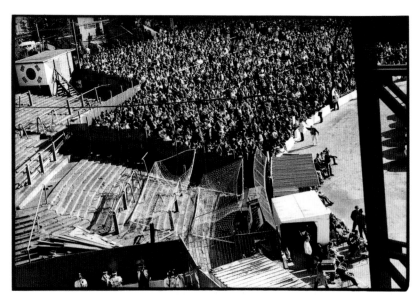

The Shed End, 1992.

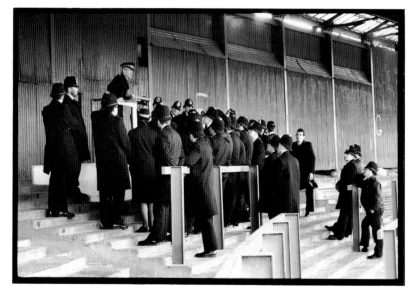

The Old Bill take The Shed.

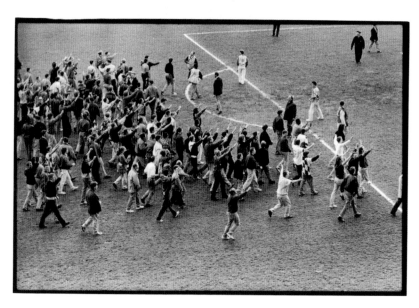

The fans take the pitch. Chelsea vs Arsenal, 1992.

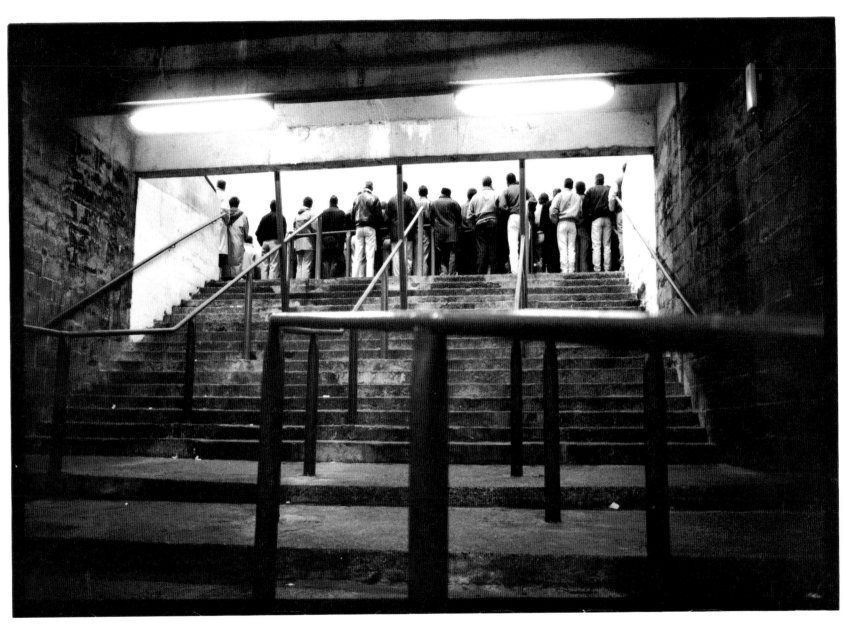

The Shed End, Bovril Gate Terrace. Chelsea 2 – Queens Park Rangers 0, 1991.

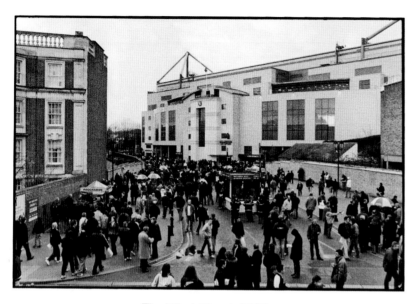

The West Stand, 2005.

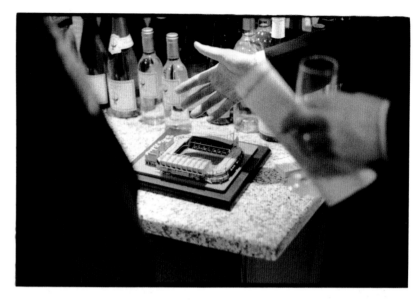

Launch party for £1million-a-season executive boxes, 2000.

The Footbal Factory. The East Stand, 2001.

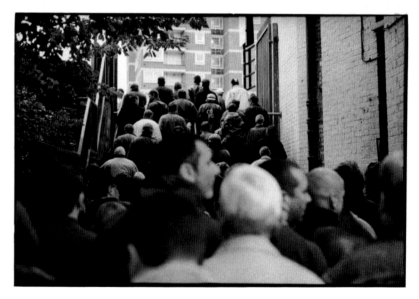

Perry's Passage, 2000.

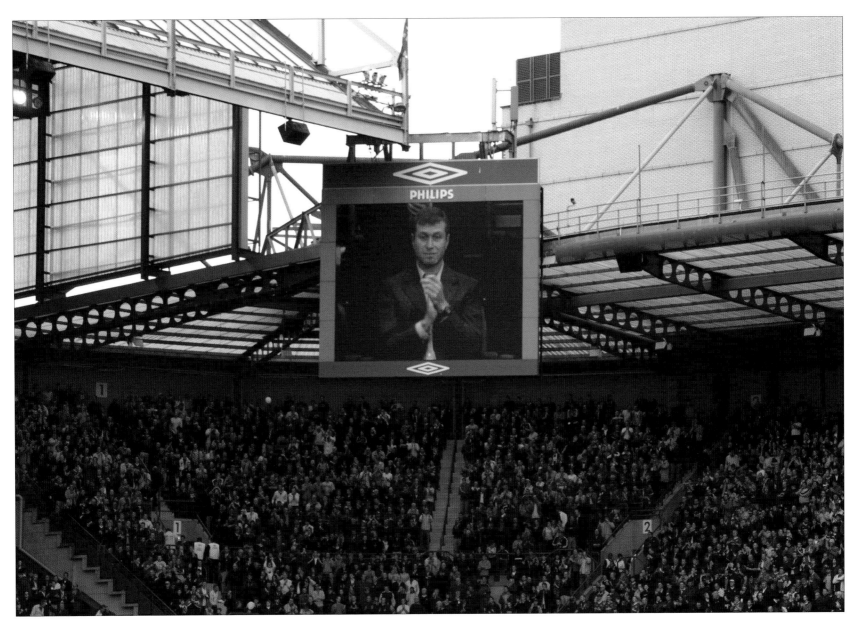

Chelsea's new owner greets the home crowd, 2004.

The home dressing room, 1990.

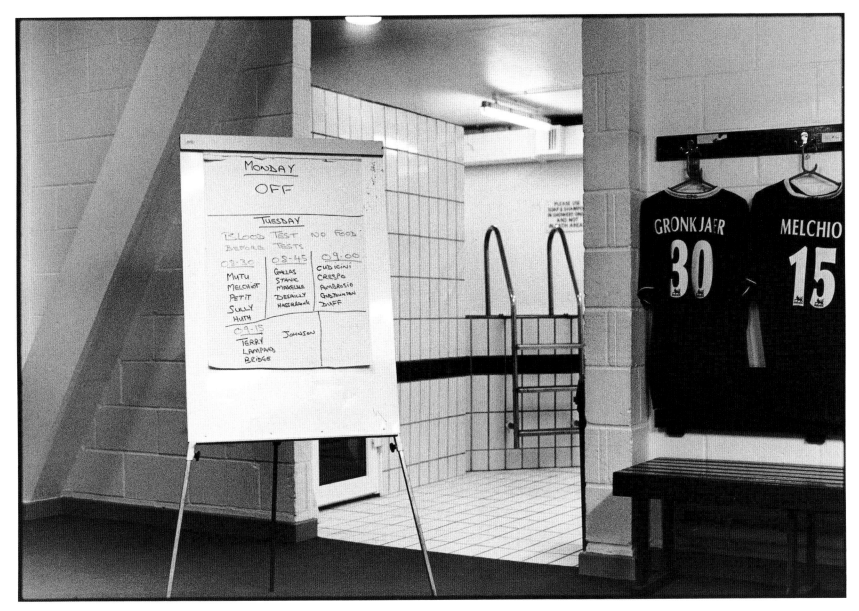

The home dressing room, 2004.

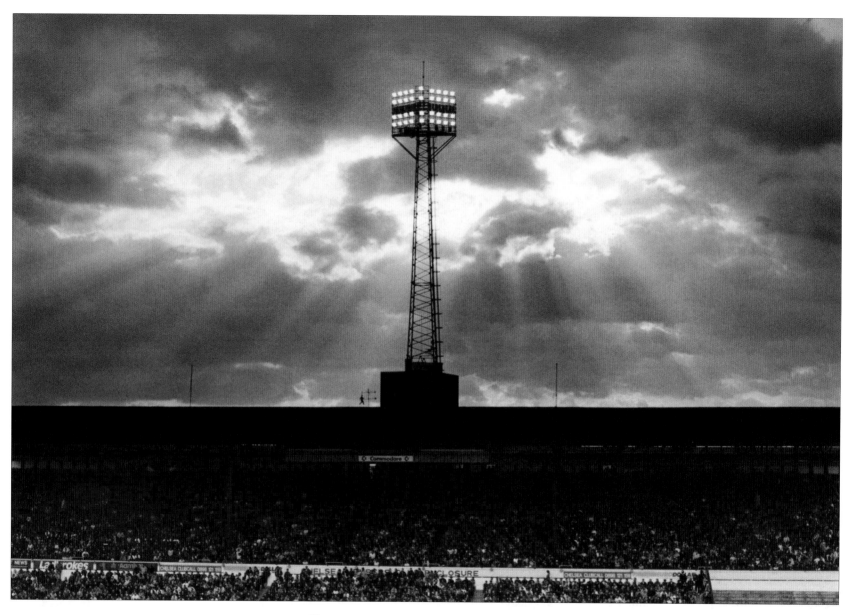

The sun sets over the West Stand, 1991.

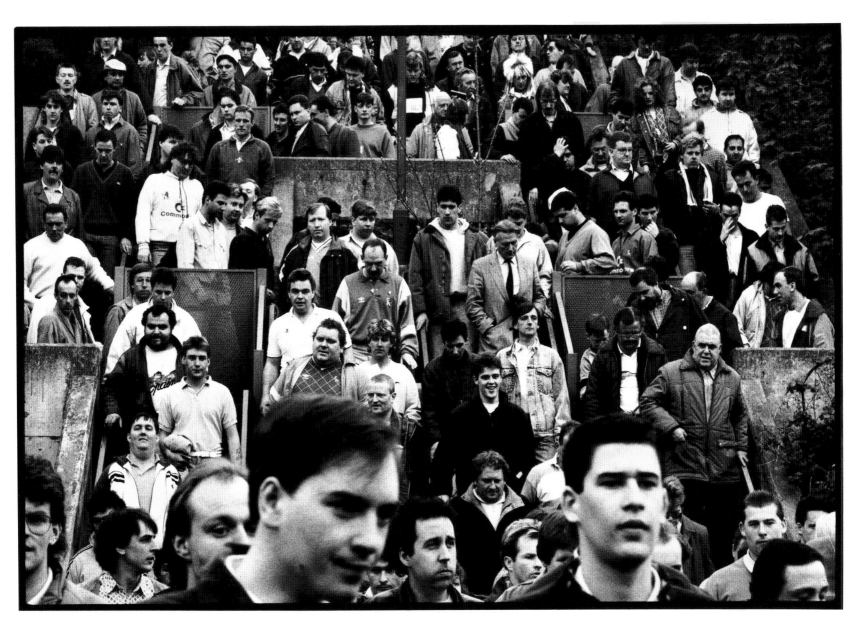

The West Stand steps, 1990.

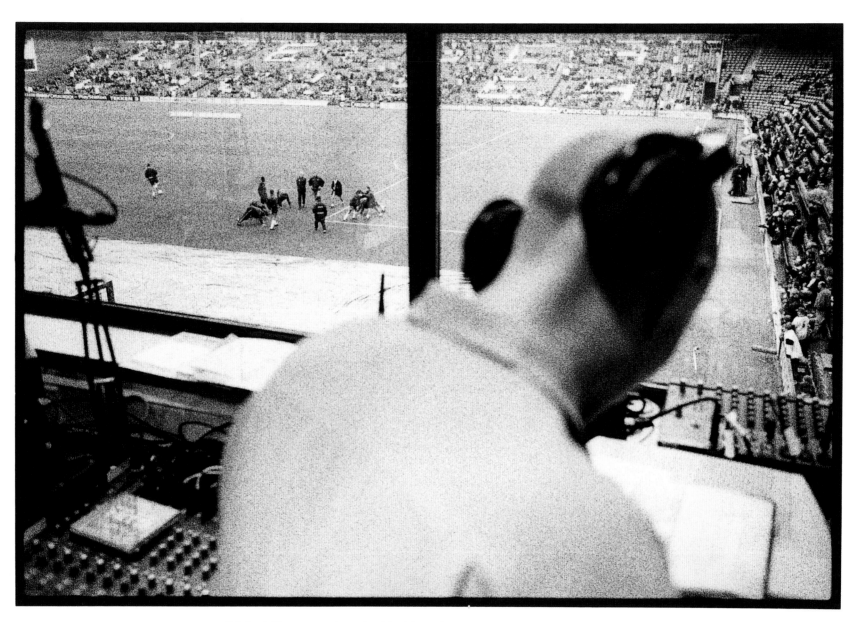

DJ Carl Chapman plays the Liquidator DJ booth in the East Stand, 1999.

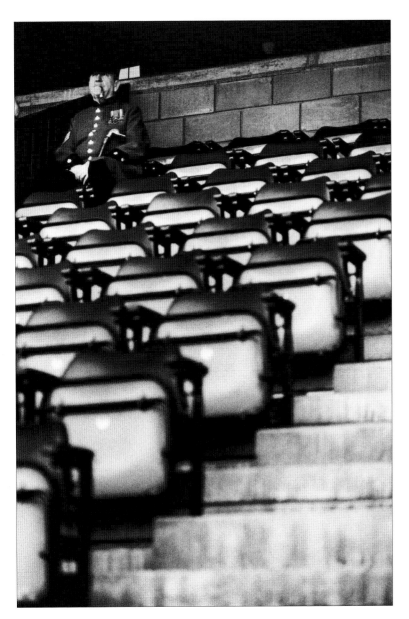

Chelsea pensioner. East Stand, 1991.

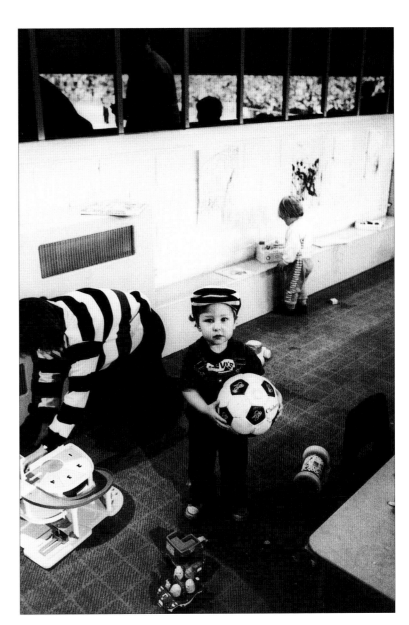

The crèche under the East Stand, 1990.

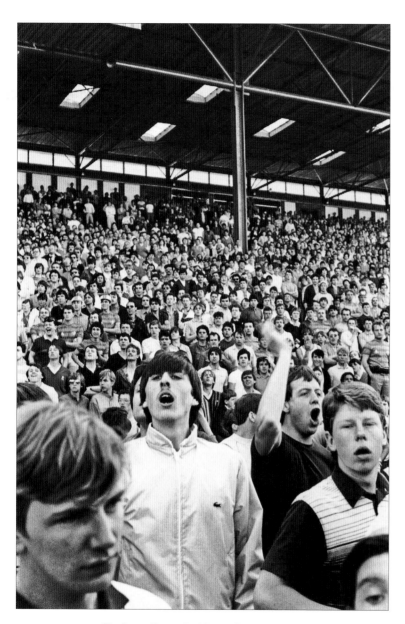

Chelsea Casuals. West Stand, 1984.

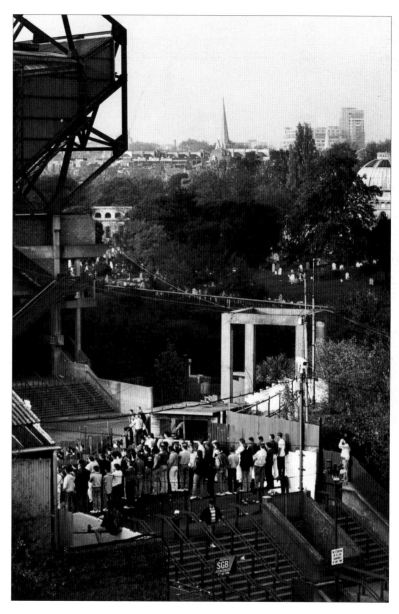

'We're the boys in blue in Division Two, and we won't be there for long.' The Shed steps, 1989.

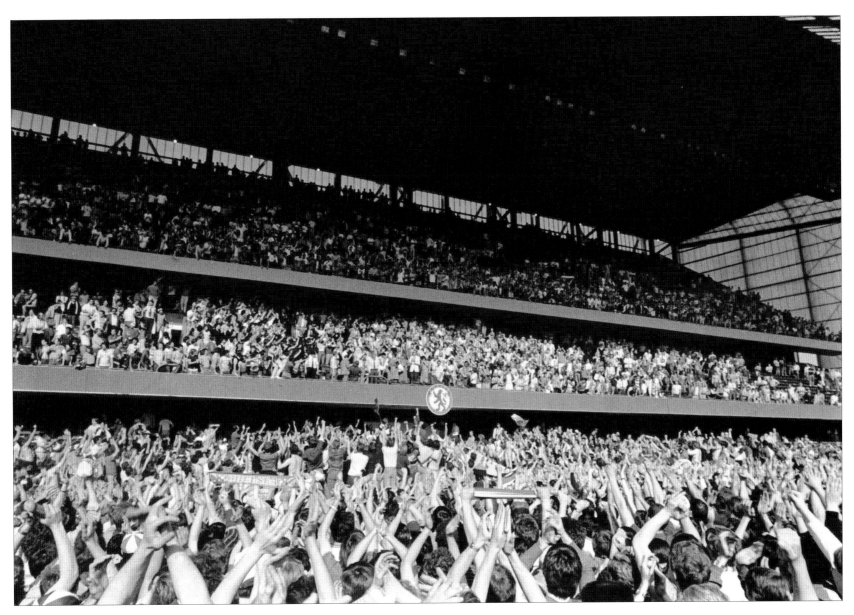

Tiers of joy. The East Stand celebrates promotion to Canon League Division One. Chelsea 5 – Leeds United 0, 1984.

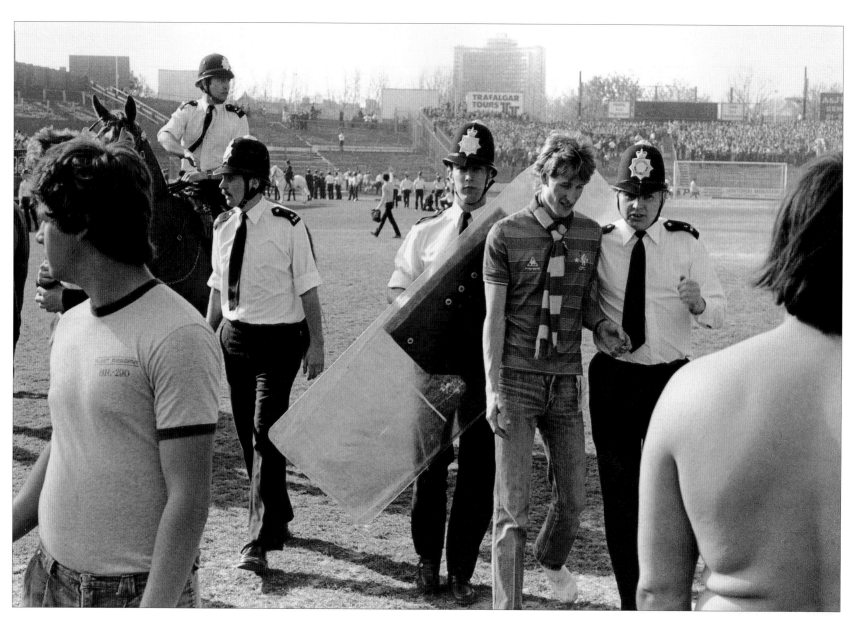

Chelsea promoted. Some people are on the pitch... Chelsea 5 – Leeds United 0, 1984.

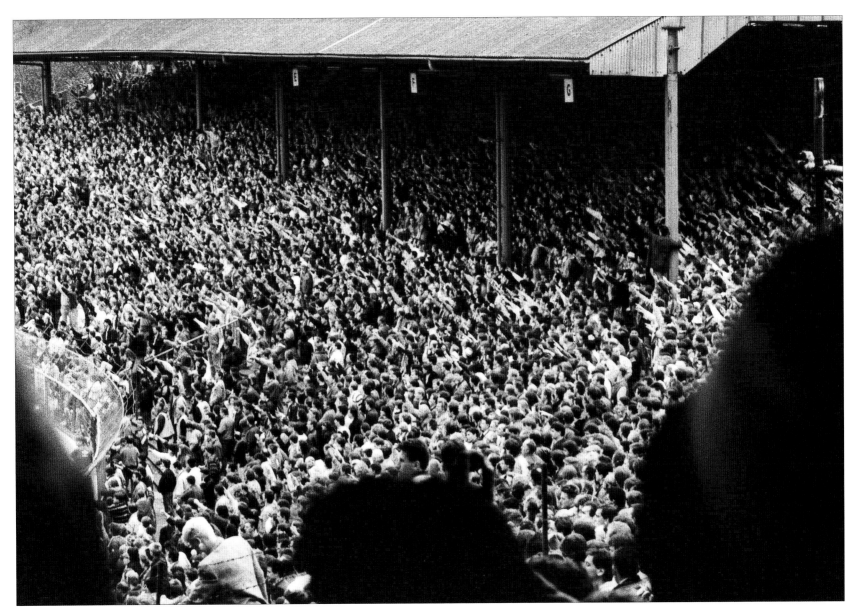

The Shed End, 1985.

Lower East Stand seats, 1989.

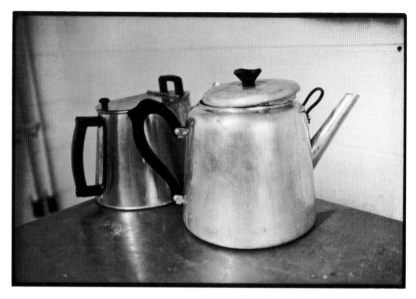

Home and away teapots in the dressing room, 1994.

A message from the Chairman of Chelsea Village in the reception at Stamford Bridge.

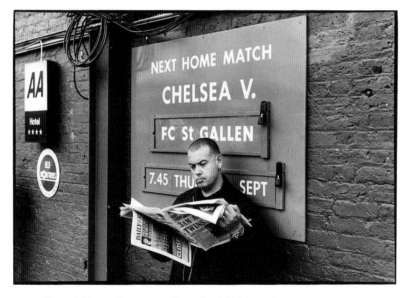

Fan at the entrance to Stamford Bridge, September 2000.

The story of O. The Shed Upper Stand, 1999.

East Stand dining room, 2004.

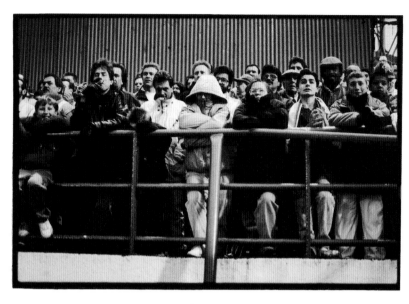

In The Shed, 1991.

One man went to mow, 1997.

Workmen remove the gates to Stamford Bridge, August 1998.

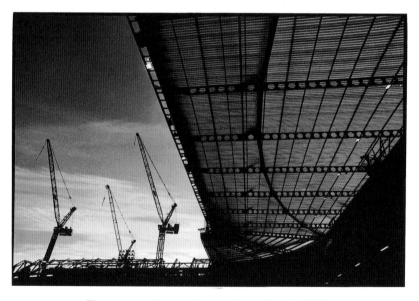

The cranes that built the West Stand, 2000.

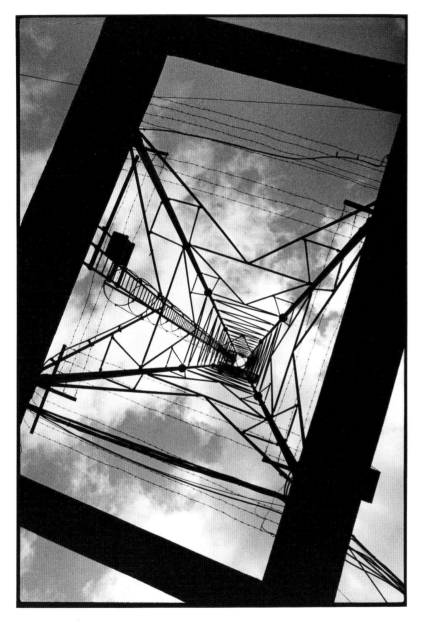

Away end floodlights, 1990.

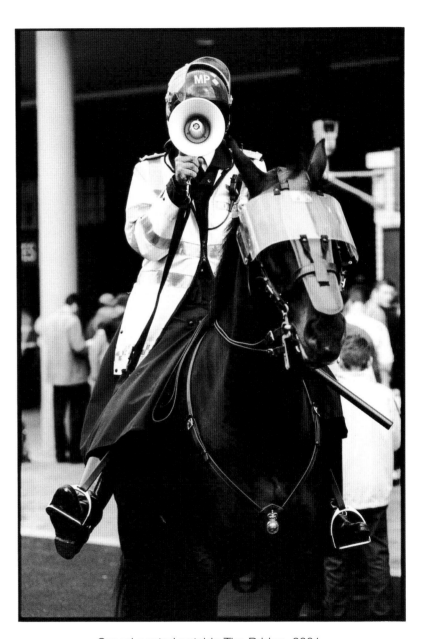

Crowd control outside The Bridge, 2001.

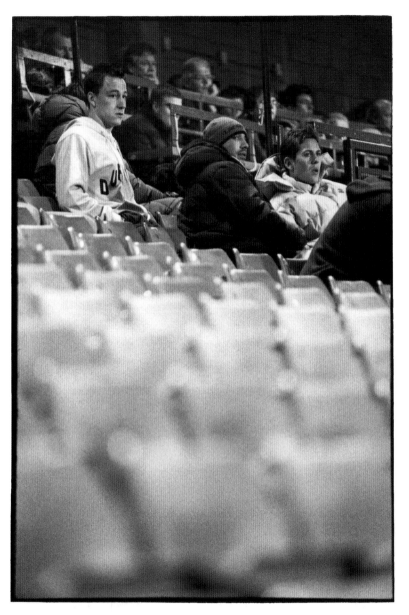

John Terry, Rob Wolleaston and Jon Harley watch the reserves play.
East Stand, 2001.

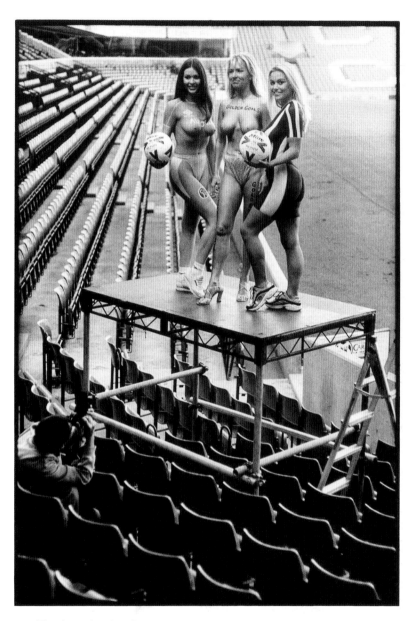

The launch of online gaming website www.goldengoals.com.
Stamford Bridge, 1999.

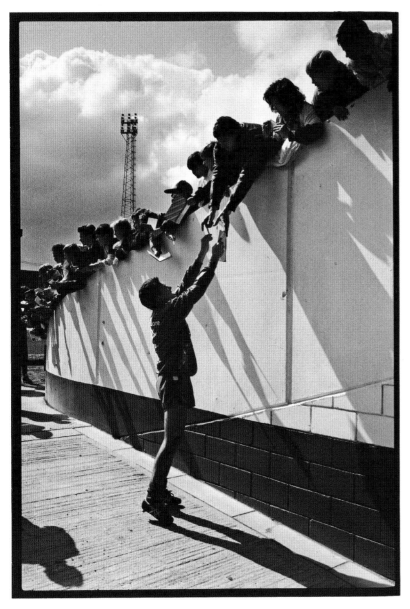

Tony Dorigo signs autographs, 1991.

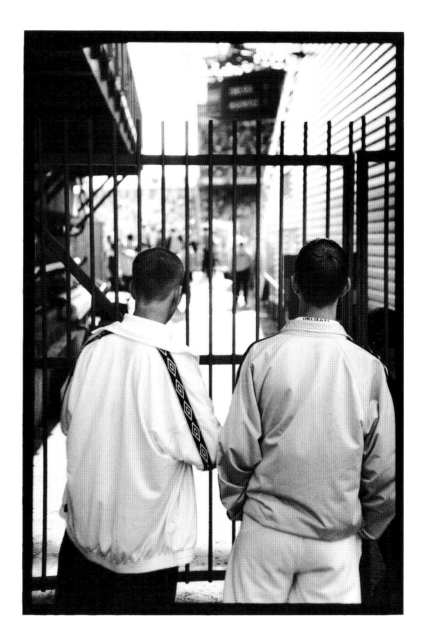

Restricted view, 1998.

The Shed End Lower Stand, August 1998.

Stamford Bridge tunnel, 2003.

Stamford Bridge tunnel, 2001.

The East Stand facilities, 1990.

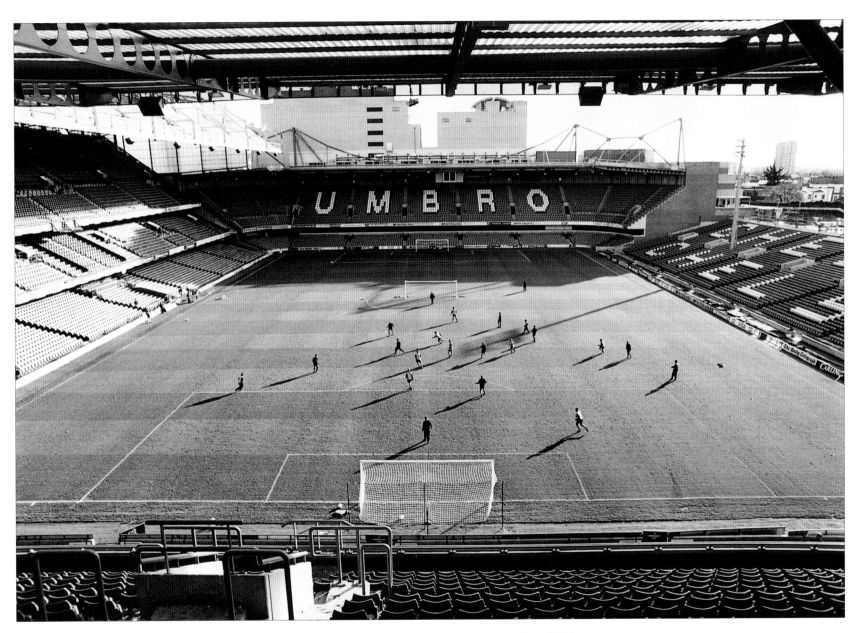

Chelsea practice the Christmas tree formation, 1999.

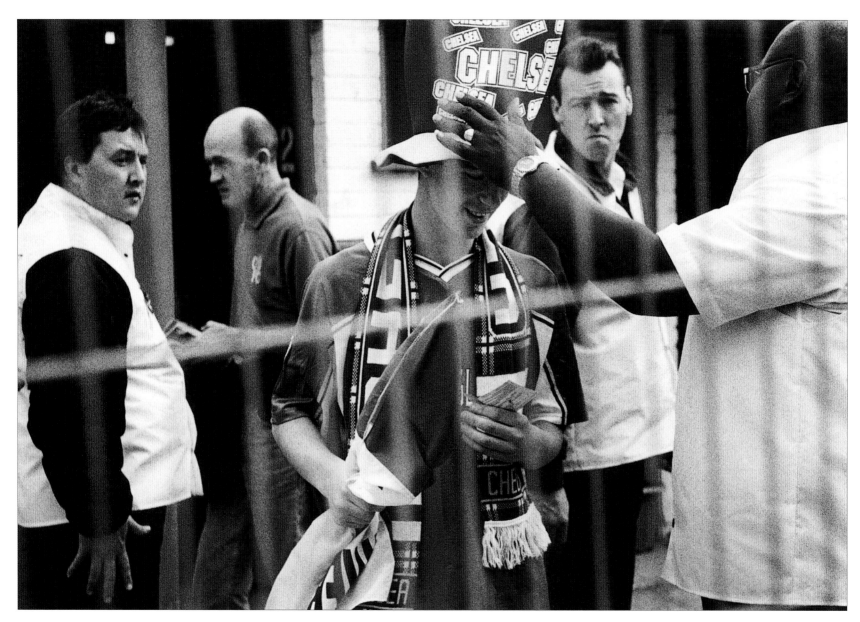

West Stand turnstiles, 1996.

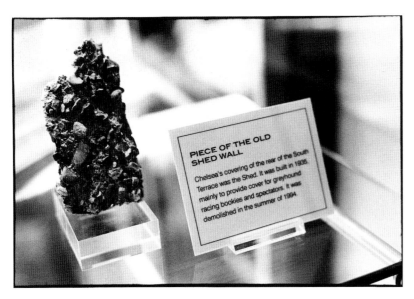

**PIECE OF THE OLD SHED WALL**

Chelsea's covering of the rear of the South Terrace was the Shed. It was built in 1935, mainly to provide cover for greyhound racing bookies and spectators. It was demolished in the summer of 1994.

Priceless artefacts on display in the Chelsea World of Sport, 2001.

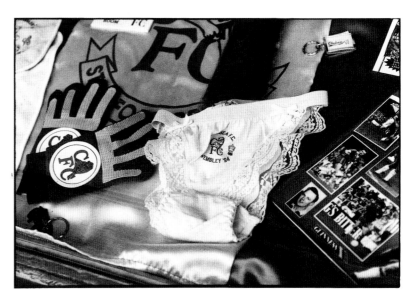

The club shop window, FA Cup Final week, 1994.

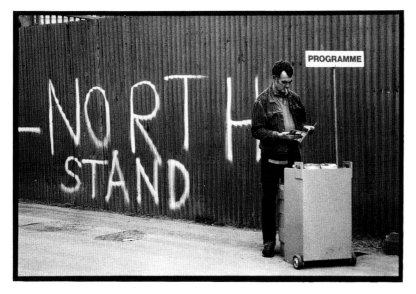

-NORTH STAND

PROGRAMME

Corporate signage during redevelopment, 1996.

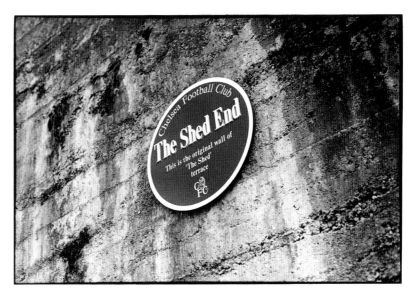

Chelsea Football Club
**The Shed End**
This is the original wall of 'The Shed' terrace

The blue plaque celebrating The Shed, 2000.

# home & away

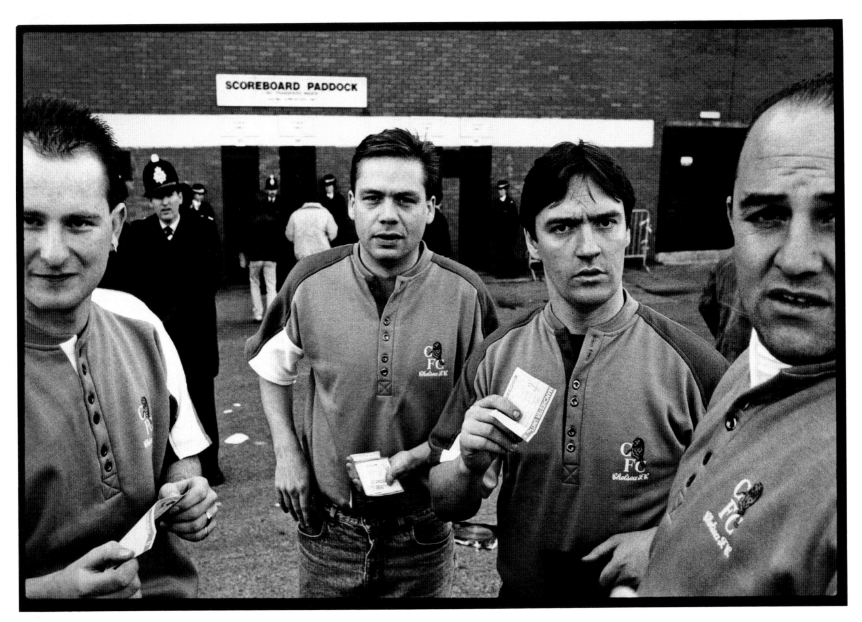

Fans at Old Trafford. Manchester United 2 – Chelsea 3, 1990.

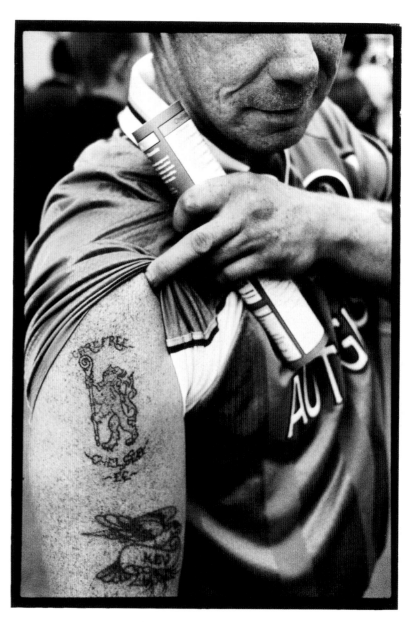

Stamford Bridge, 1998.

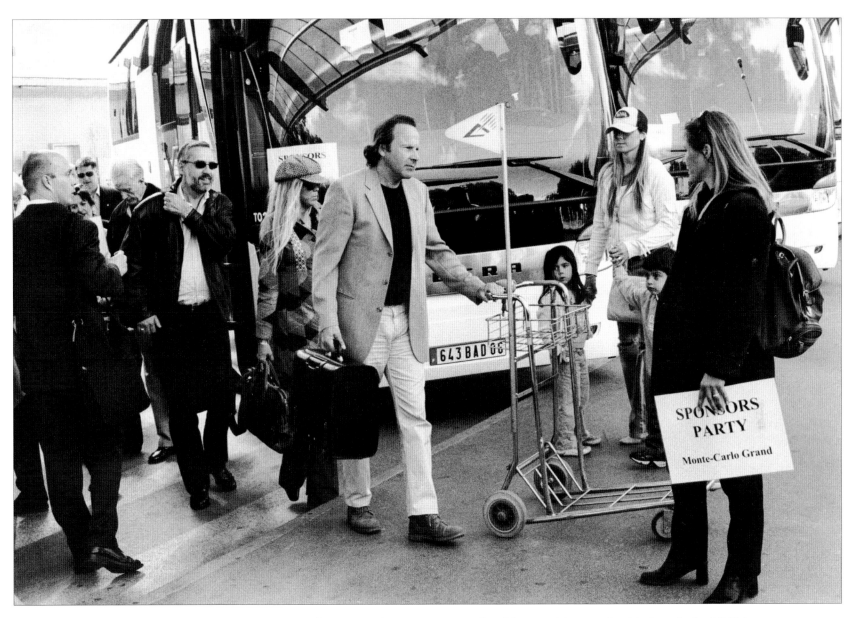

Fans arrive at Nice airport before the Champions League game against Monaco. Monaco 3 – Chelsea 1, April 2004.

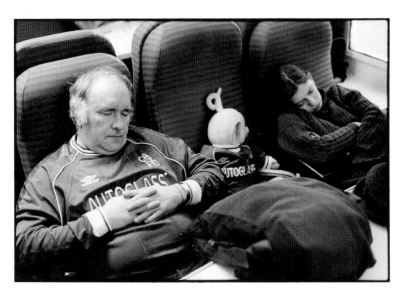

Fans on the ferry en-route to the Champions League game in
Rotterdam. Feyenoord 1 – Chelsea 3, March 2000.

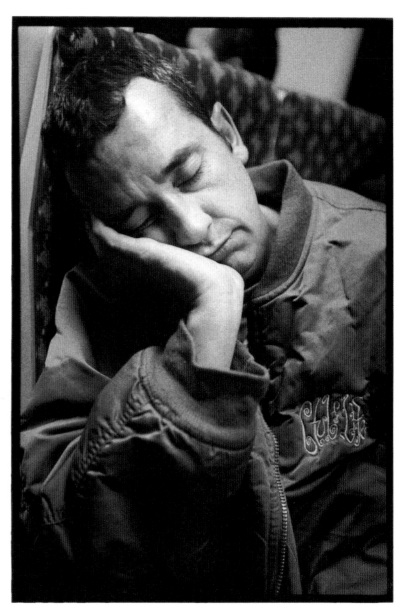

Fan on a train returning from the game at Anfield.
Liverpool 1 – Chelsea 1, October 1998.

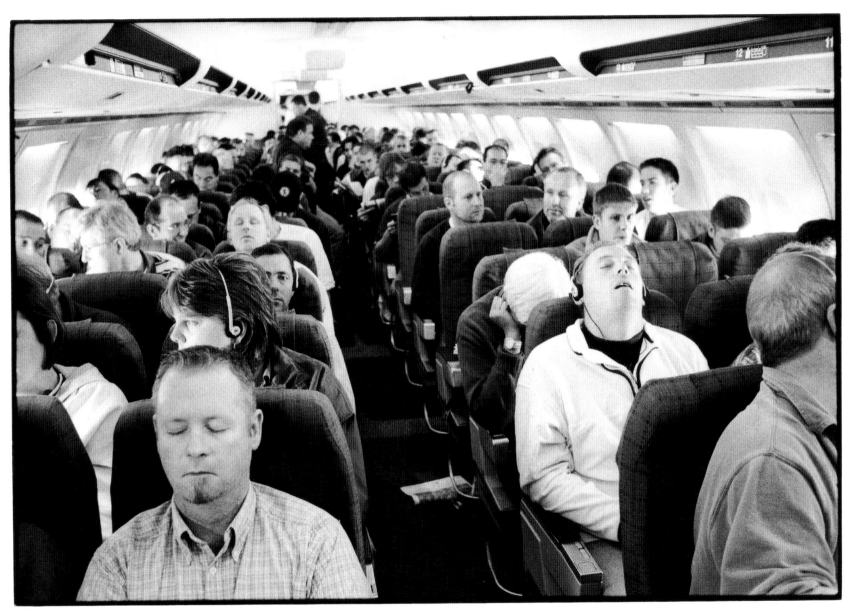

Fans on an easyJet flight to the Champions League game in Rome. Lazio 0 – Chelsea 0, December 1999.

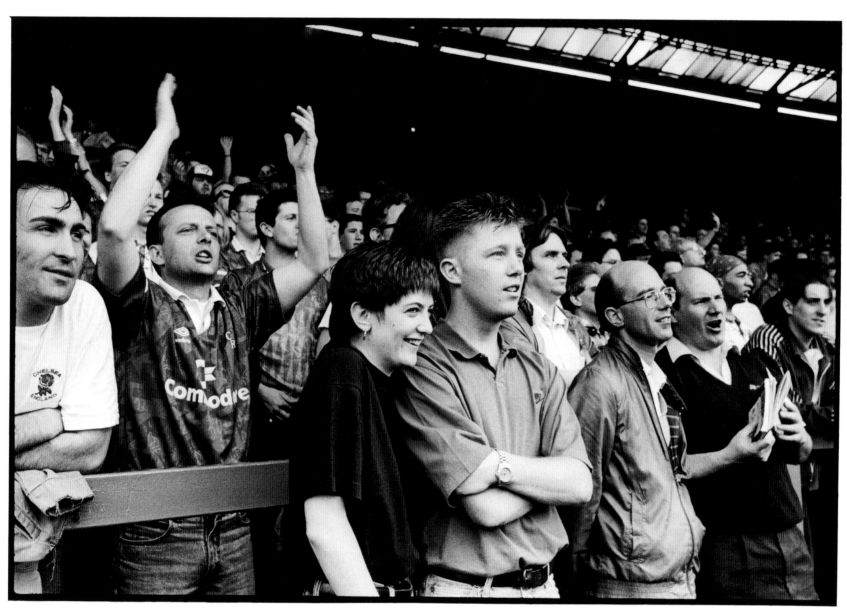

A date in The Shed. FA Cup third round. Chelsea 0 – Barnet 0, 1994.

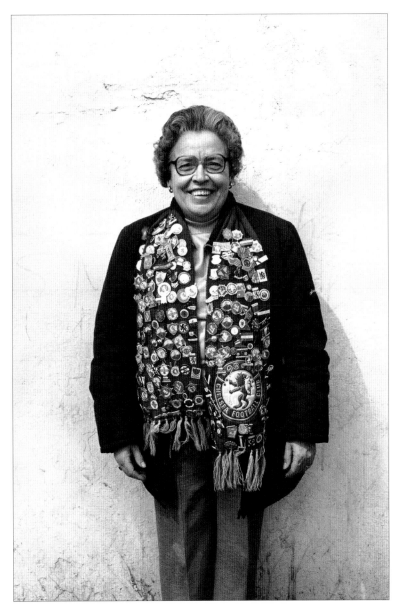

Pauline. Fulham Road, 1983.

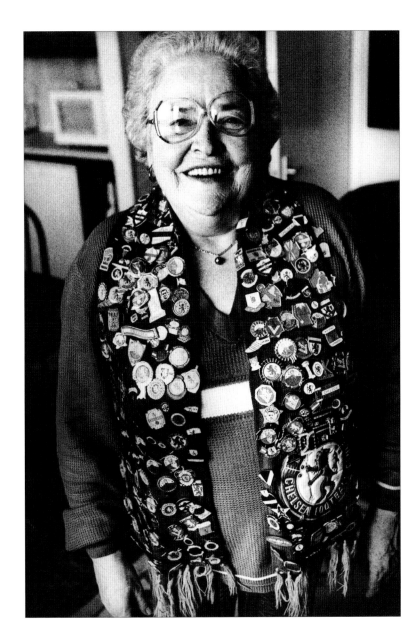

Pauline. Clapham, 1998.

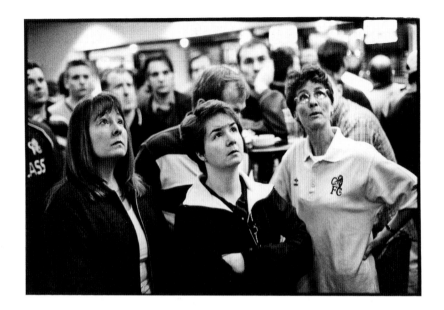
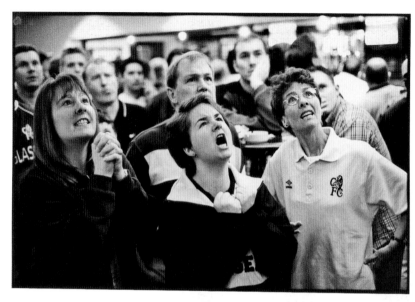
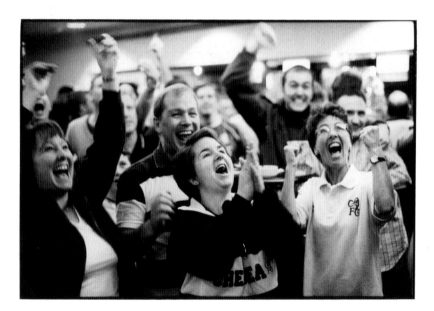
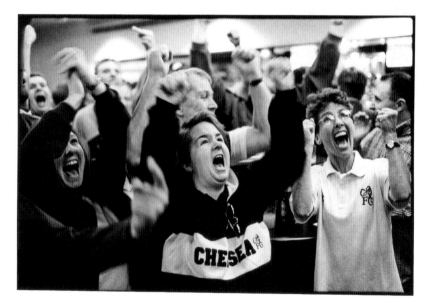

Fans in Drake's Bar at Stamford Bridge watch Michael Owen take a penalty during live TV broadcast of a Liverpool vs Chelsea game.
Liverpool 1 – Chelsea 0, October 1999.

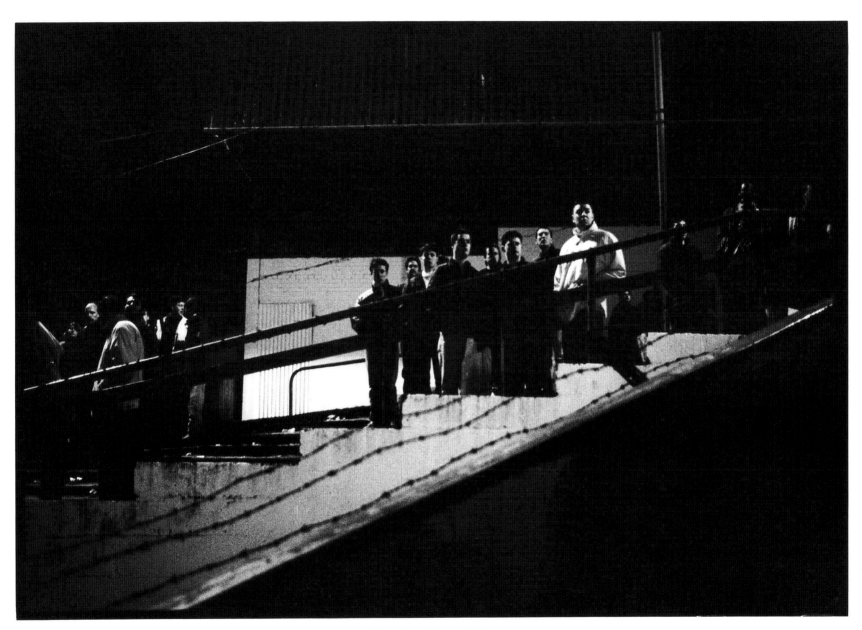

The Shed End, 1990.

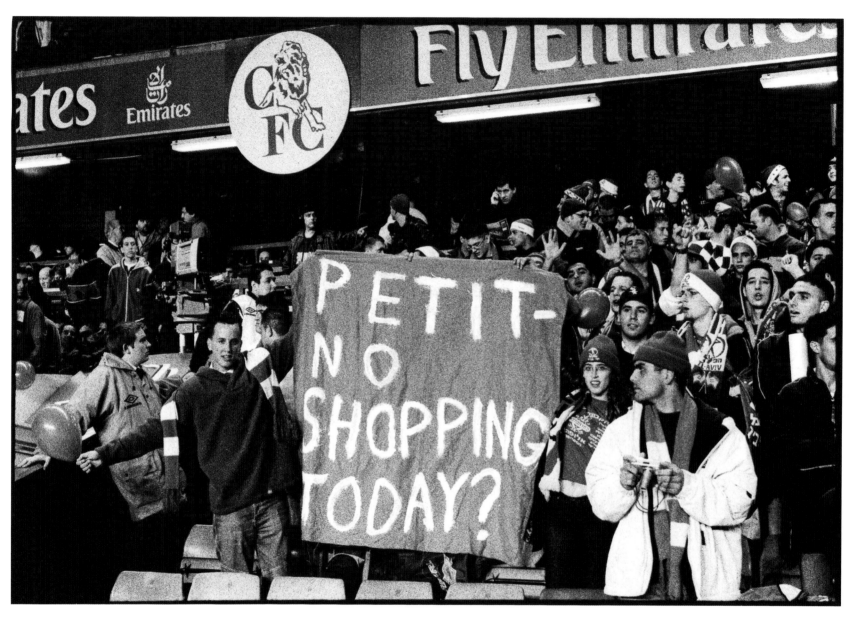

Hapoel Tel Aviv fans ask questions of Emmanuel Petit before the second leg of the UEFA Cup second round.
Chelsea 1 – Hapoel Tel Aviv 1, October 2001.

Wembley way, FA Cup Final day.
Chelsea 2 – Middlesbrough 0, May 1997.

Fan at Selhurst Park. Wimbledon 2 – Chelsea 1, December 1998.

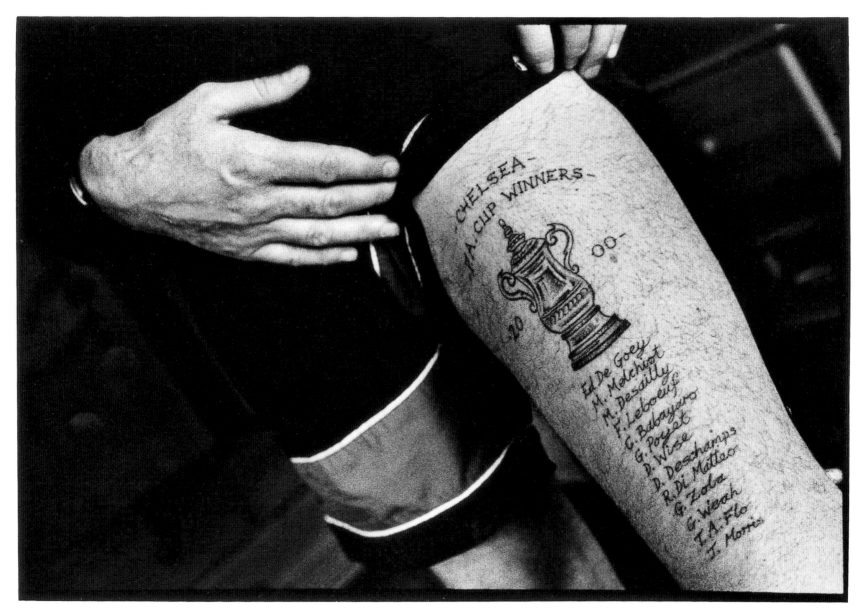

Fan's tattoo, 2001.

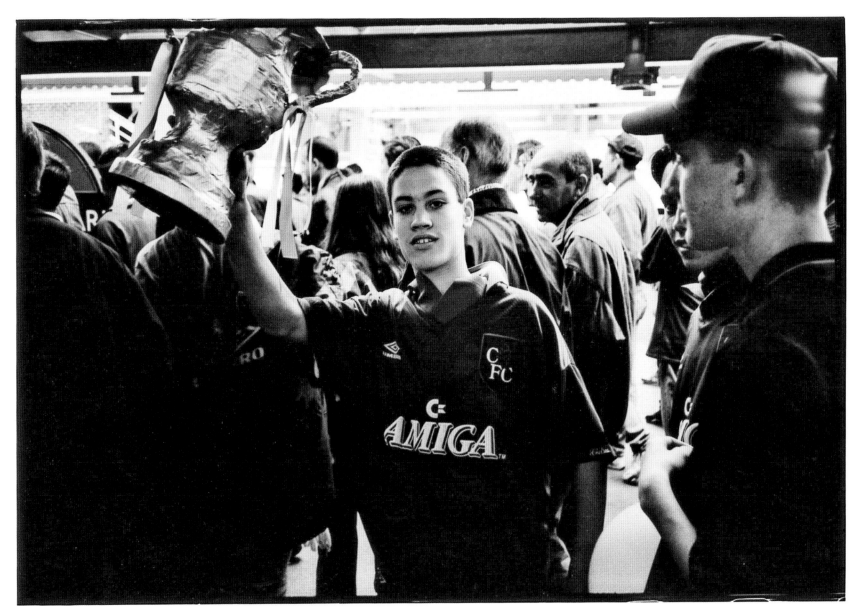

Wembley Park tube station. FA Cup Final day, 1994.

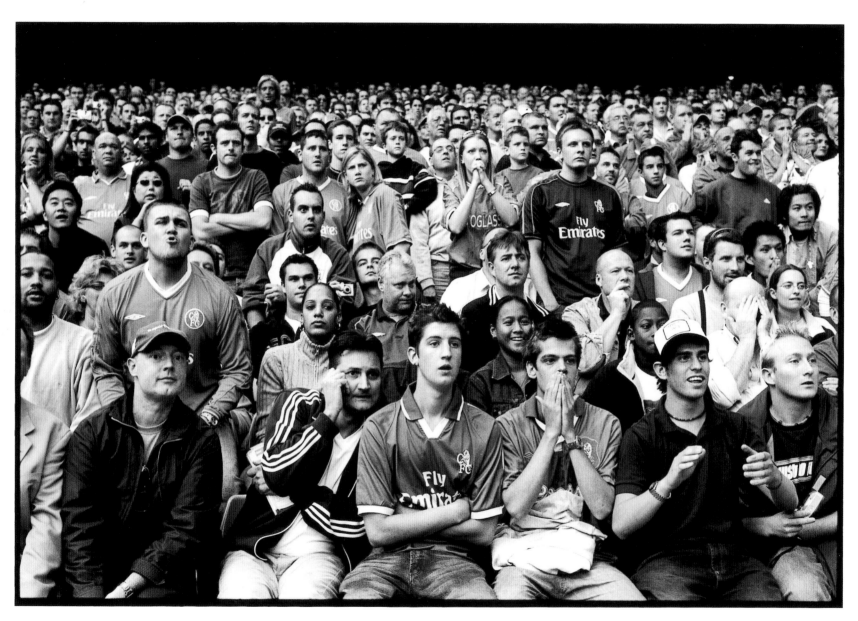

Fans in the Matthew Harding Lower Stand, 2000.

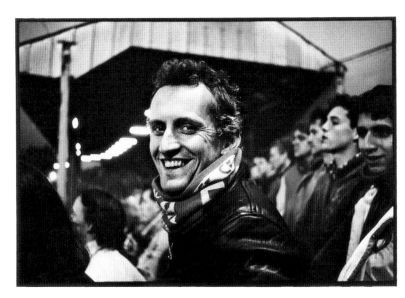

The Shed End, 1991.

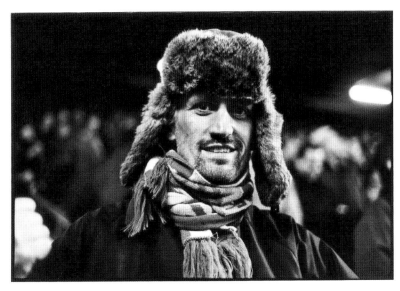

The Matthew Harding Lower Stand, 2005.

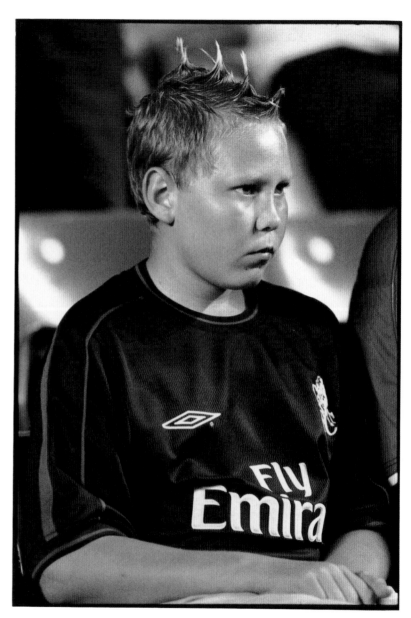

Young fan sports a 'Beckham', 2002.

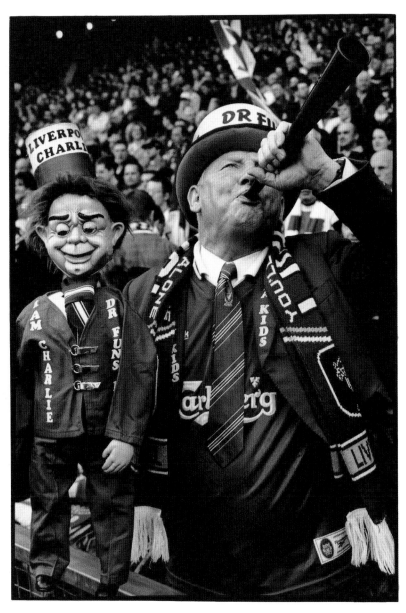

Fan at the Cop End at Anfield. Liverpool vs Chelsea, 2001.

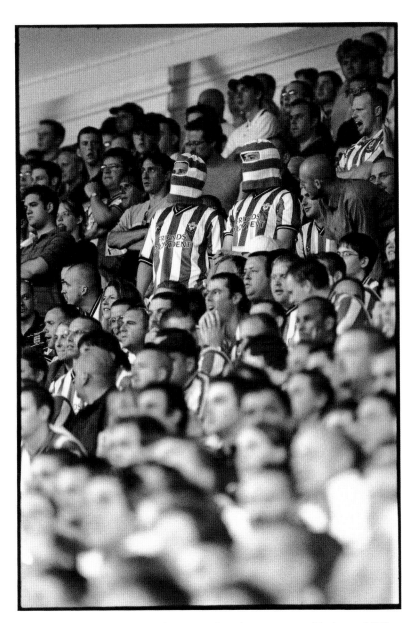

Saints fans at St Mary's Stadium. Southampton vs Chelsea, 2002.

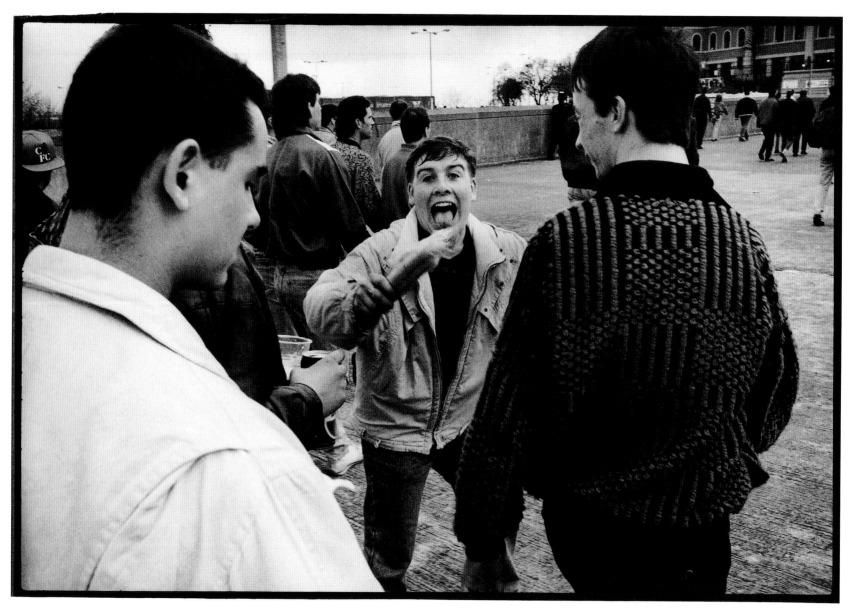

Fan with celery on Wembley Way. Zenith Data Systems Final. Chelsea 1 – Middlesbrough 0, 1990.

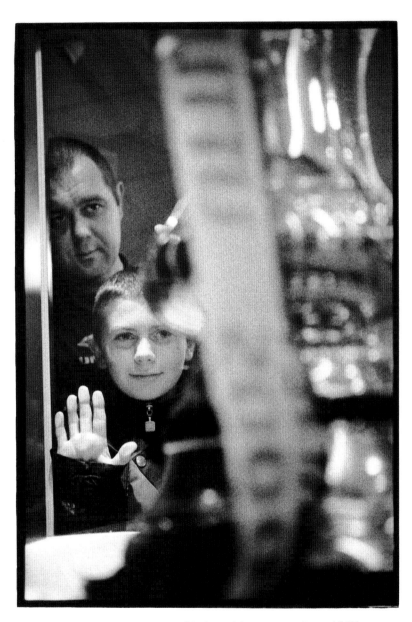

Father and son in the Chelsea Megastore, June 1997.

Window display in Battersea. FA Cup Final week, May 1997.

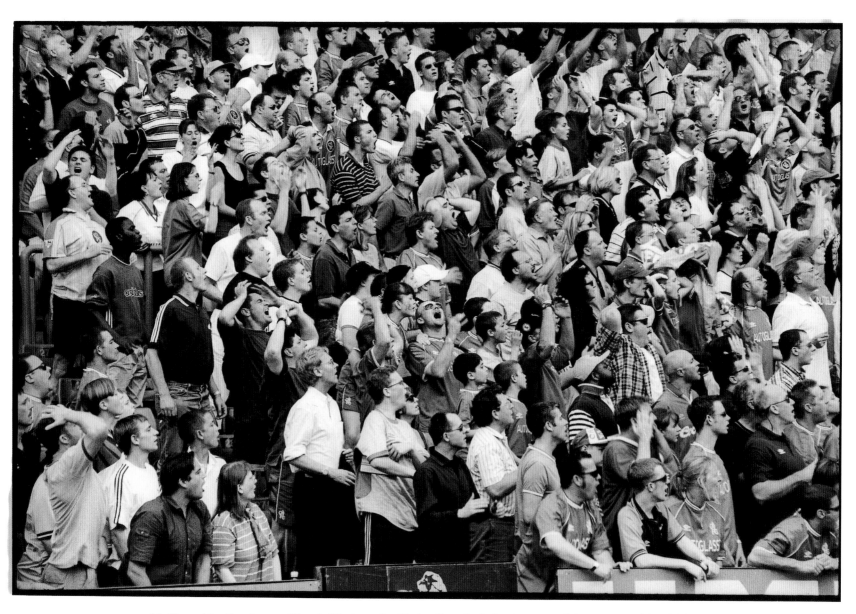

Matthew Harding Lower Stand. Chelsea 4 – Derby County 0. Last game of the season, May 2000.

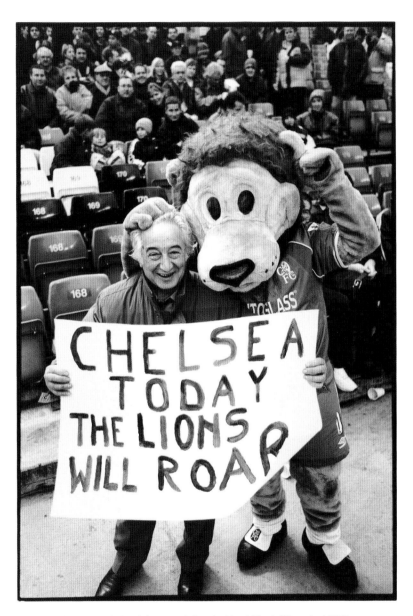

Stamford the Lion and fan in the West Stand, 1999.

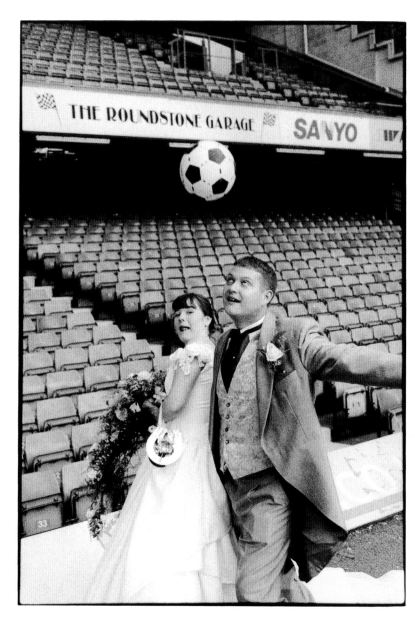

A Chelsea wedding. Stamford Bridge, 2000.

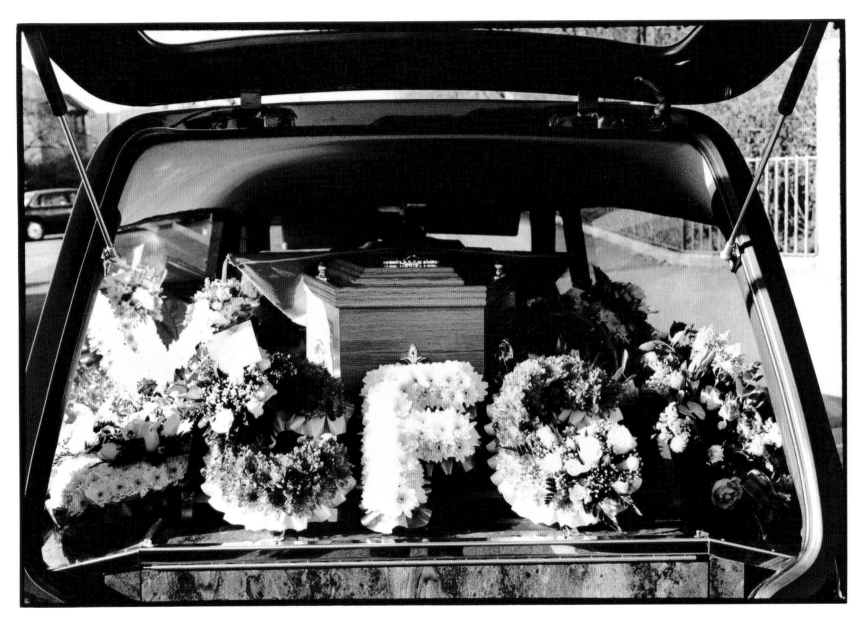

A Chelsea funeral. Headington, Oxford, 2002.

Half time at the Stade Louis II. Champions League Quarter Final.
Monaco 3 – Chelsea 1, April 2004.

Fans in the Stadio Olimpico, Rome. Champions League.
Lazio 0 – Chelsea 0, December 1999.

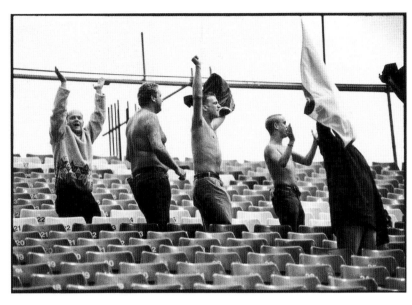

Fans conga in the West Stand, 1999.

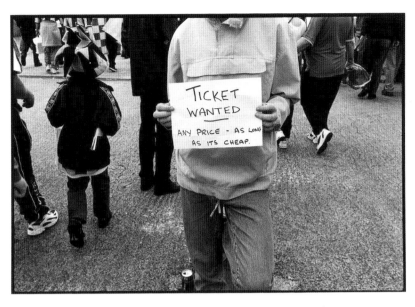

Ticketless fan. Wembley Way, FA Cup Final day.
Chelsea 1 – Aston Villa 0, May 2000.

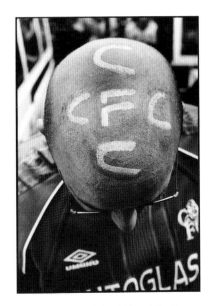

Fan on Wembley Way. FA Cup
Final day, May 2000.

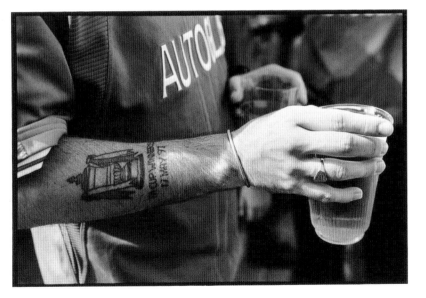

Fan at Stamford Bridge, 1997.

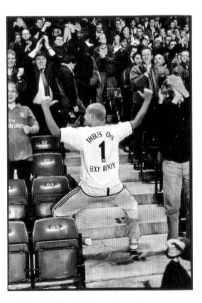

Thank God there's only one.
West Stand, 2001.

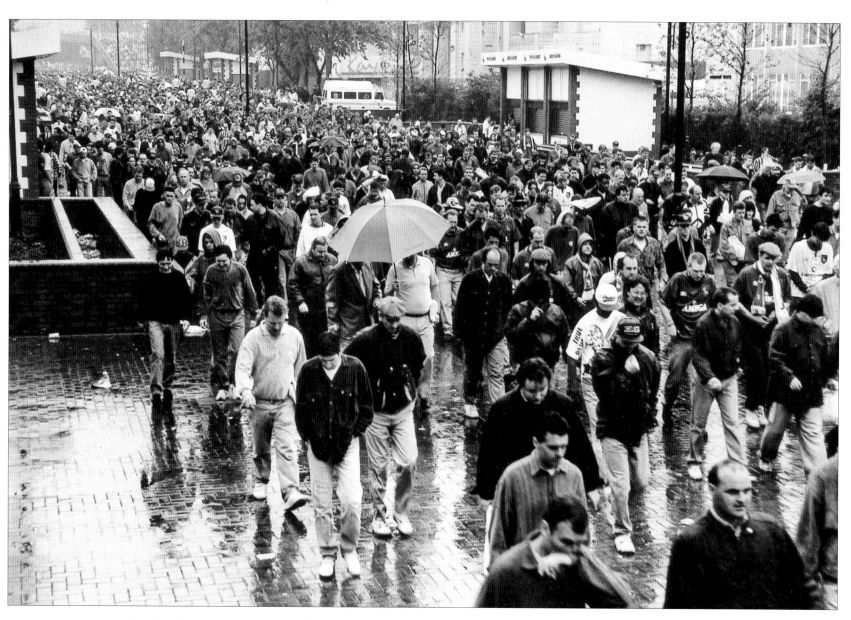

Wembley Way, five minutes after the end of the 1994 FA Cup Final defeat. Chelsea 0 – Manchester United 4.

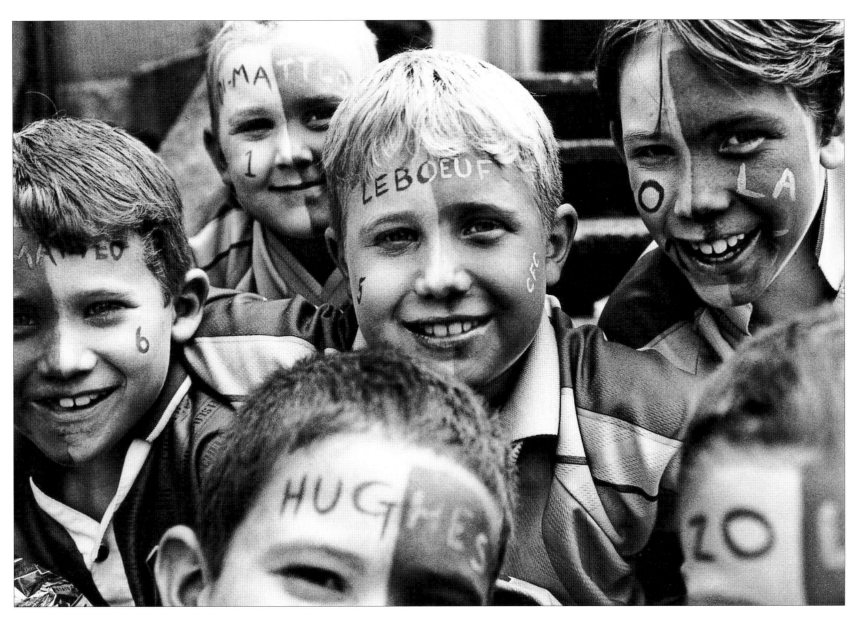

Wembley Way. FA Cup Final day, 1997.

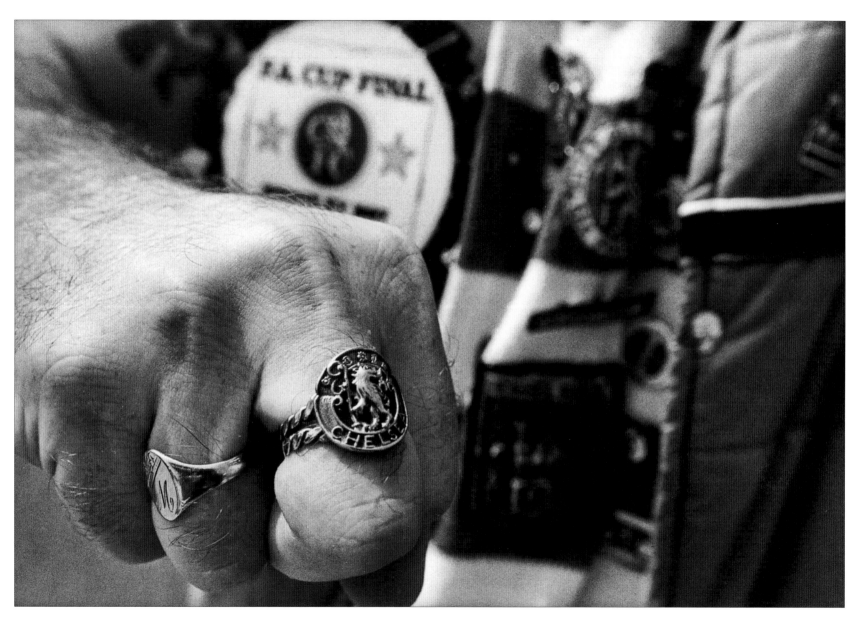

Wembley Way. FA Cup Final day, 1997.

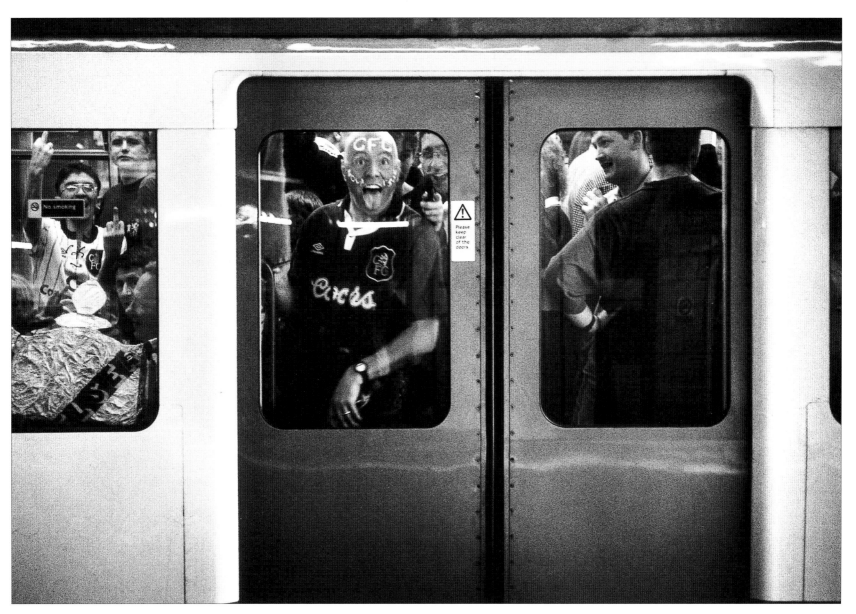

Baker Street station. FA Cup Final day, 1997.

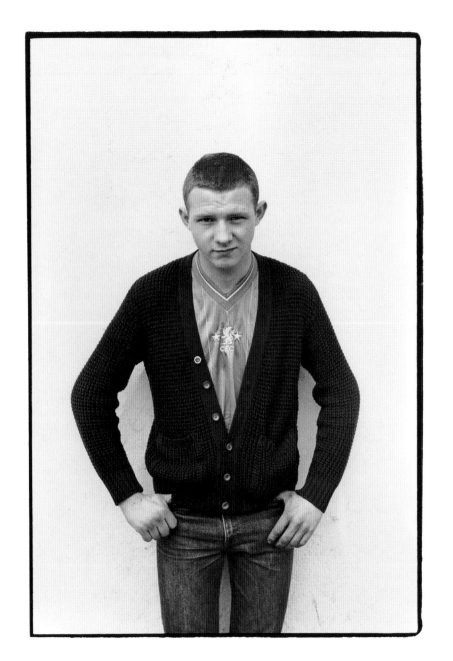
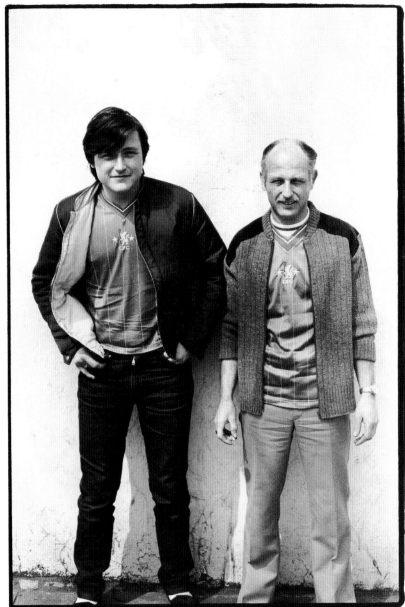

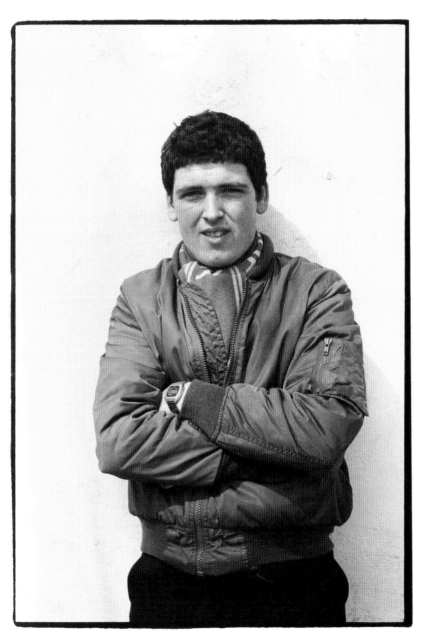

Fans on the Fulham Road, 1980.

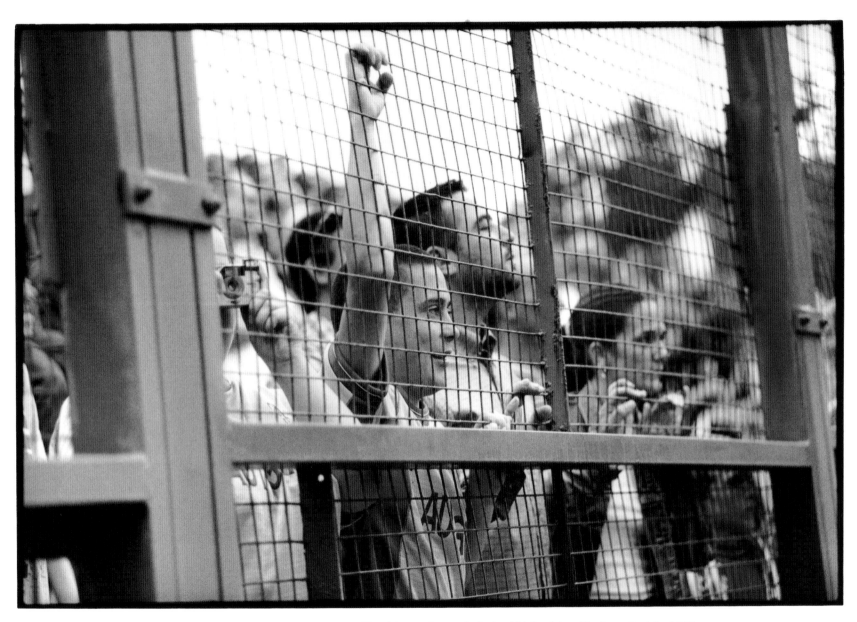

Fans attend a pre-season friendly at The Manor Ground. Oxford United 1 – Chelsea 5, July 2000.

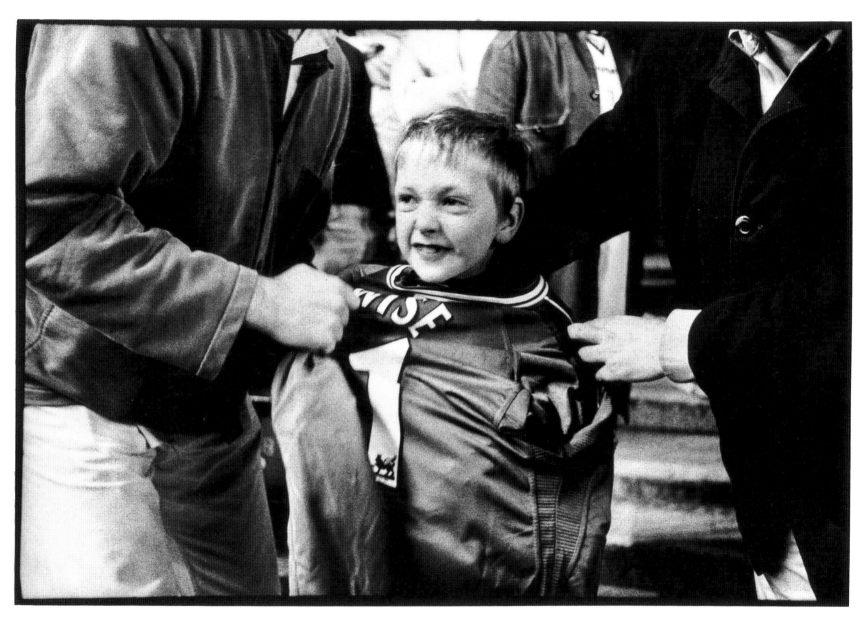

Fan with captain Dennis Wise's shirt at the end of the game. Liverpool 2 – Chelsea 2, May 2001.

Fan in the Matthew Harding Lower Stand, 1999.

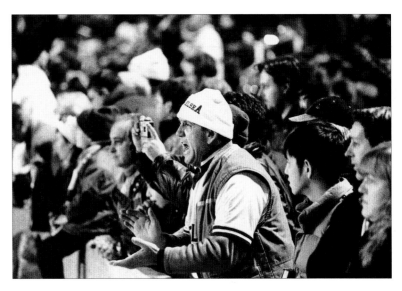

Fan in the West Stand, 1999.

Fans at the Millennium Stadium, Cardiff. FA Cup Final day.
Chelsea 0 – Arsenal 2, May 2002.

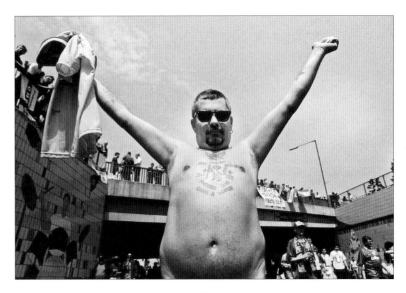

Wembley Way. FA Cup Final day, 1997.

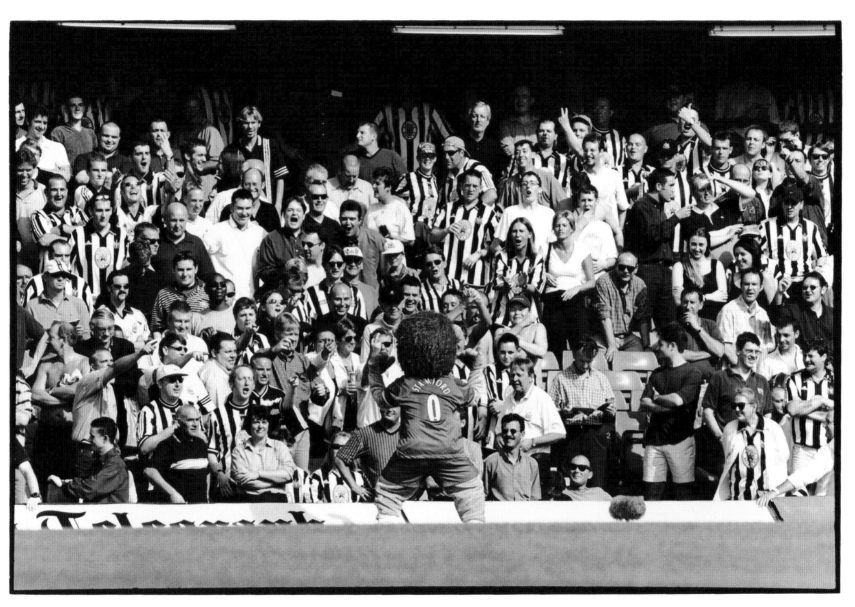

Stamford the Lion welcomes Newcastle United fans to The Bridge. Chelsea 1 – Newcastle 0, September 1999.

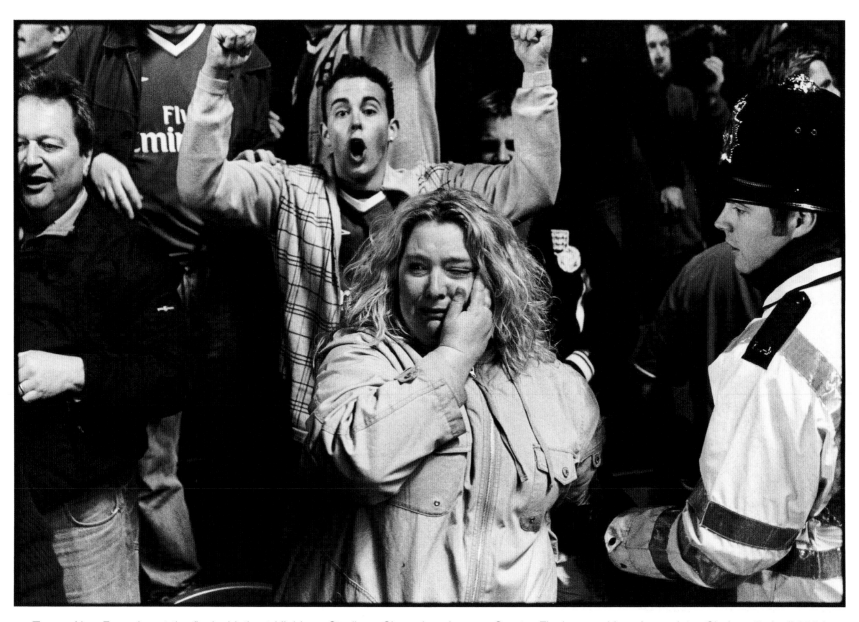

Tears of joy. Fan cries at the final whistle at Highbury Stadium. Champions League Quarter Final second leg. Arsenal 1 – Chelsea 2, April 2004.

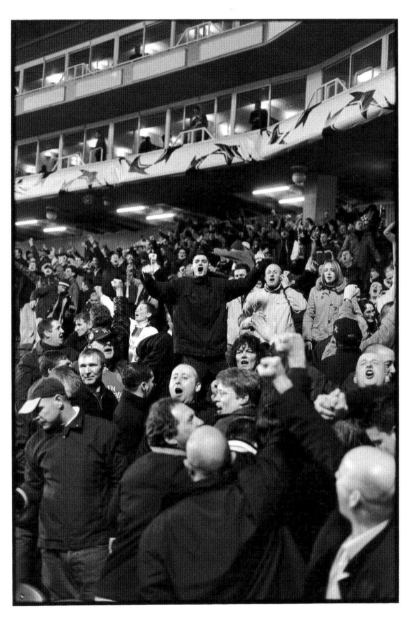

Fans celebrate Claudio Ranieri's greatest result as Chelsea take the Clock End.

# the players

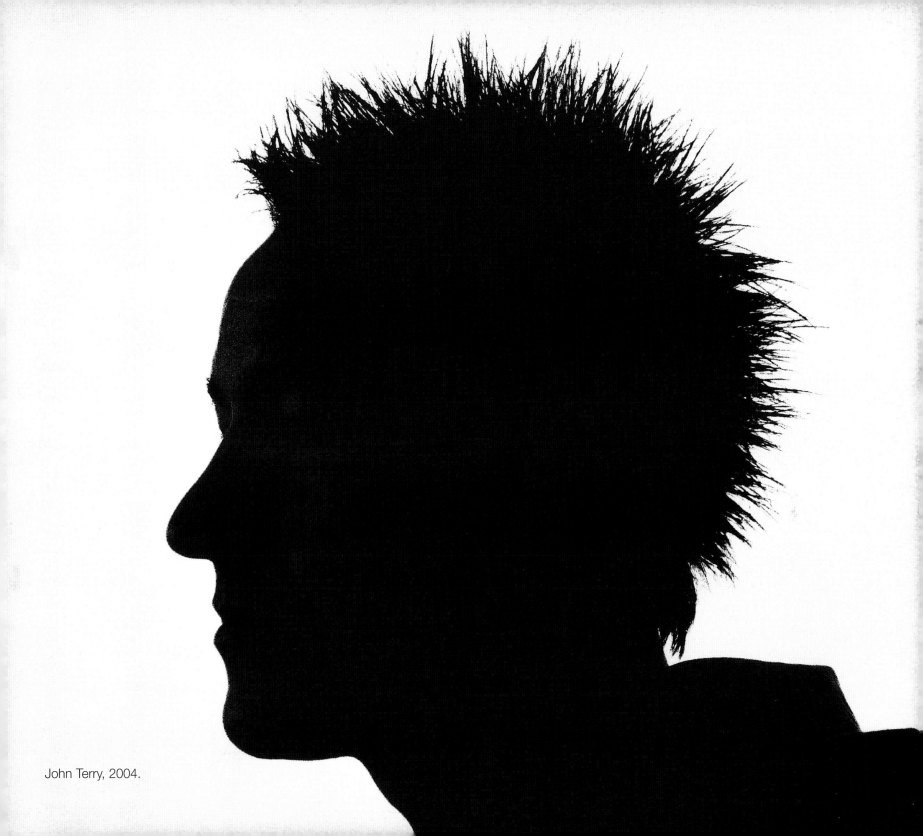

John Terry, 2004.

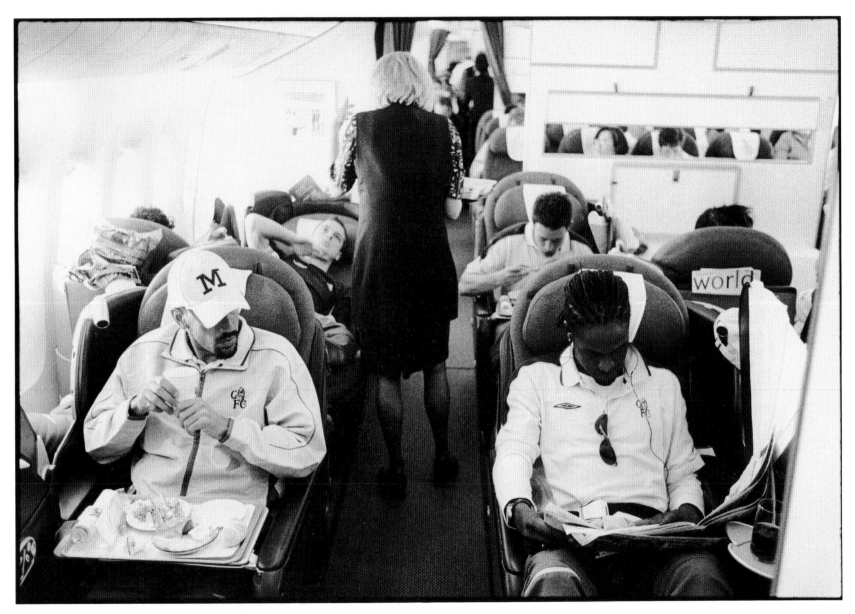

Players in the first-class cabin of their British Airways flight to Nice for the Champions League Quarter Final against Monaco, April 2004.

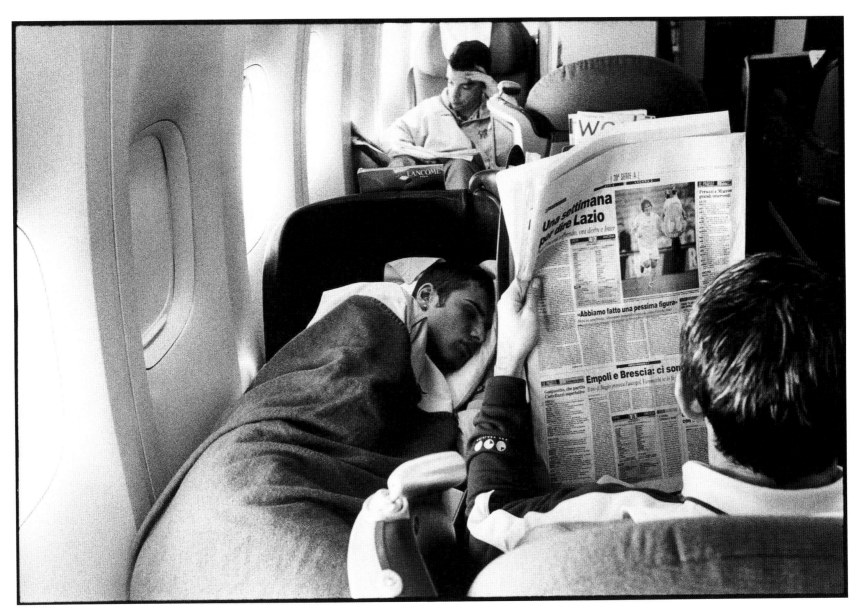

On the plane Adrian Mutu sleeps.

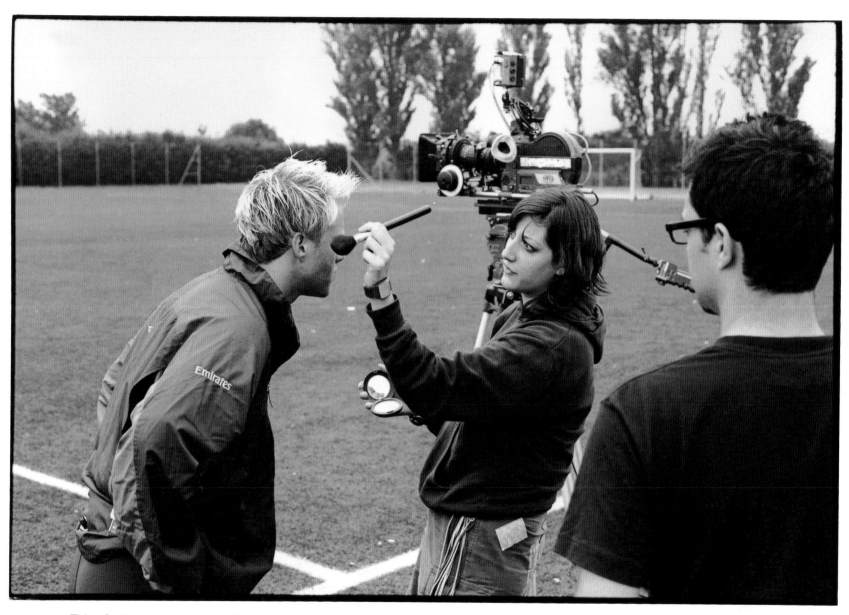

Eidur Gudjohnsen gets ready for his close-up. Filming the title sequence for *The Premiership* TV programme. Harlington, 2002.

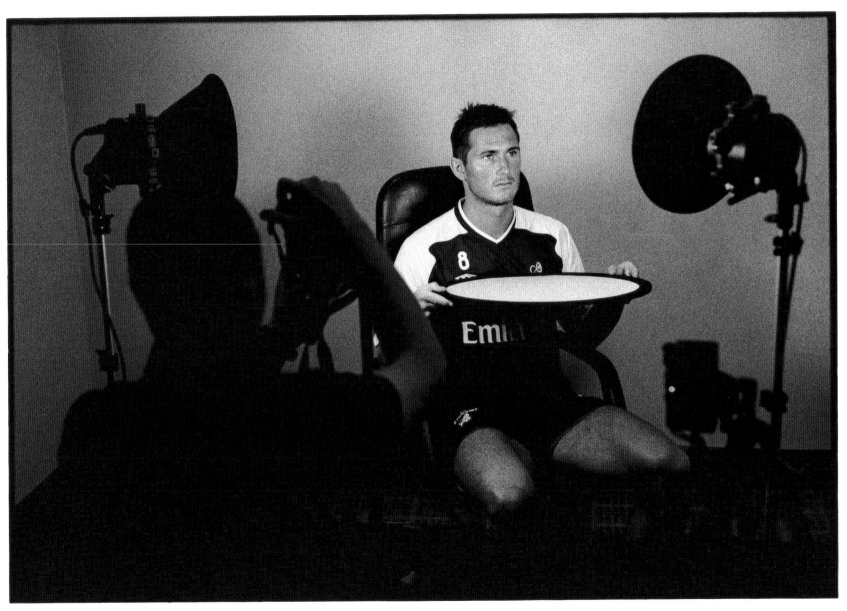

Frank Lampard poses for photographs used to create his 3D PlayStation character. Holiday Inn Heathrow, July 2004.

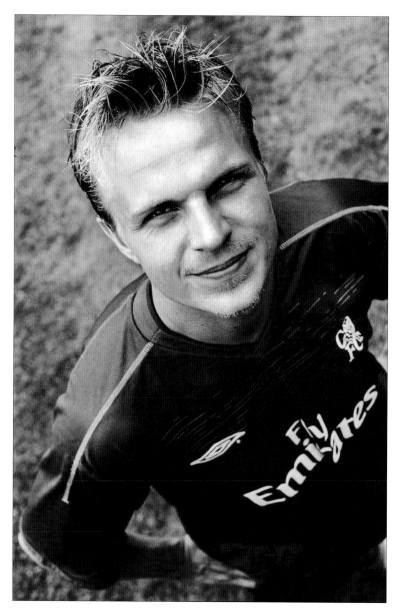

Jesper Gronkjaer, 2002.

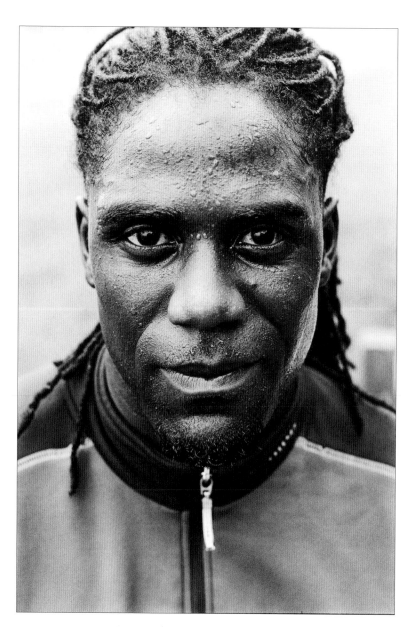

Mario Melchiot at the end of training, 2002.

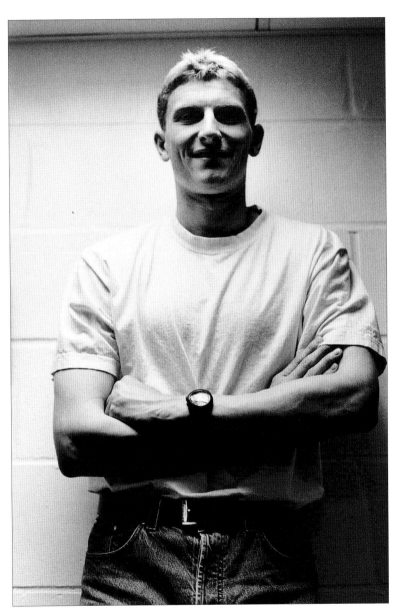

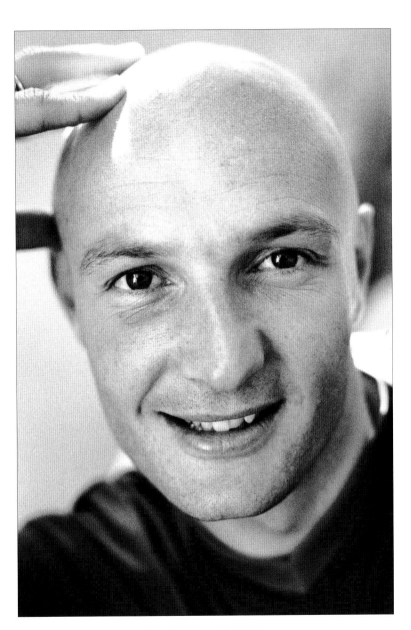

Tore Andre Flo. Stamford Bridge press room, 2000.

Frank Leboeuf, 2001.

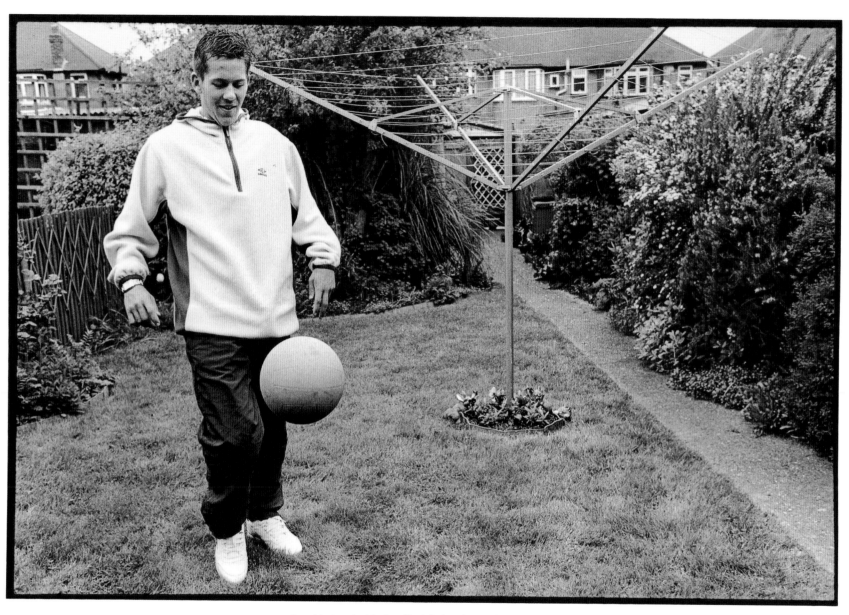

Jon Harley in his landlady's back garden, 2000.

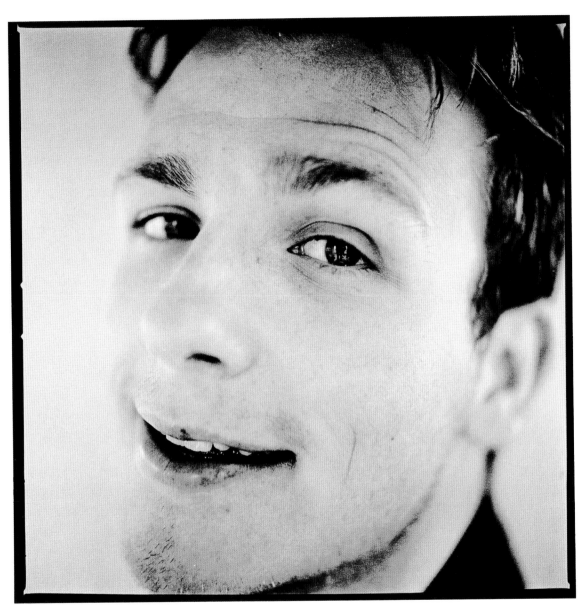

Jody Morris, 1999.

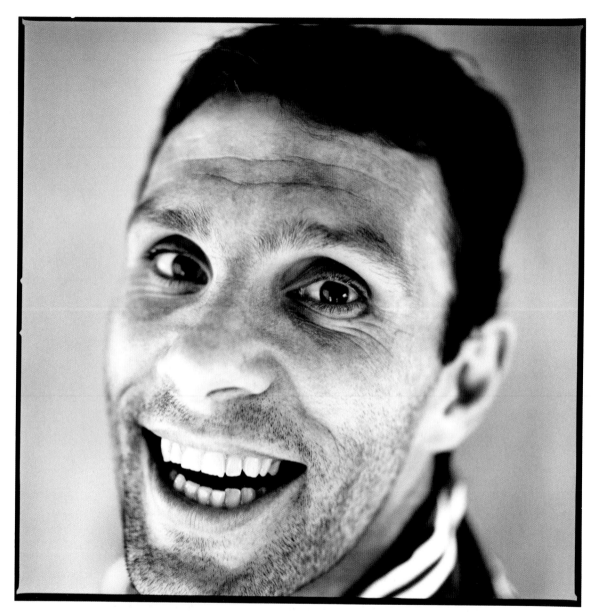

Gustavo Poyet, 1999.

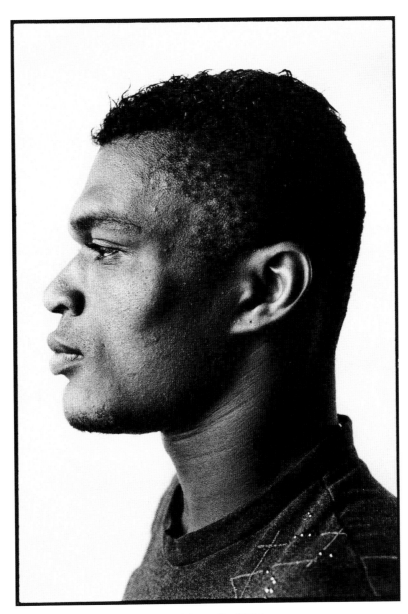

Marcel Desailly, 2000.

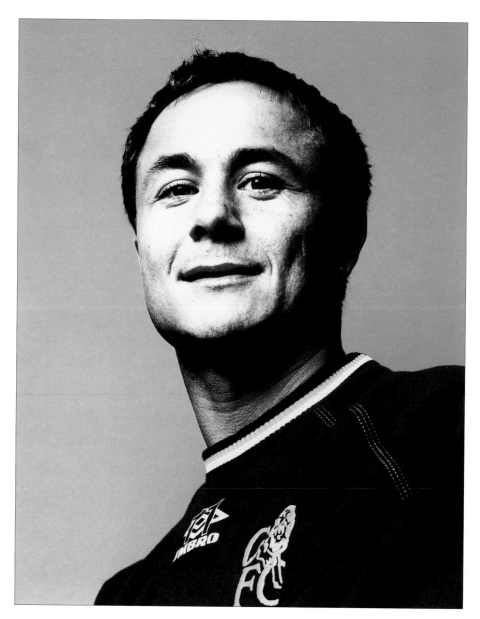

Dennis Wise, 1998.

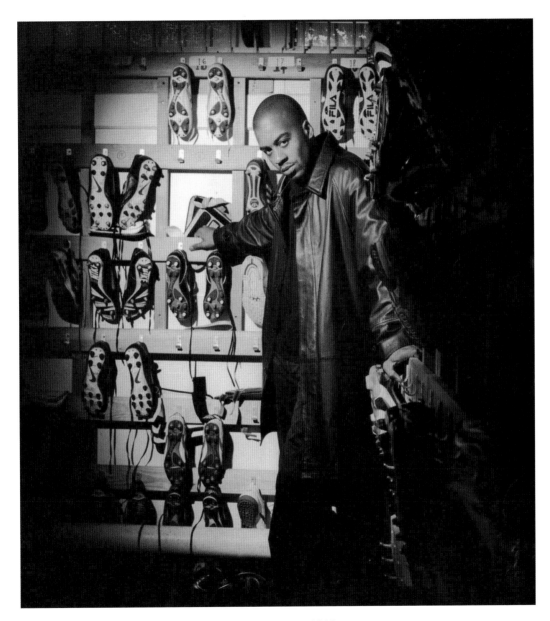

Eddie Newton, 1999.

Ed de Goey, 2000.

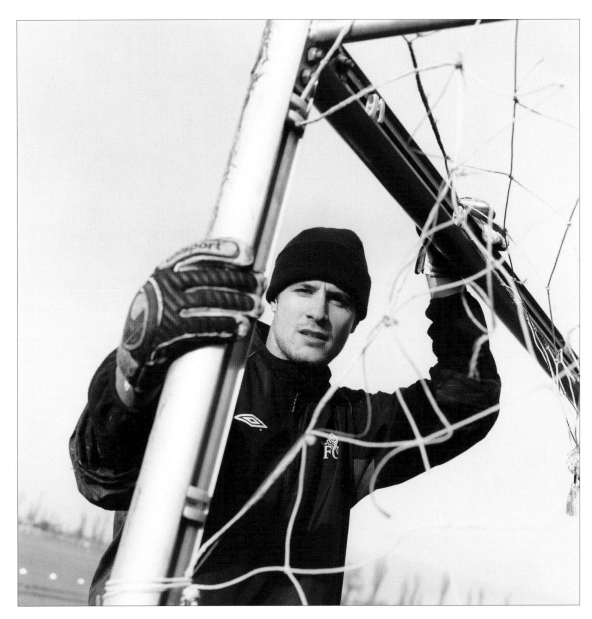

Carlo Cudicini, 2001.

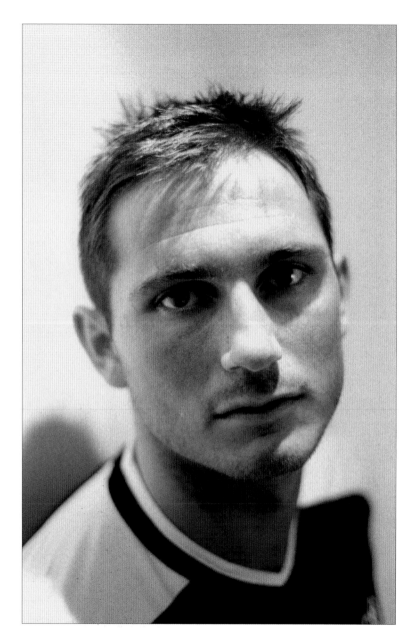

Frank Lampard, 2004.

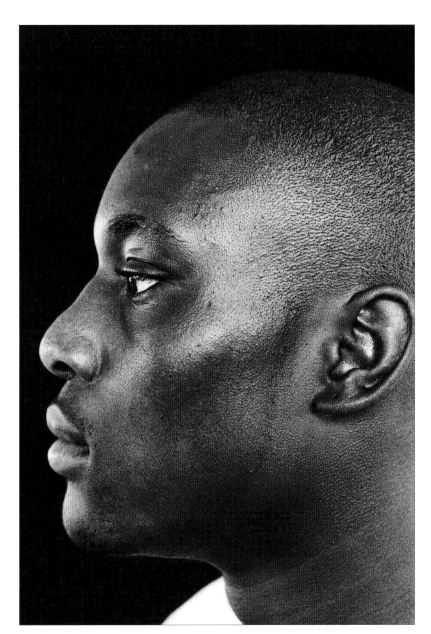

Eidur Gudjohnsen on his first day as a Chelsea player after signing
from Bolton Wanderers. Harlington, July 2000.

Carlton Cole, 2002.

# the backup

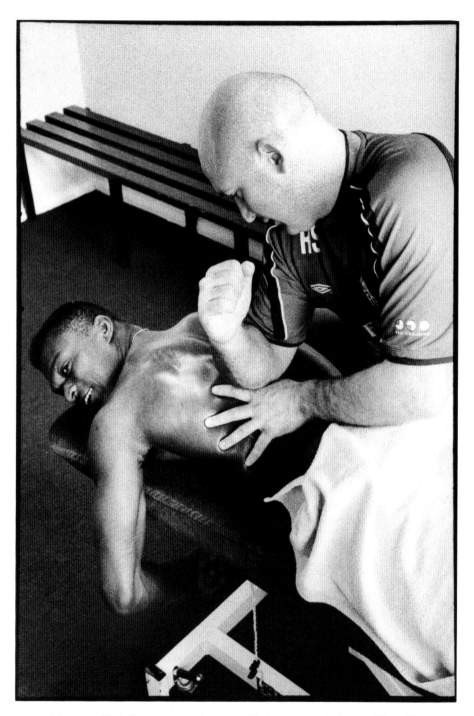

Masseur Bob Spencer working on Chelsea captain Marcel Desailly.
Harlington massage room, 2002.

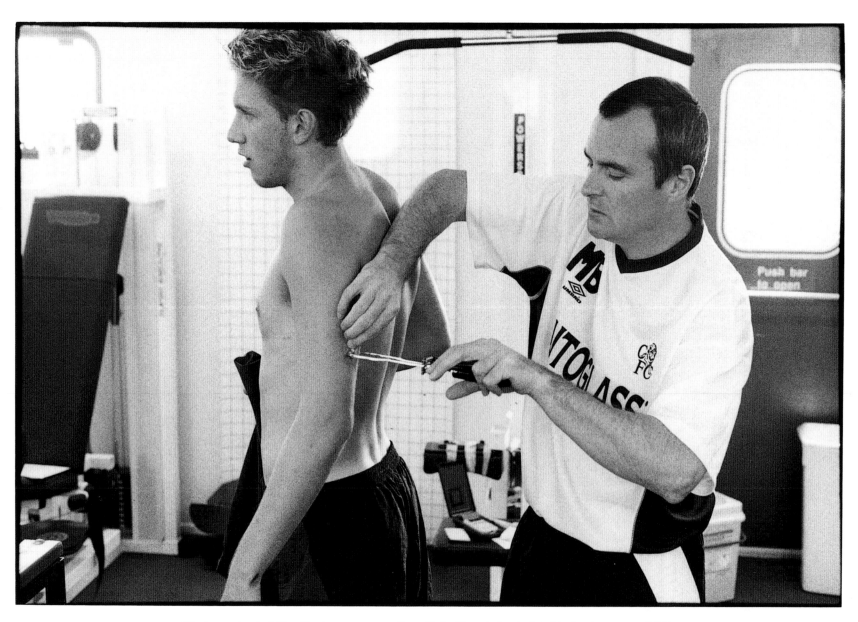

Chelsea physio Mike Banks measures Sam Dalla Bona's body fat. Harlington gym, 2000.

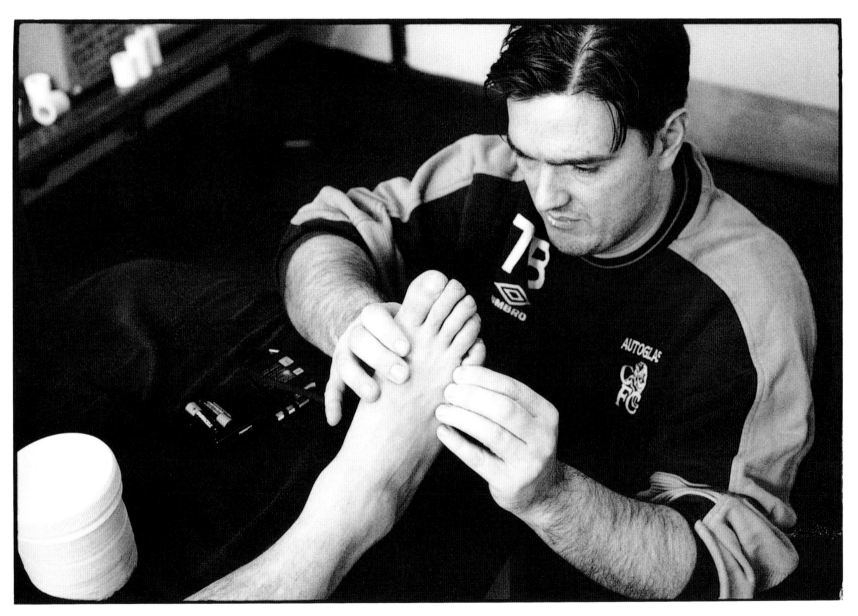

Terry Byrne massages Dennis Wise's injured foot. Harlington massage room, 2000.

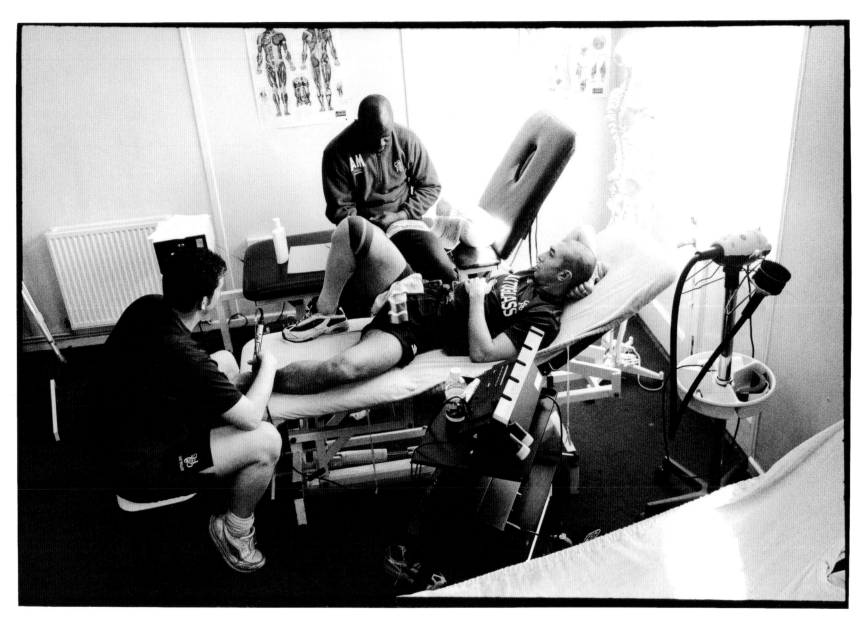

Roberto Di Matteo, physio Andy Rolls and fitness coach Ade Mafe. Harlington treatment room, 2001.

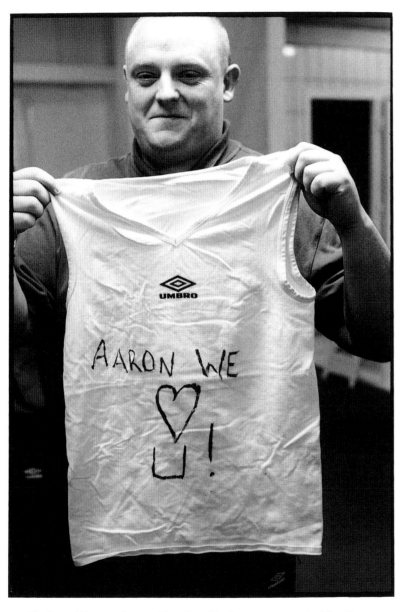

Chelsea kit man Aaron Lincoln with the vest worn in his tribute
by Eidur Gudjohnsen. The vest featured in on-pitch celebrations
of Chelsea's first away win of the season at West Ham.
Chelsea changing room, March 2001.

Chelsea masseur Terry Byrne in the Wembley dressing room before the FA Cup Semi-Final. Newcastle United 0 – Chelsea 1, April 2000.

Kit men Alex Nairn and Stewart Bannister in the dressing room at Kingstonian FC before reserve game against Charlton, 2000.

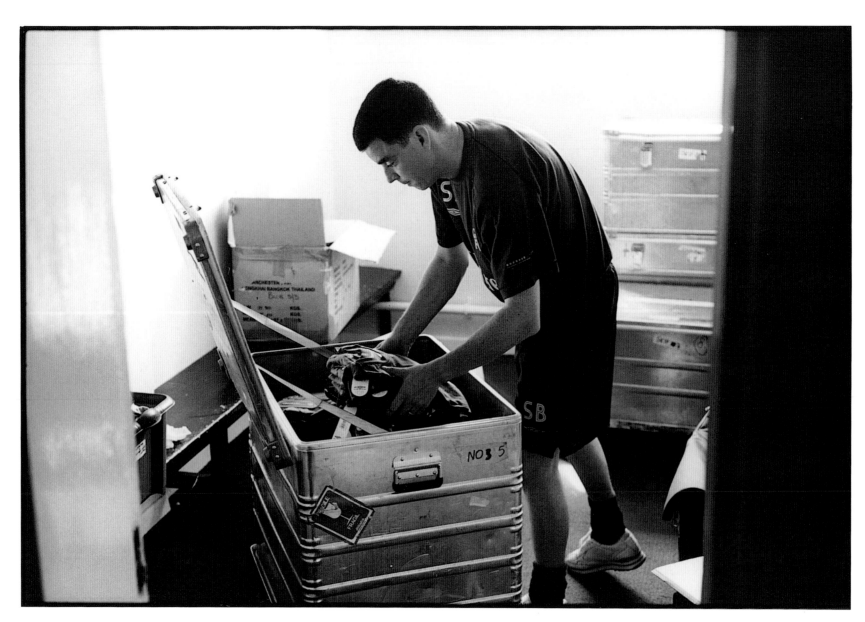

Kit man Stewart Bannister packs for pre-season training in Italy, 2002.

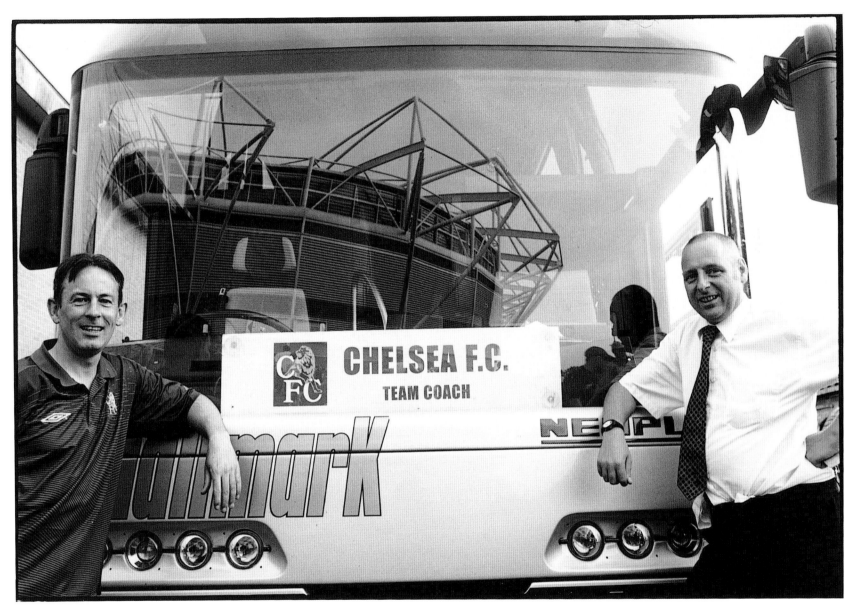

The Chelsea coach drivers, 2002.

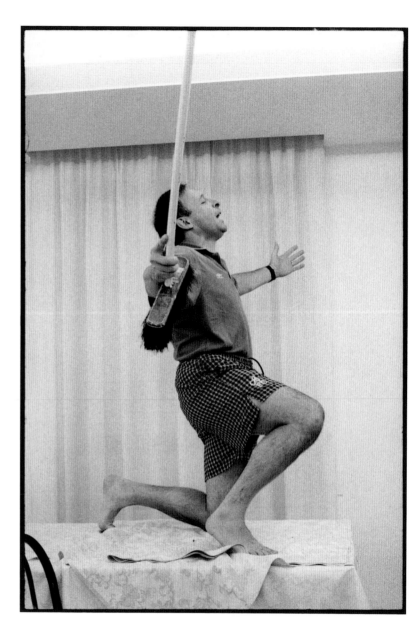

Fitness coach Roberto Sassi serenades the squad during dinner at pre-season training in Roccaporena, Italy, July 2001.

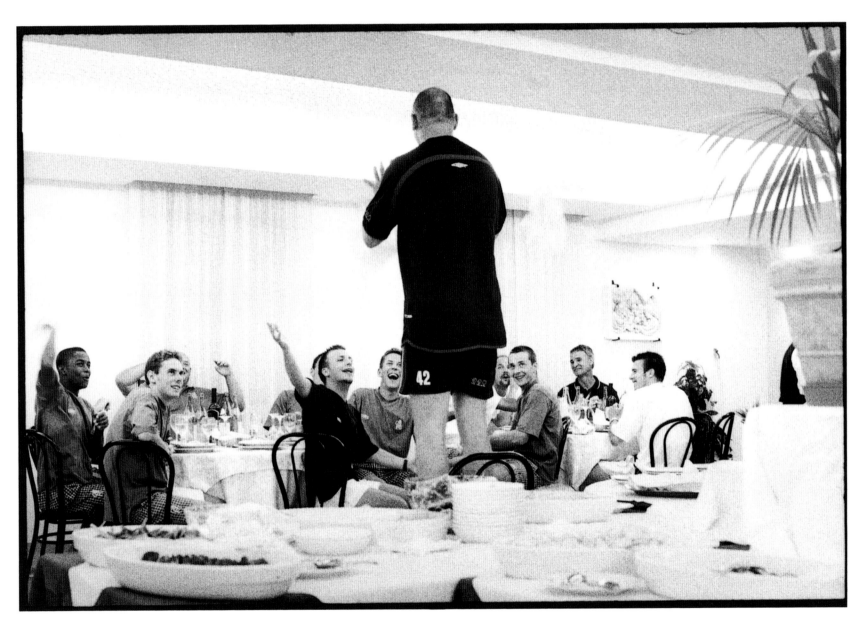

Masseur Bob Spencer takes his turn to entertain.

# legends

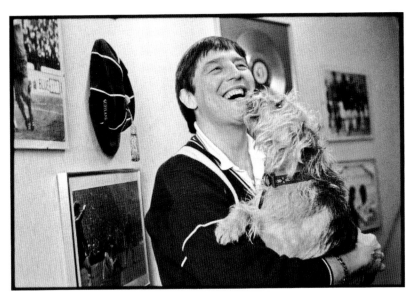

Ian Hutchinson, 2001.

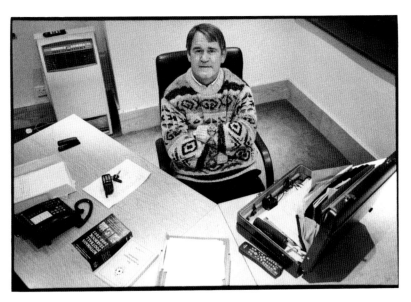

David Webb. Southend United manager's office, 2000.

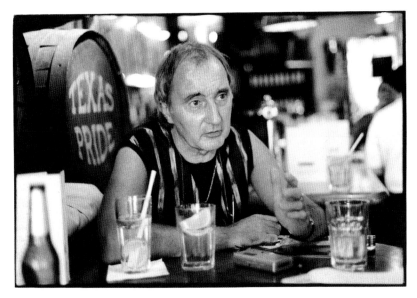

Alan Hudson. The Big Easy restaurant, Kings Road, 2000.

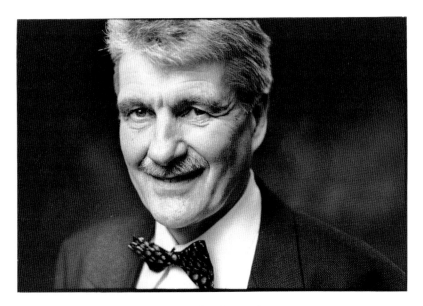

Charlie Cooke, 2001.

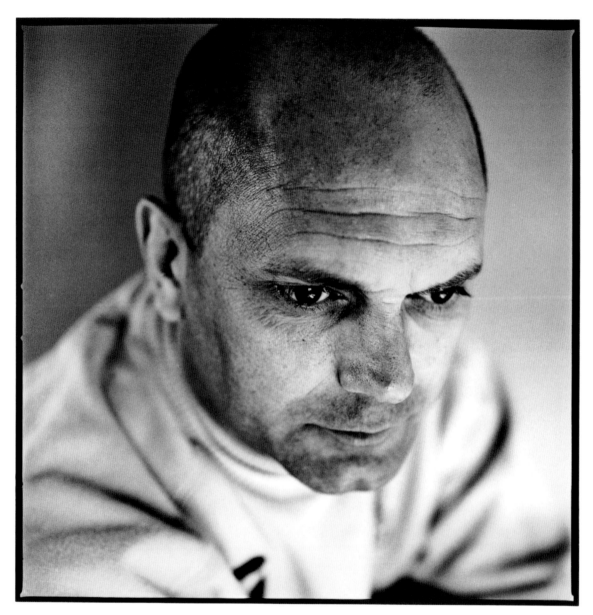

Ray Wilkins, 1999.

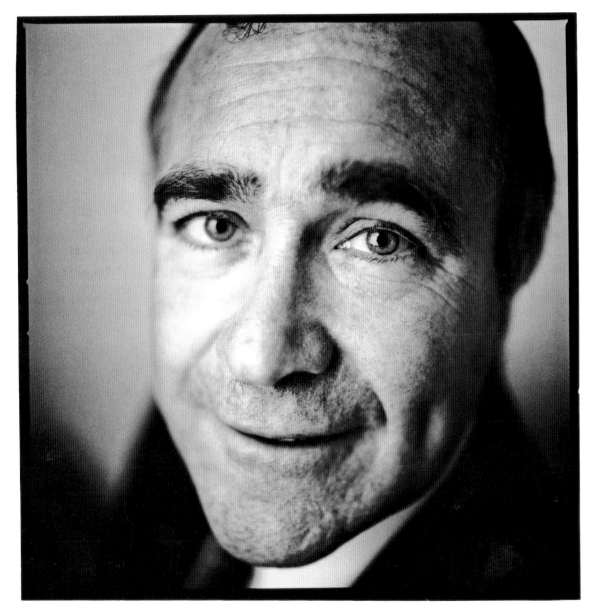

Ron Harris, 1997.

Micky Droy. Kensal Rise, 2000.

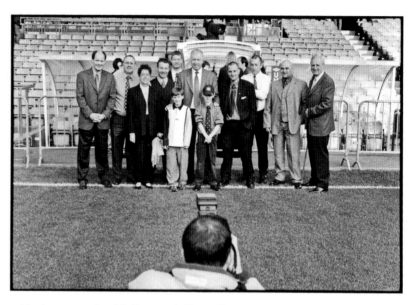

You've never had it Osgood. Peter Osgood poses for photographs after leading a tour of The Bridge.

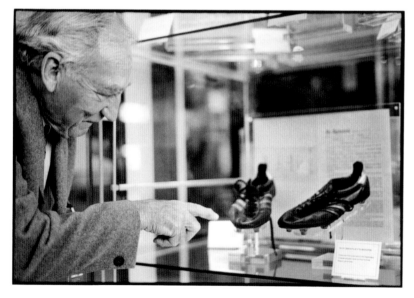

Roy Bentley at the opening of the Chelsea World of Sport.

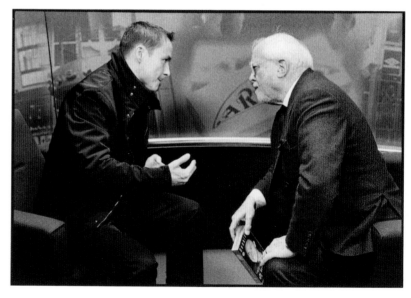

Lord Attenborough and Dennis Wise. Chelsea TV studio, 2002.

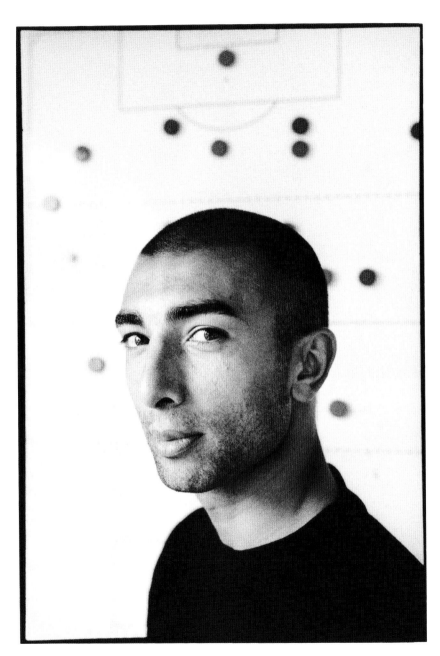

Roberto Di Matteo, 2000.

# the greatest

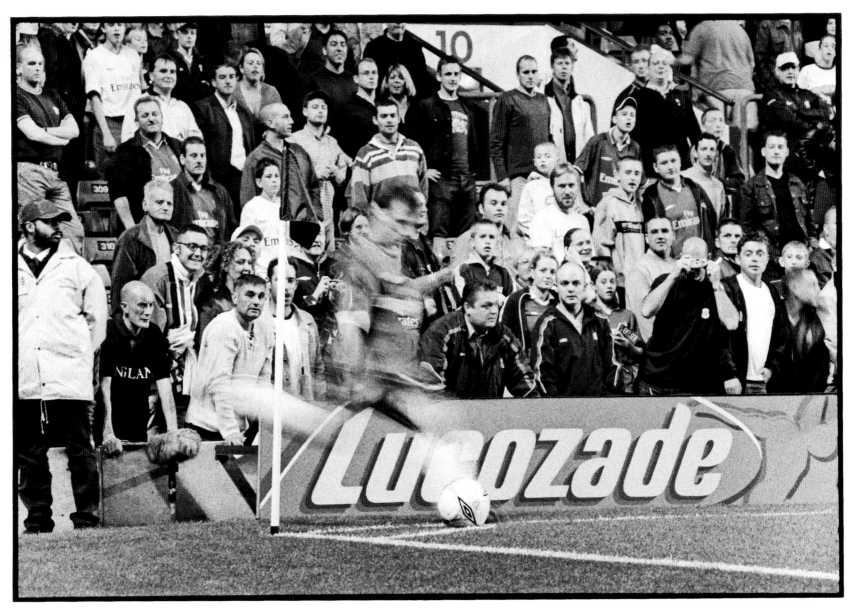

Gianfranco Zola, 2002.

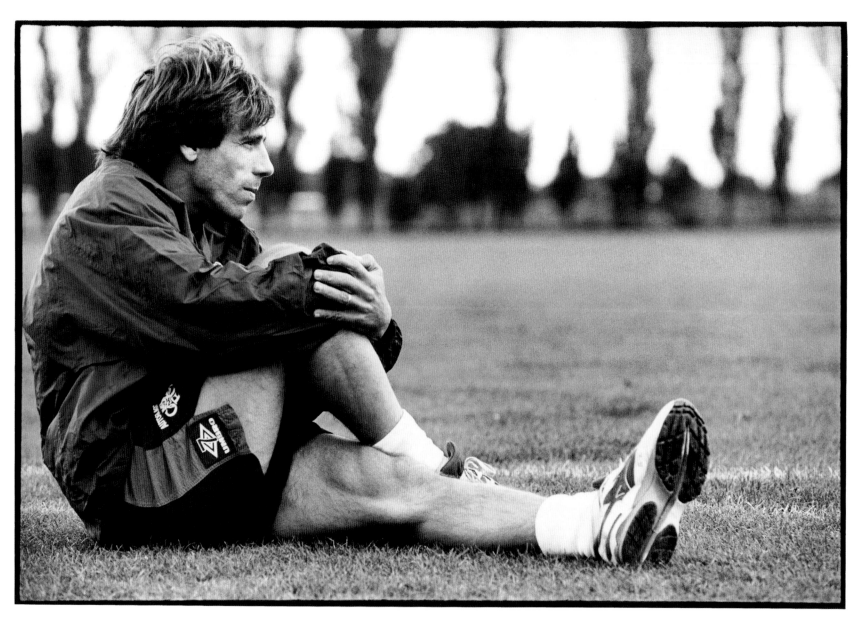

Gianfranco Zola. Harlington, 2000.

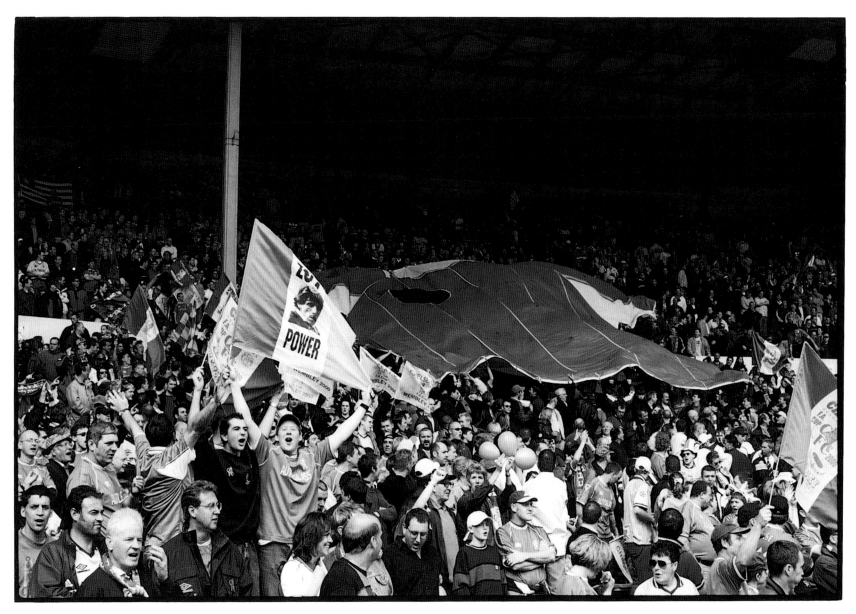

Fans at Wembley Stadium, FA Cup Final. Chelsea 1 – Aston Villa 0, May 2000.

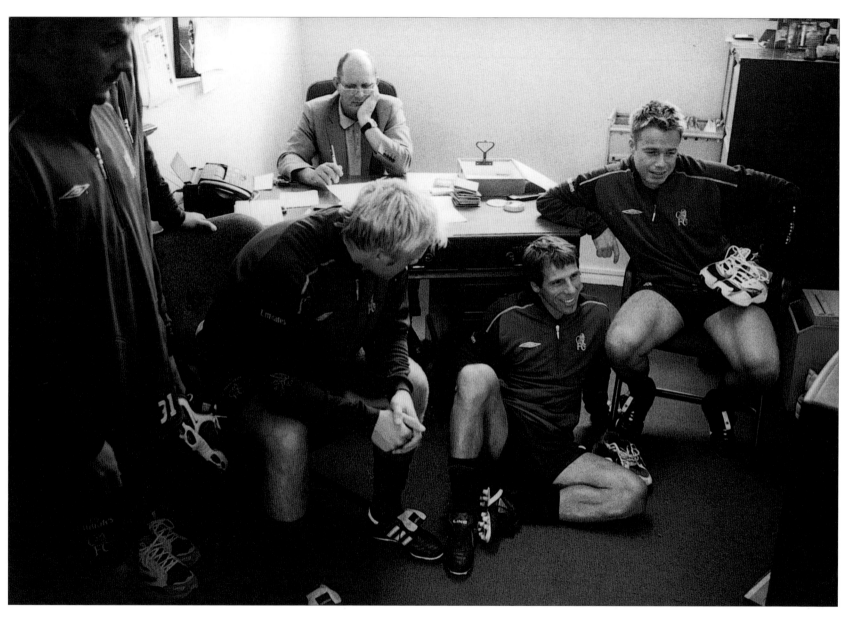

Gianfranco Zola, Albert Ferrer, Eidur Gudjohnsen and Graeme Le Saux watch Tim Henman being knocked out of Wimbledon on the TV in Gwyn Williams' office. Harlington, July 2002.

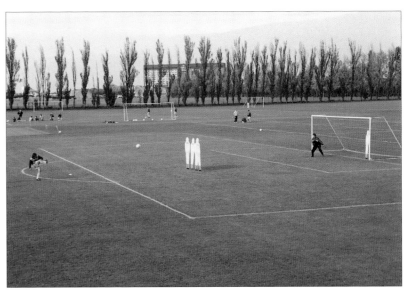
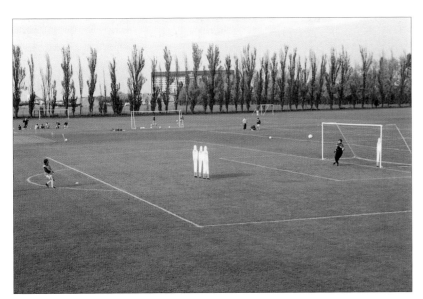
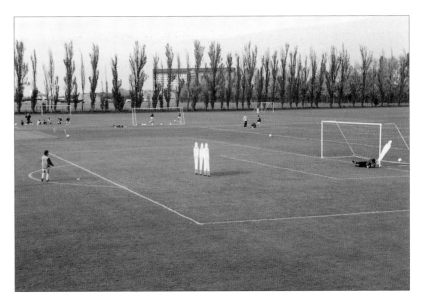

Gianfranco Zola practices free kicks at Harlington, 1999.

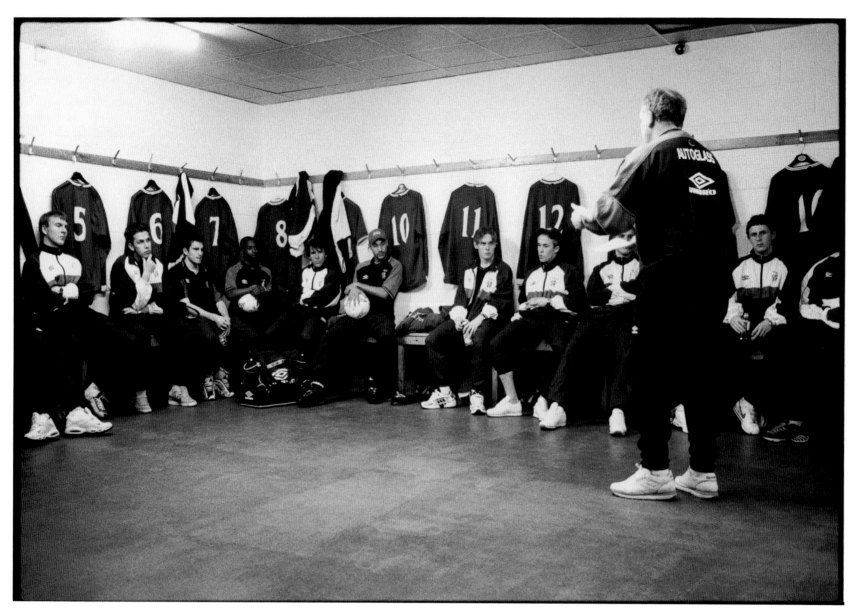

Gianfranco Zola dropped to the reserves. Dressing room at Kingstonian FC, February 2000.

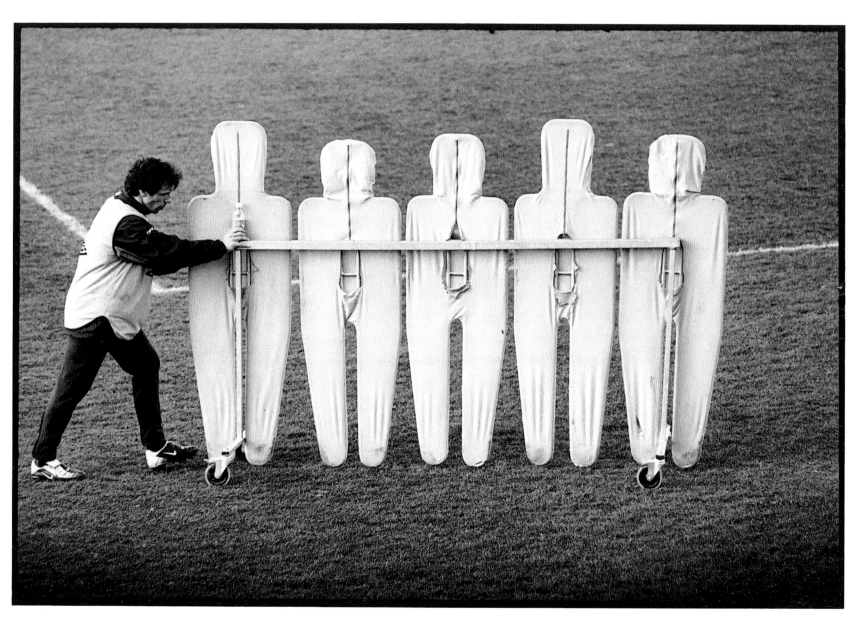

Mr Nice Guy. Gianfranco Zola returns the practice men to their hut after training. Harlington, 2002.

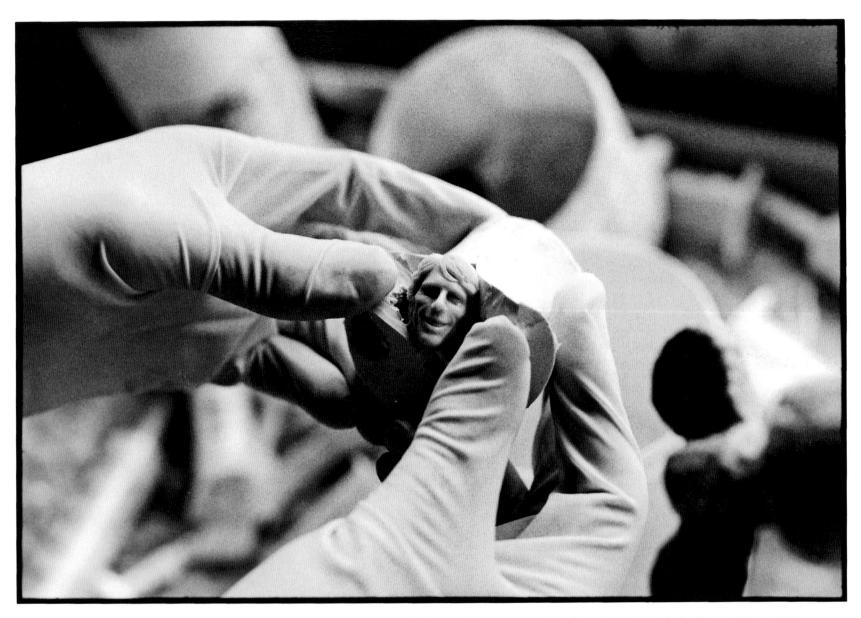

Birth of a legend. The master sculpture for the Gianfranco Zola Corinthian figure, created by the artists of Banjo in Hertfordshire, 2002.

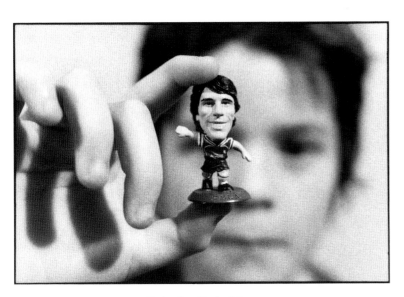

Zola the Corinthian.

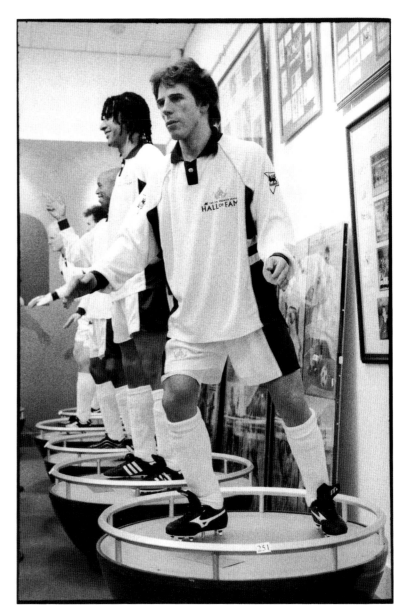

A waxwork of Gianfranco Zola at auction at Sotheby's, Olympia, 2001. Bids fail to reach the reserve price of £5,000.

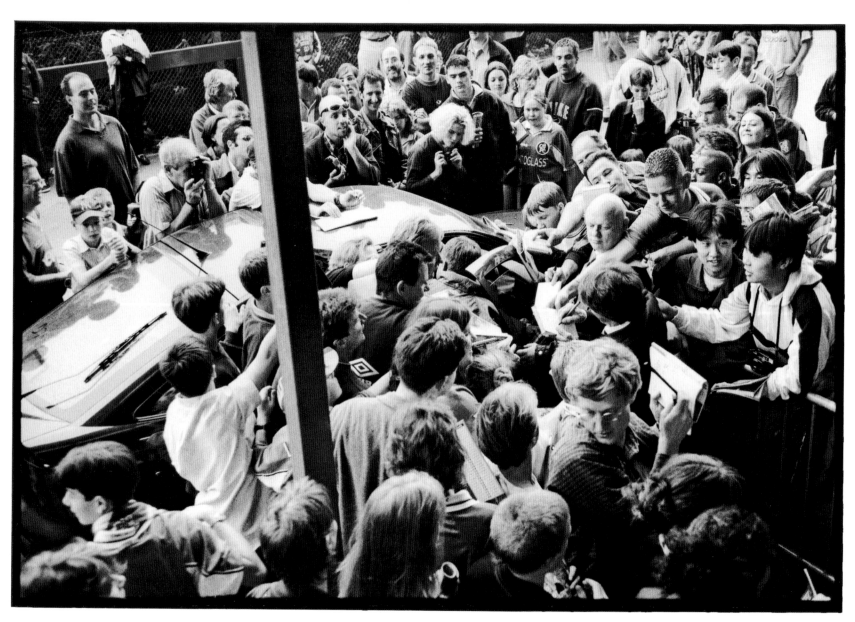

Zola and his minder are mobbed. Stamford Bridge, 1997.

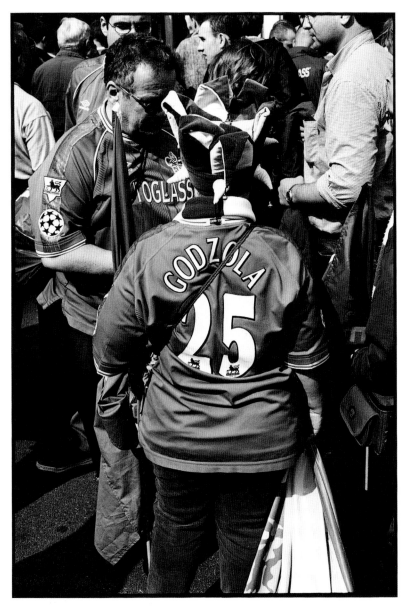

Fan at FA Cup Final. Wembley Stadium, May 2000.

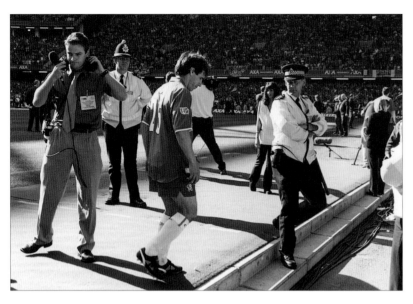

Gianfranco Zola leaves the pitch after Chelsea lose 2 – 0 to Arsenal.
FA Cup Final, Millennium Stadium, Cardiff, 2002.

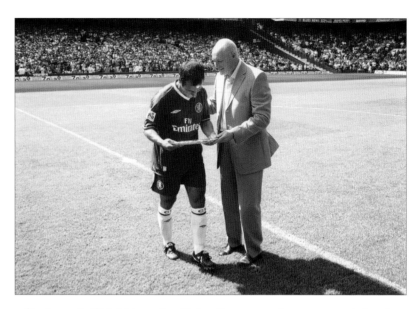

Chelsea plc Chief Executive Peter Kenyon makes a presentation to
Zola before his tribute game against Real Zaragoza, August 2004.

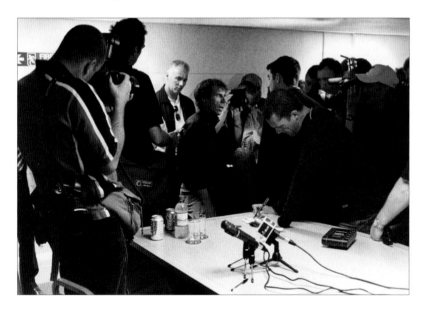

After seven seasons at Chelsea, Zola announces that he is moving to
Cagliari at an emotional final press conference in the Stamford Bridge
press room, July 2003.

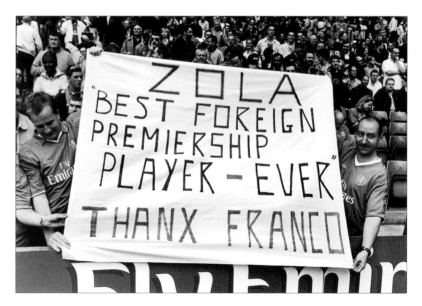

Fans tribute to The Greatest, 2004.

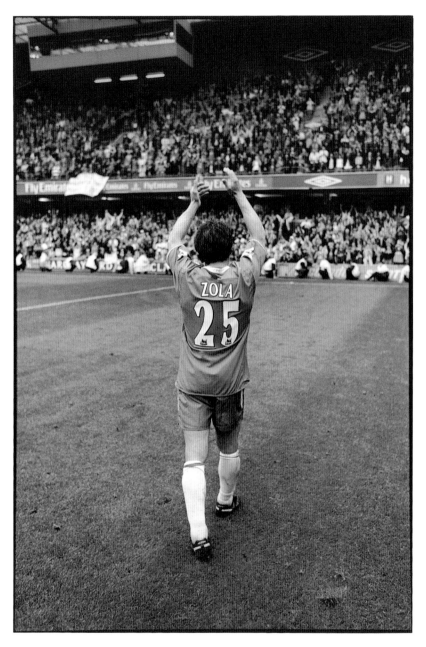

Zola says goodbye to The Shed End. Last game of the season.
Chelsea 2 – Liverpool 1, May 2003.

# the management

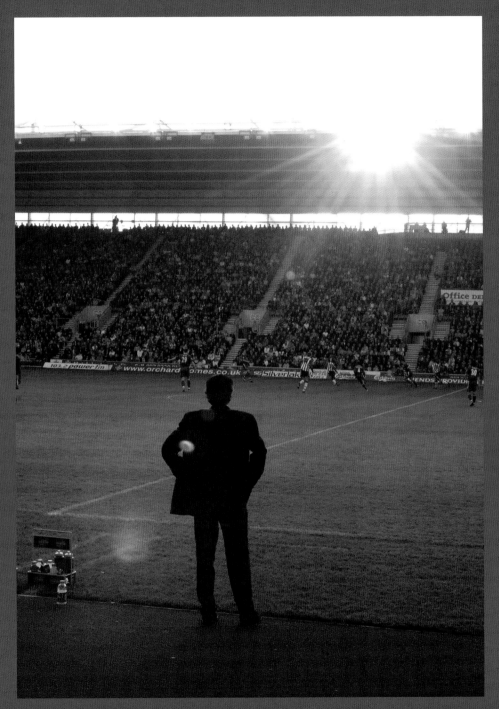

José Mourinho – The Special One. St Mary's Stadium.
Southampton 1 – Chelsea 3, April 2005.

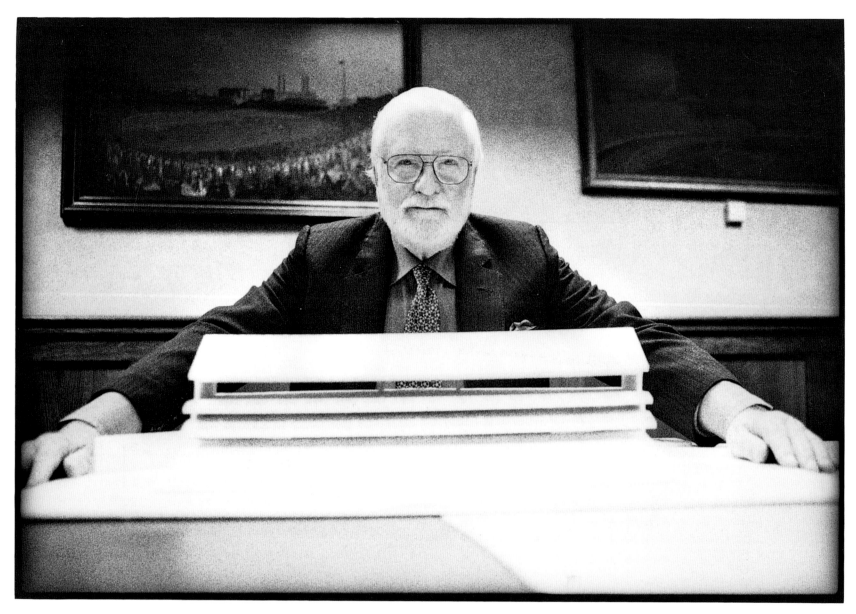

Ken Bates with a model of the West Stand. Stamford Bridge boardroom, September 1999.

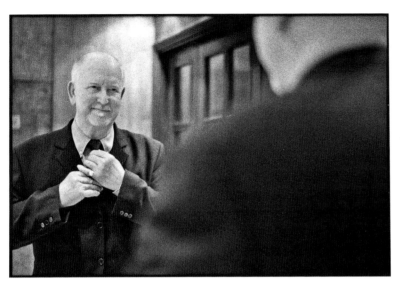

Brian Mears. The Rib Room & Oyster Bar, Carlton Tower Hotel, Knightsbridge, 2004.

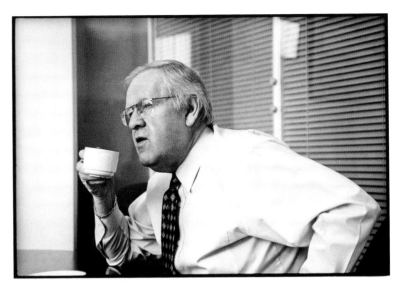

Managing Director Colin Hutchinson in his Stamford Bridge office, 1999.

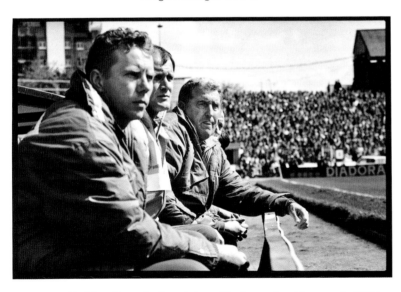

Manager Bobby Campbell watches Chelsea play Liverpool, 1991.

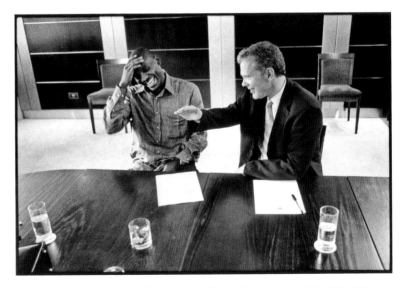

Chelsea Chief Executive Trevor Birch signs Geremi for £7million from Real Madrid. Lillie Langtree suite, West Stand, July 2003.

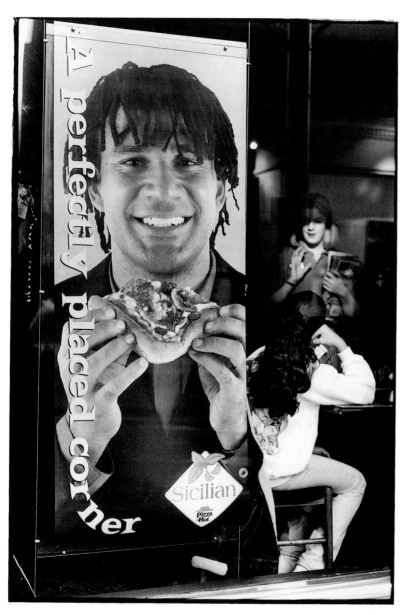

Manager Ruud Gullit promotes pizza. Leicester Square, 1998.

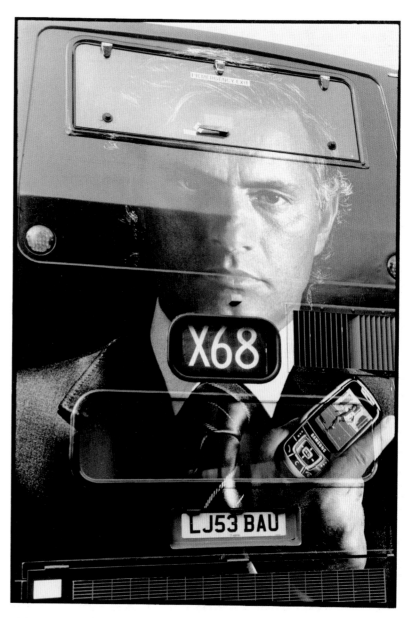

Manager José Mourinho promotes mobile phone. Battersea, 2005.

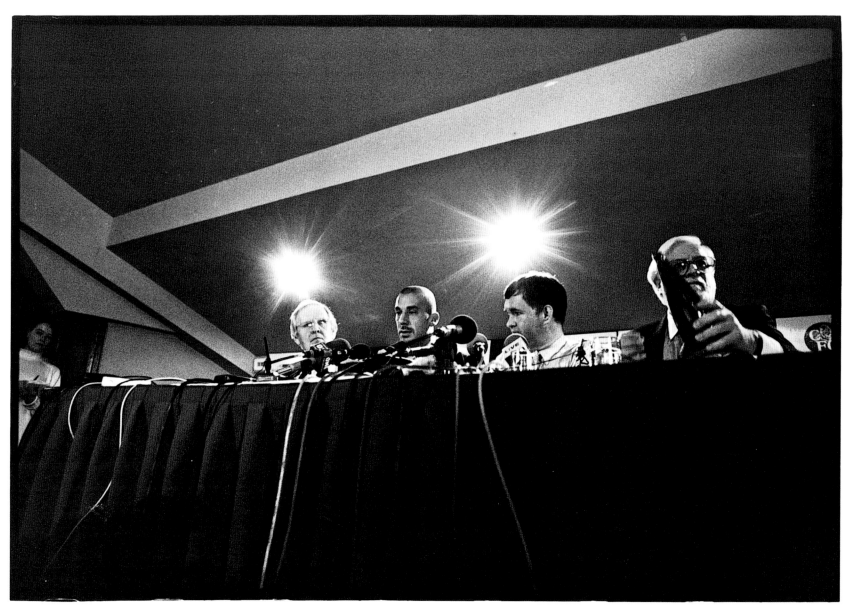

Gianluca Vialli crowned Chelsea manager, February 1998.

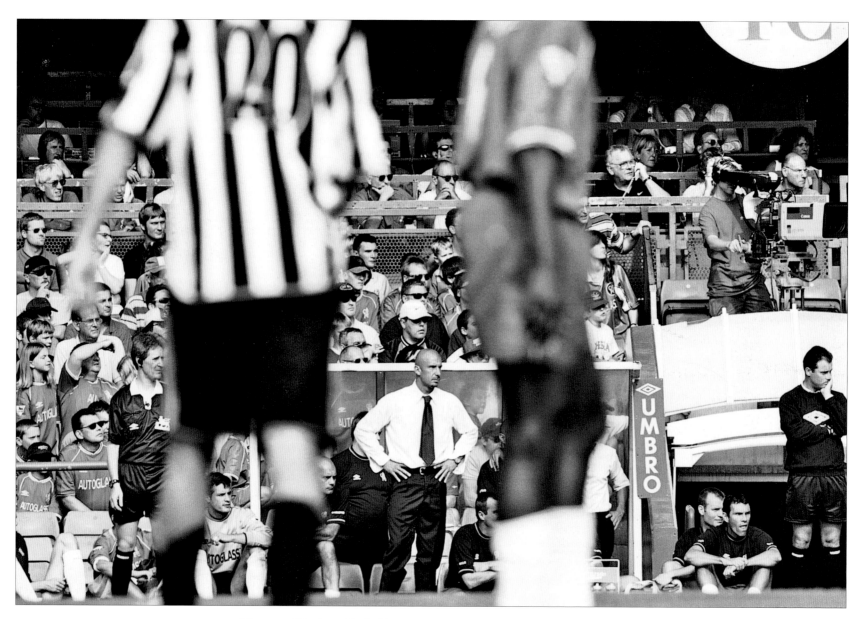

Manager Gianluca Vialli. Chelsea 1 – Newcastle 0, September 1999.

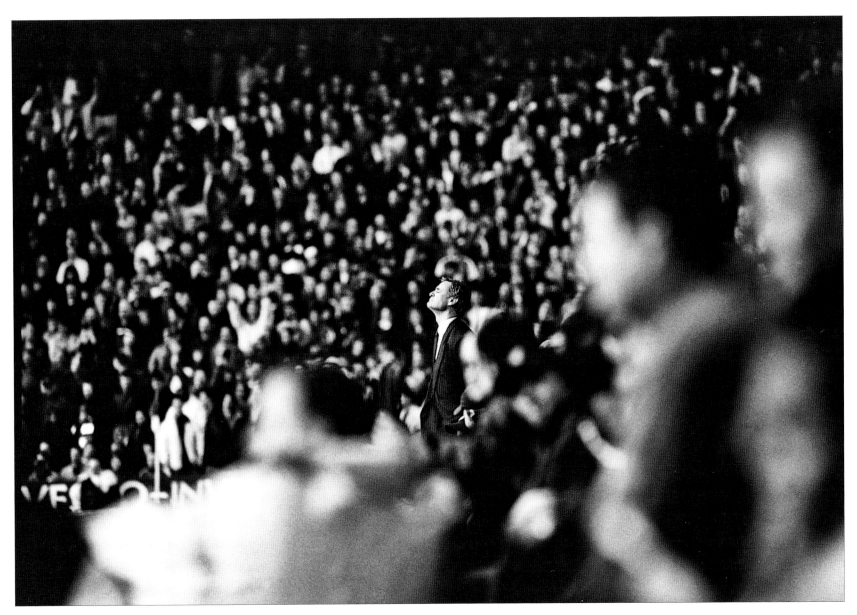

Claudio Ranieri at Highbury. FA Cup fifth round, Arsenal 3 – Chelsea 1, February 2001.

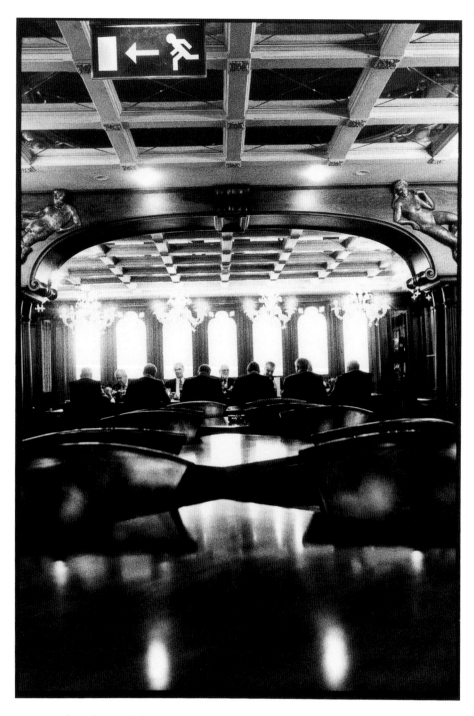

Lunch to celebrate the unveiling of Emirates as Chelsea's new
sponsor. Canaletto's restaurant, East Stand, 2001.

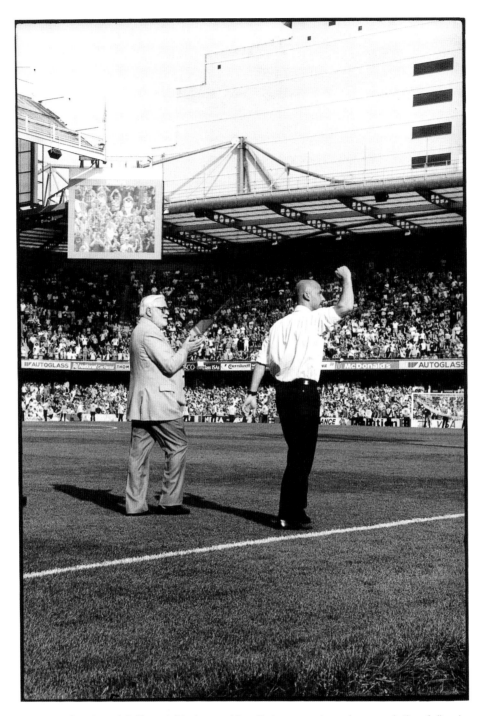

Manager Gianluca Vialli and Chairman Ken Bates on a lap of appreciation following the last home game of the 1999-2000 season. Chelsea 4 – Derby County 0.

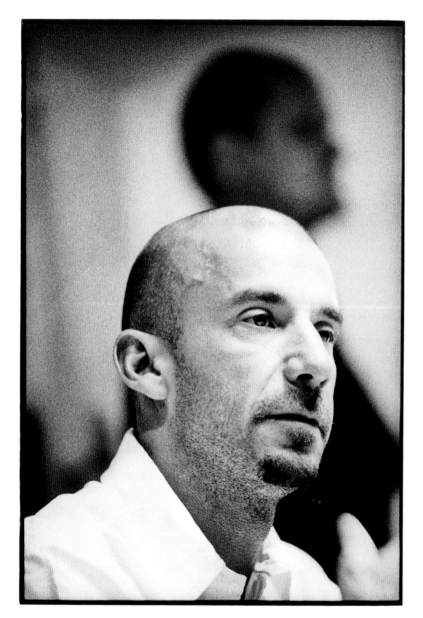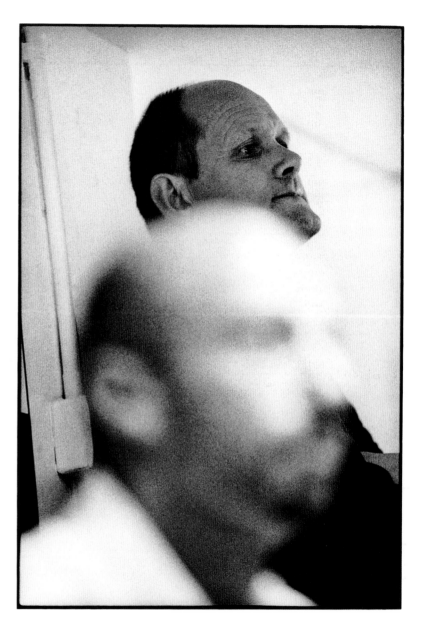

Manager Gianluca Vialli with Assistant Manager Gwyn Williams, 1999.

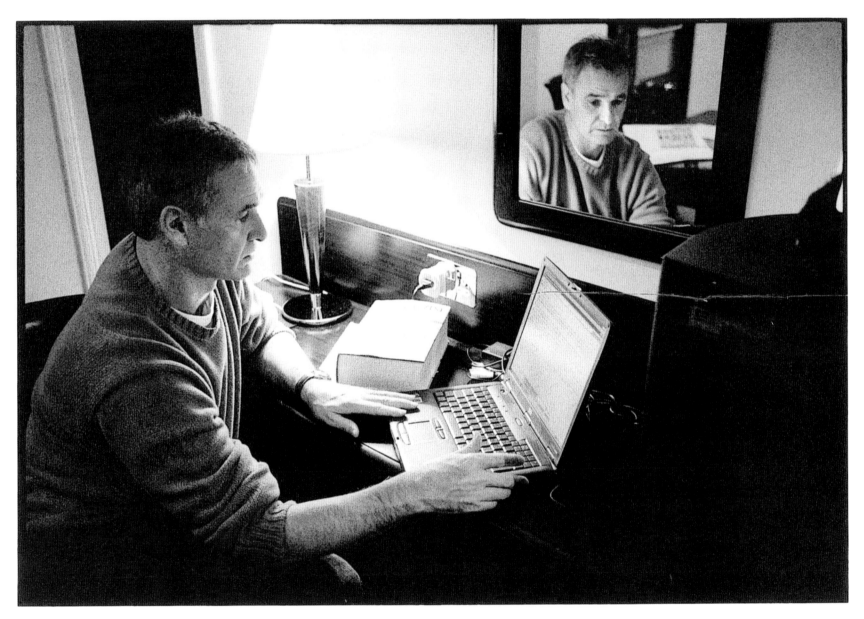

Claudio Ranieri in his Stamford Bridge hotel room before his English lesson, October 2000.

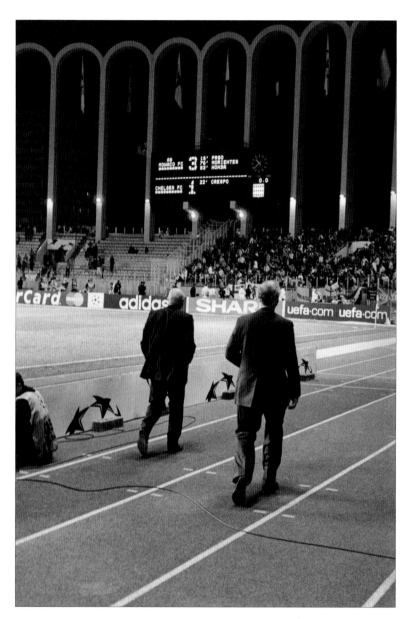

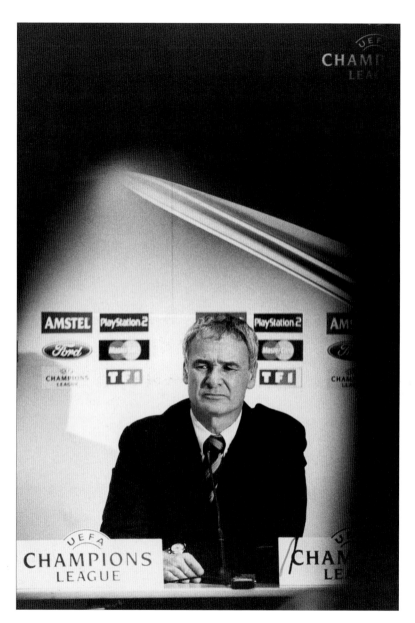

Chief Executive Peter Kenyon and Chairman Bruce Buck head for the Chelsea dressing room at the Stade Louis II following Chelsea's defeat. Monoco 3 – Chelsea 1, April 2004.

Claudio Ranieri faces the press in Monaco.

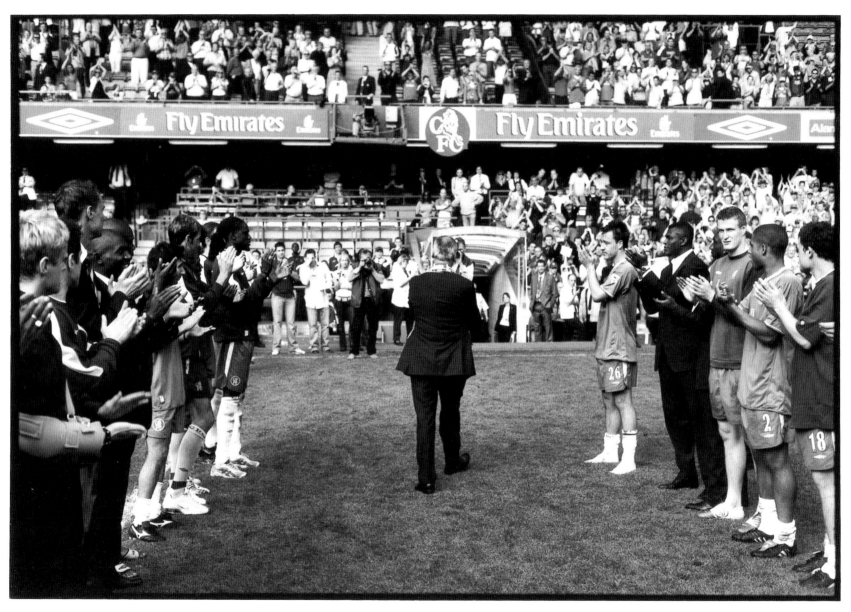

Cheers Claudio. Claudio Ranieri is applauded from the pitch after his last game as manager, May 2004.

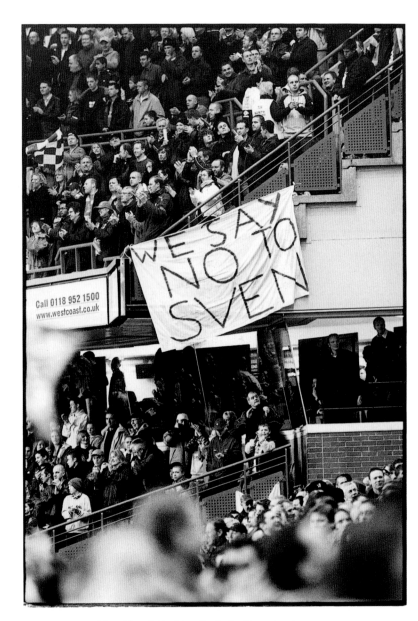

The Shed End let their feelings be known.
Chelsea 1 – Manchester United 0, December 2003.

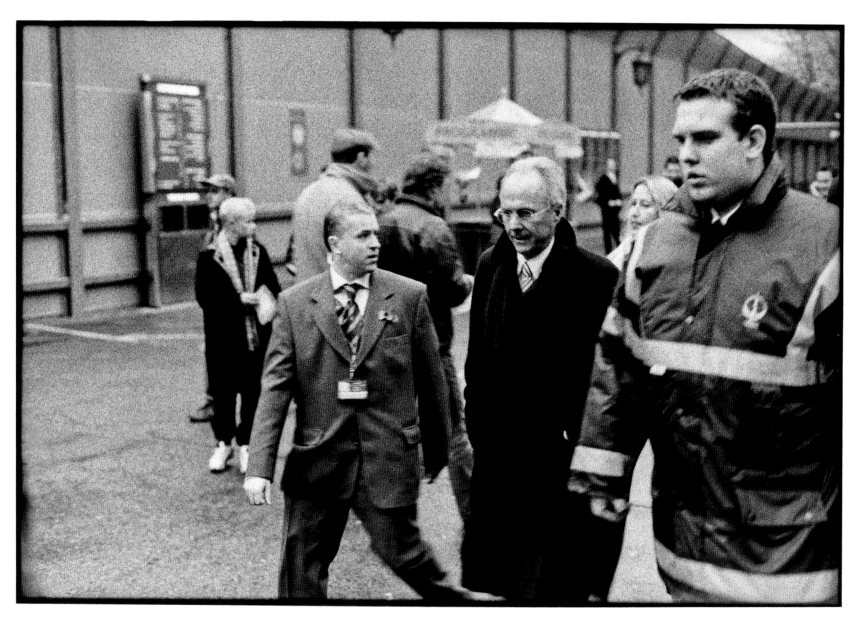

Sven Goran Eriksson at the Chelsea vs Newcastle game, November 2003.

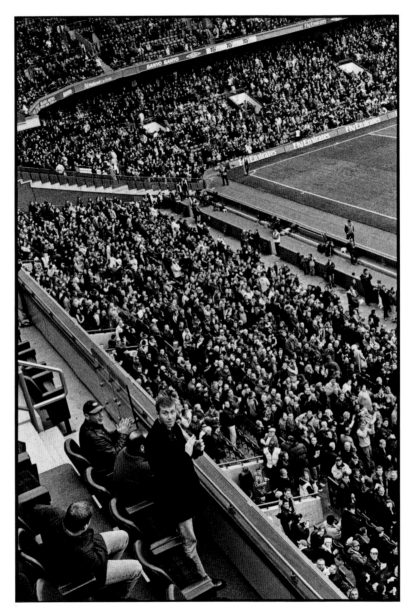

Roman's Empire, 2004.

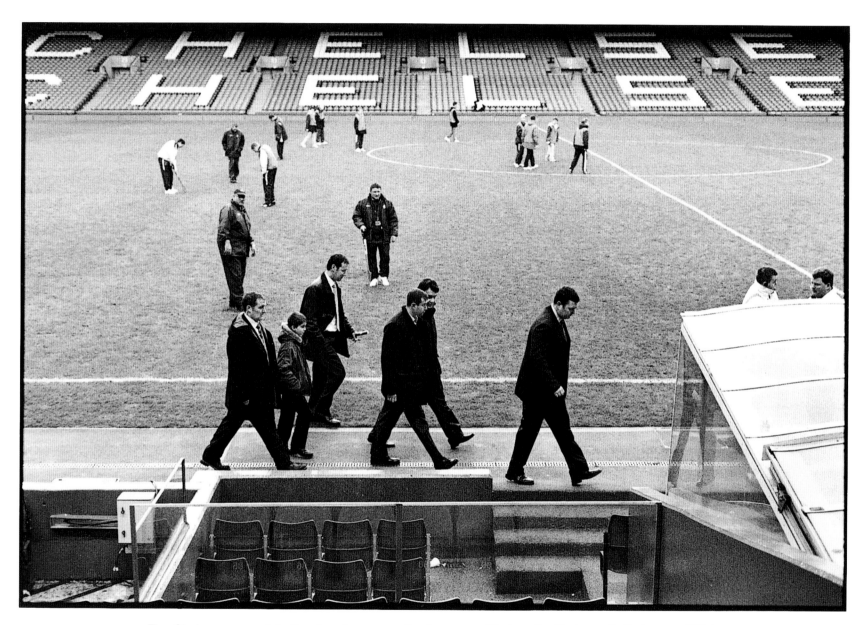

The Chelsea owner visits the dressing room after the game. Chelsea 3 – Portsmouth 0, January 2004.

# training

Mario Melchiot trains. Harlington, 2002.

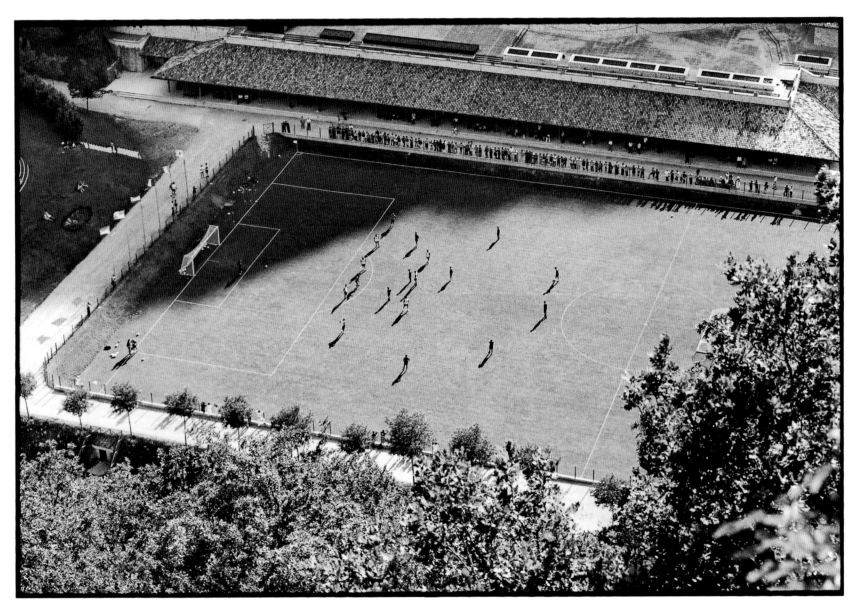

Claudio Ranieri leads pre-season training at Roccaporena, Italy, July 2001.

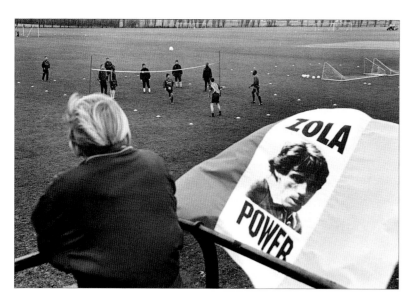

Anyone for tennis? Harlington, 1998.

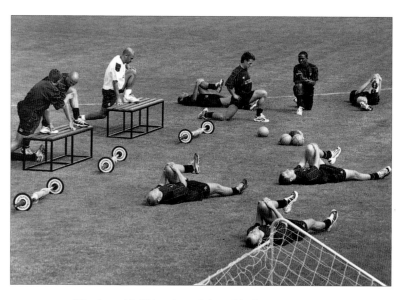

Gianluca Vialli leads training. Harlington, 1999.

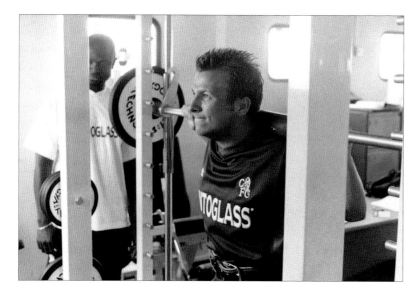

Jody Morris and Ade Mafe in the gym. First day of pre-season training. Harlington, July 2000.

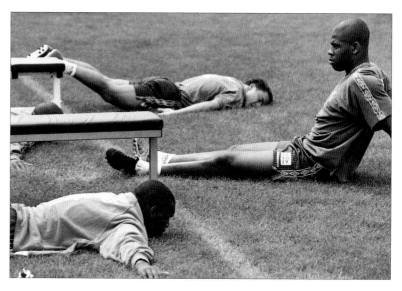

First day of pre-season training. Harlington, July 1998.

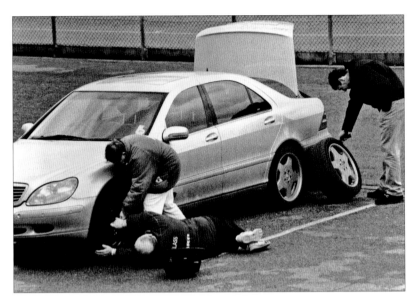

Stewards Frank and Alan pimp Chris Sutton's car. Harlington, 1999.

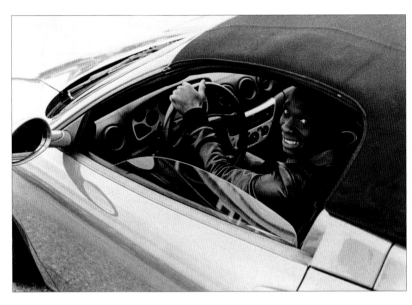

Claude Makelele. Players' car park. Harlington, 2004.

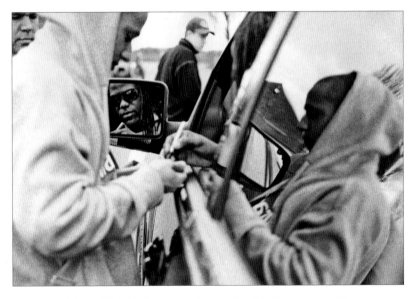

Mario Melchiot signs autographs. Harlington, 2004.

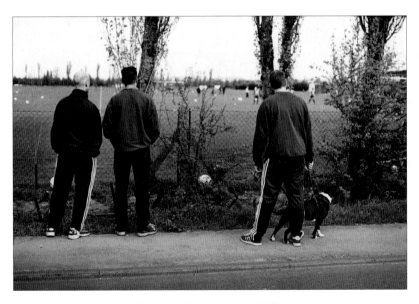

Fans at Harlington, 1999.

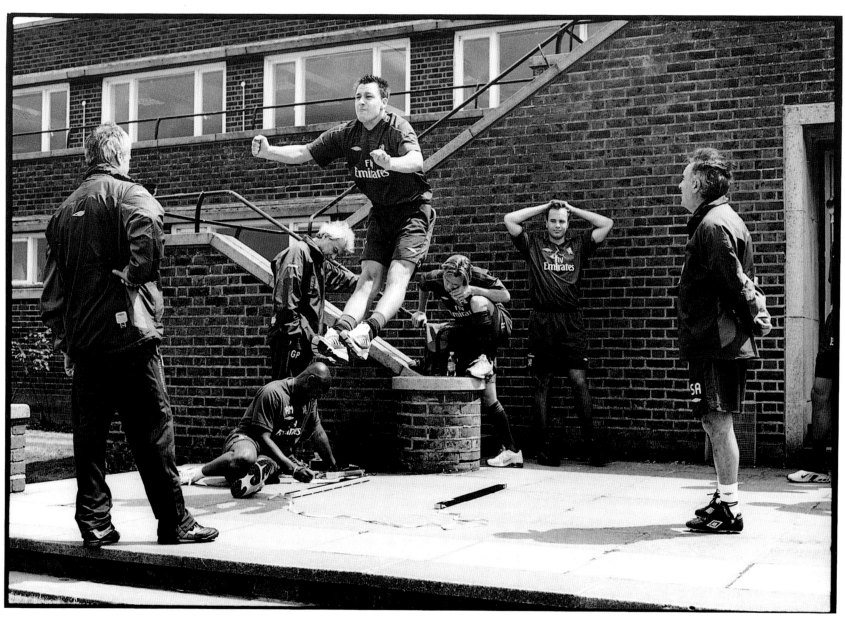

Leap of faith. John Terry during pre-season training. Harlington, 2002.

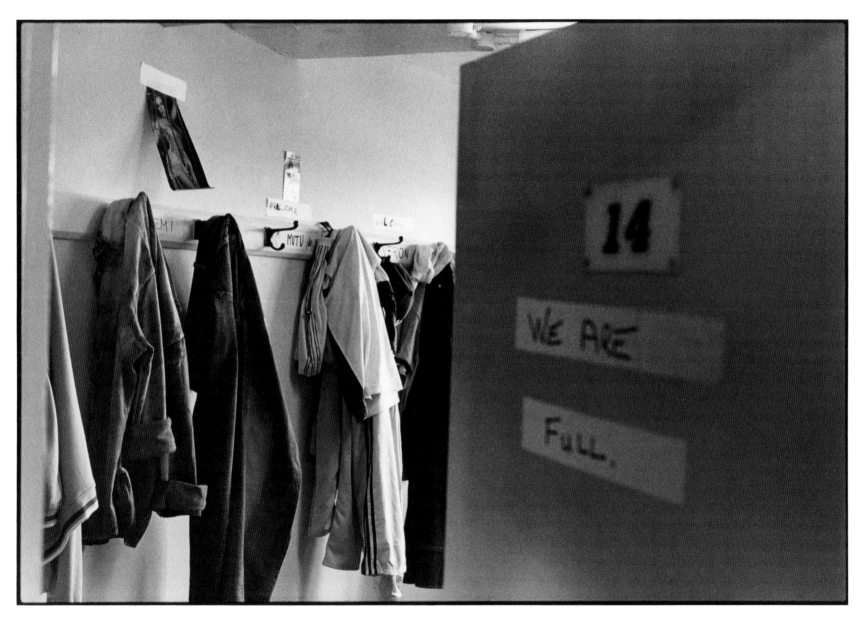

Harlington changing rooms, 2003.

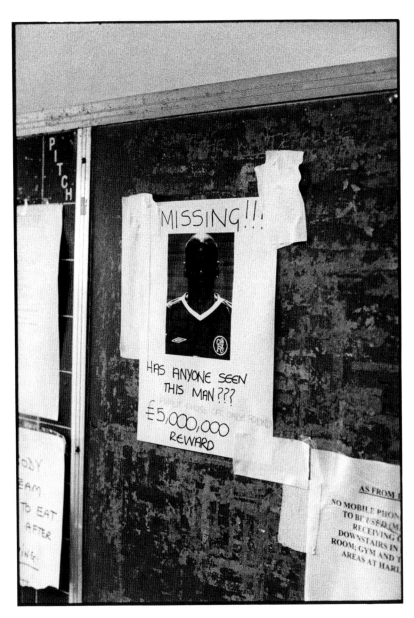

The players' notice board at Harlington, 2003.

Claudio Ranieri. Harlington, 2004.

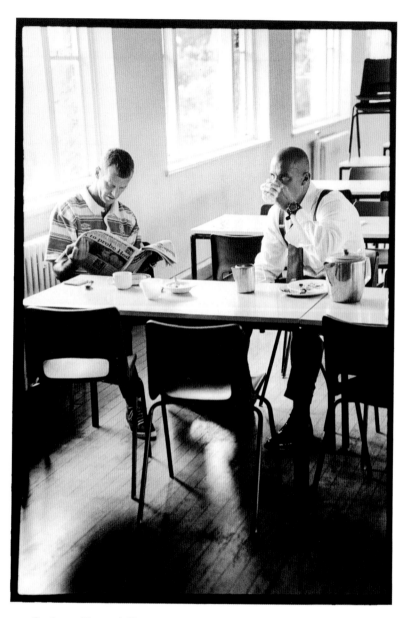

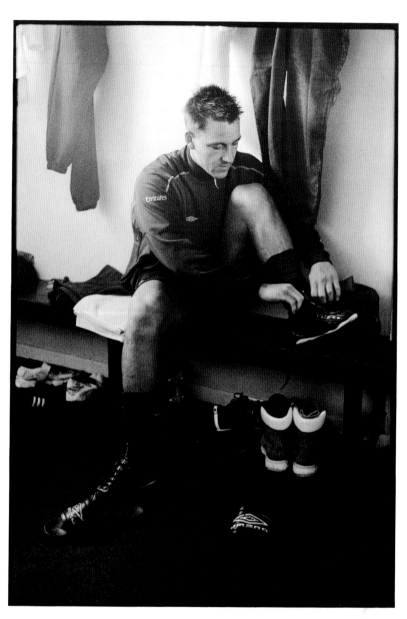

Graham Rix and Gianluca Vialli relax after training. Harlington canteen, 1998.

John Terry. Harlington changing rooms, 2002.

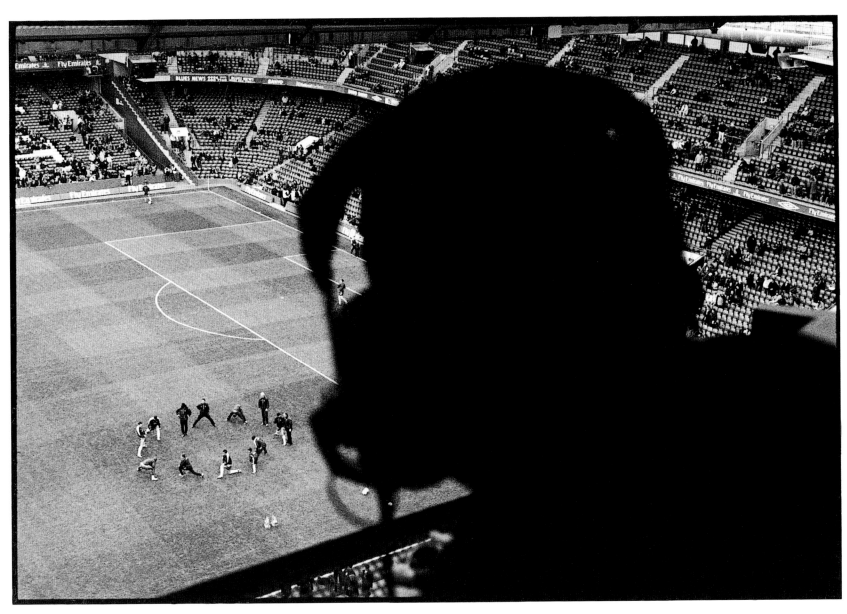

Chelsea pre-match training viewed from the East Stand TV gantry, 2004.

Fans display their new signings. Harlington, 2002.

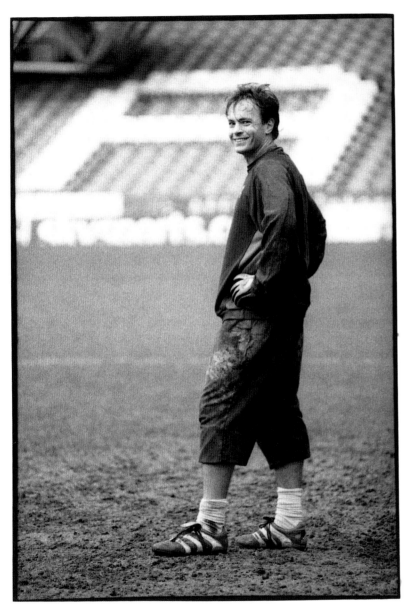

Class A. Mark Bosnich trains at Stamford Bridge, 2001.

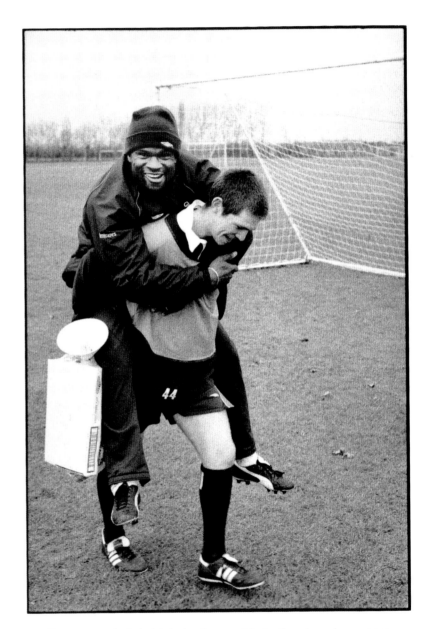

Fitness coach Ade Mafe is given a ride to the changing rooms following the annual Christmas youth team vs staff game at the training ground. Chelsea Staff 6 – Chelsea Youth 3, 2001.

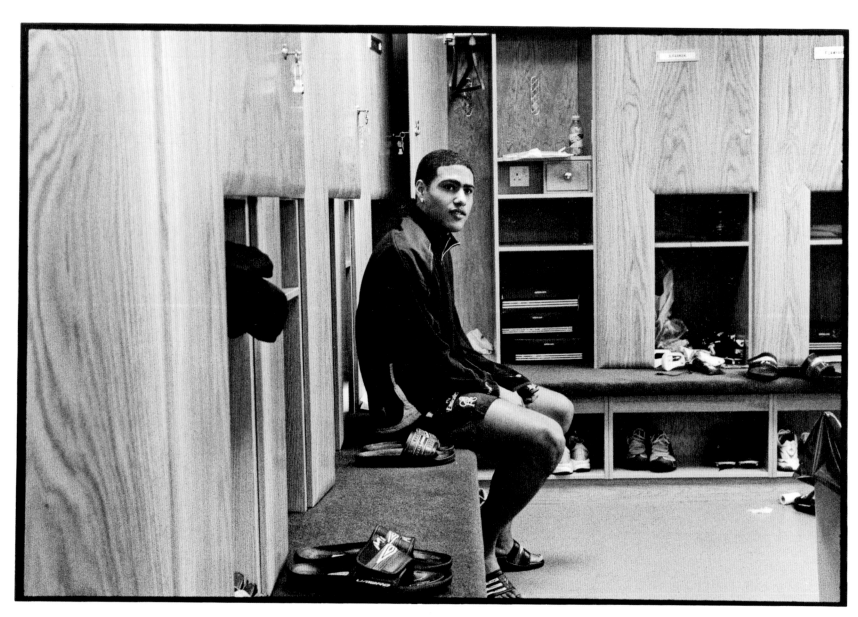

Glen Johnson in the new Harlington changing rooms, 2004.

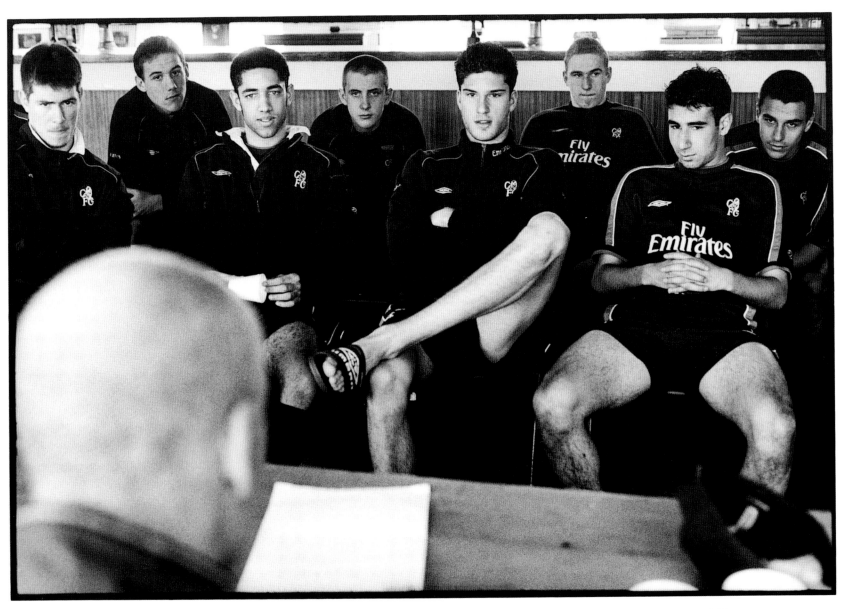

Premier League referee Dermot Gallagher lectures the youth team on the rules of football. Harlington bar, 2002.

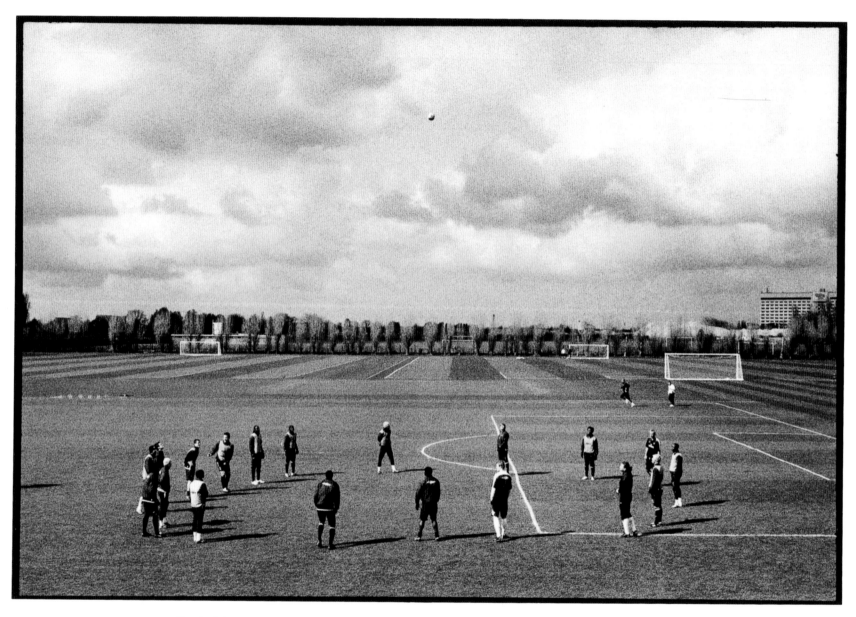

Pre-training game at Harlington 2004. The player who lets the ball bounce pays a forfeit…

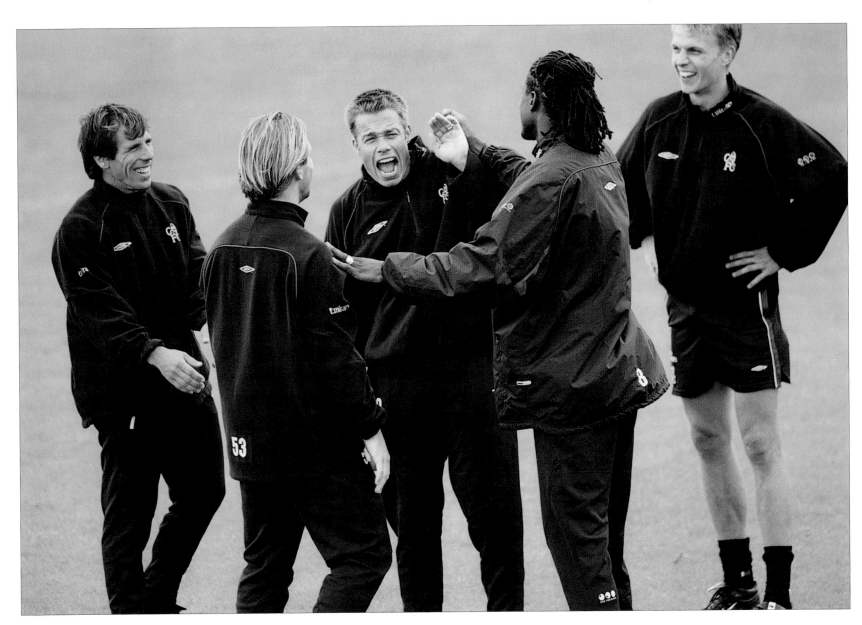

...Graeme Le Saux loses and has his ears flicked.

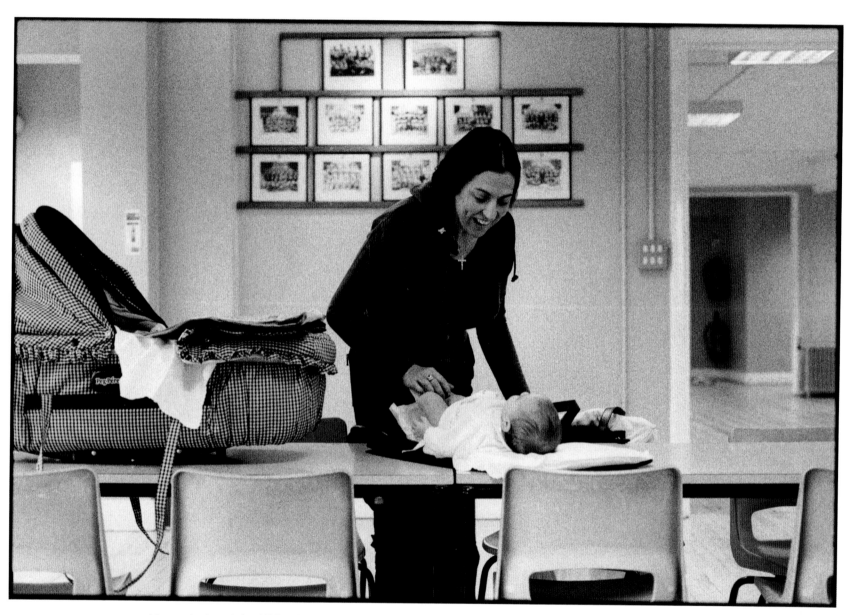

Marco Ambrosio's girlfriend, Brunella, changes their baby's nappy in the Harlington canteen, 2004.

Superfan Felicity tries to handbag Jody Morris. Harlington, 1999.

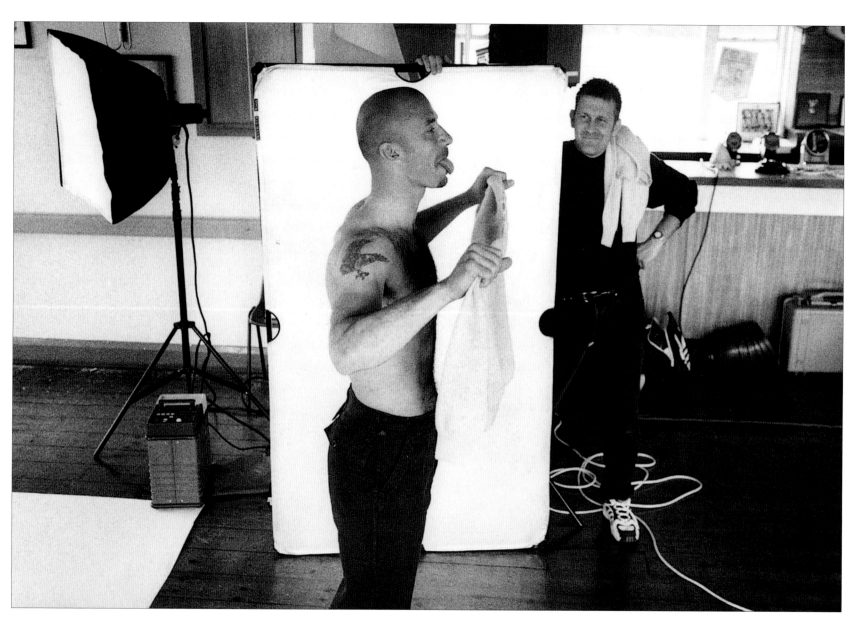

Gianluca Vialli poses for promotional photos for a knitwear company after training. Harlington bar, 1999.

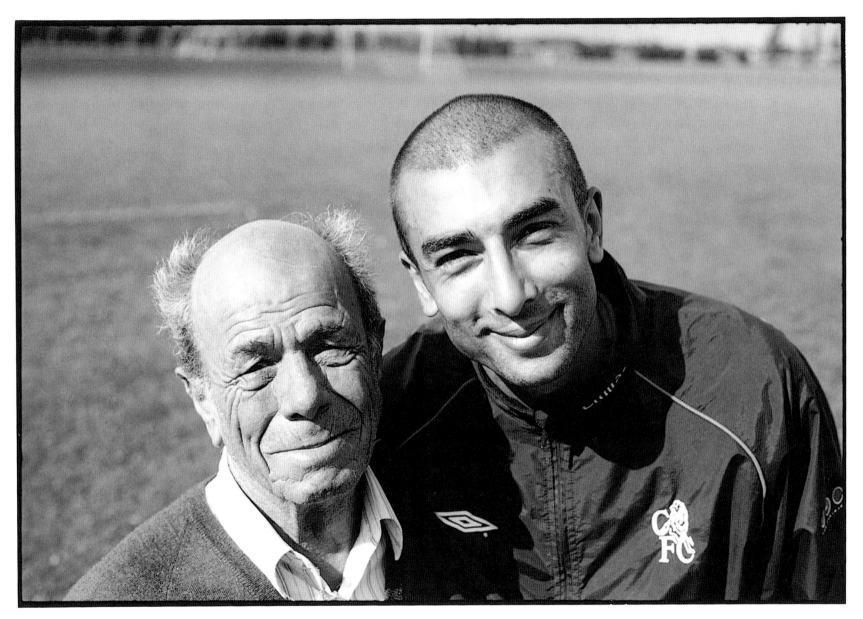

Roberto Di Matteo poses with Gianfranco Zola's father after training. Harlington, 2002.

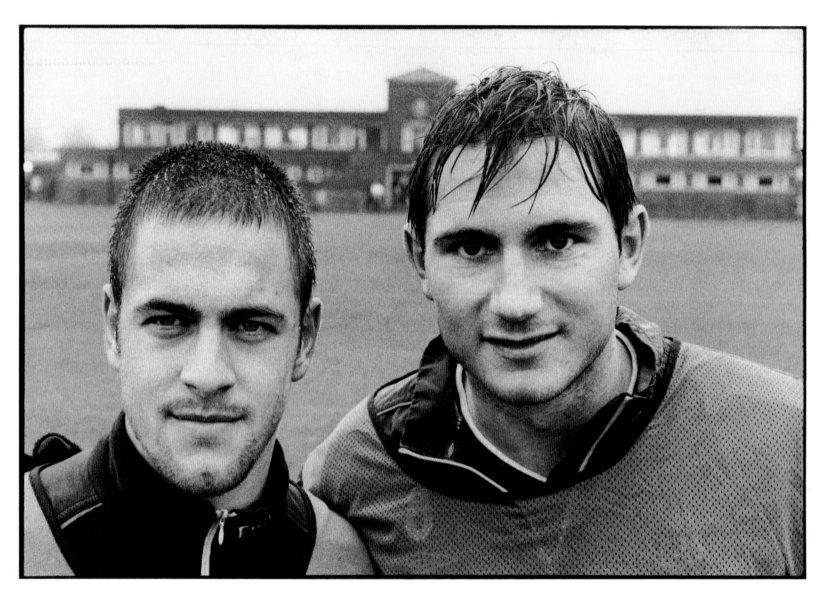

Joe Cole and Frank Lampard after training. Harlington, 2004.

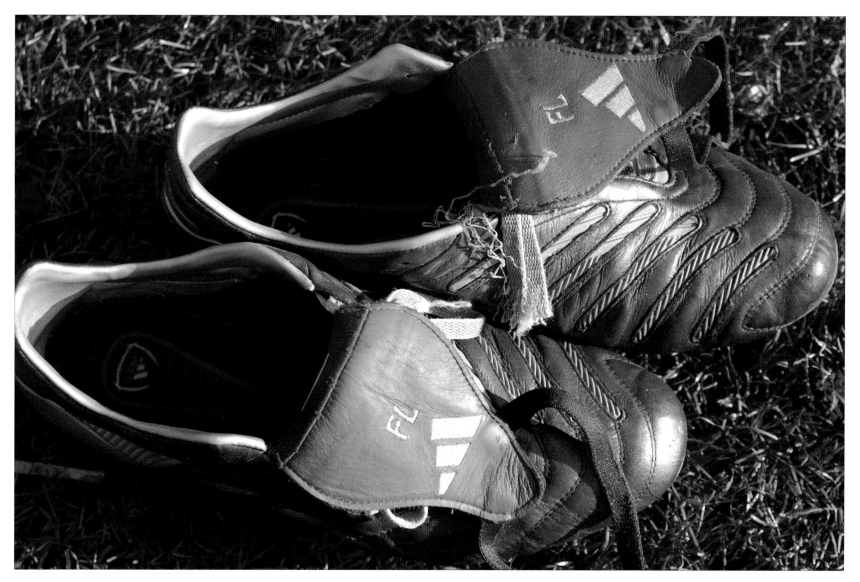

Frank Lampard's boots. Stolen during a robbery at Lampard's house, they were the only item not to be recovered by police. Cobham, January 2005.

# the match

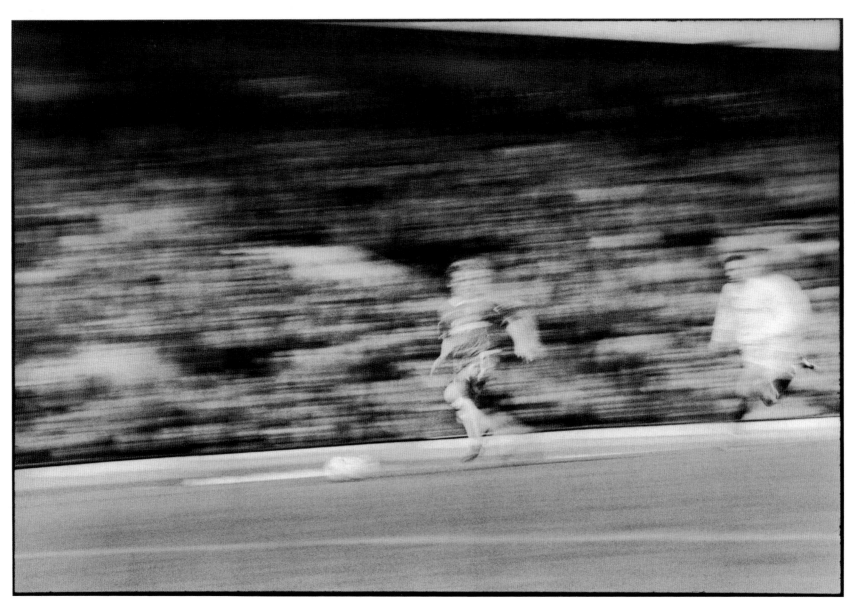

Damien Duff, 2004.

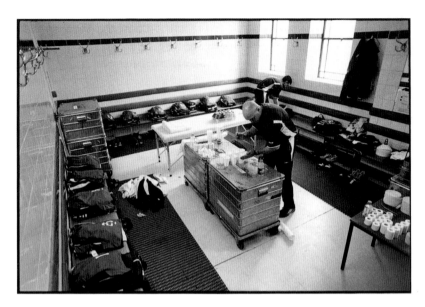
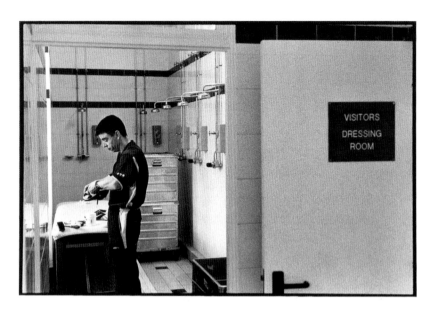

The dressing rooms at Highbury before the Champions League Quarter Final second leg, 2004.

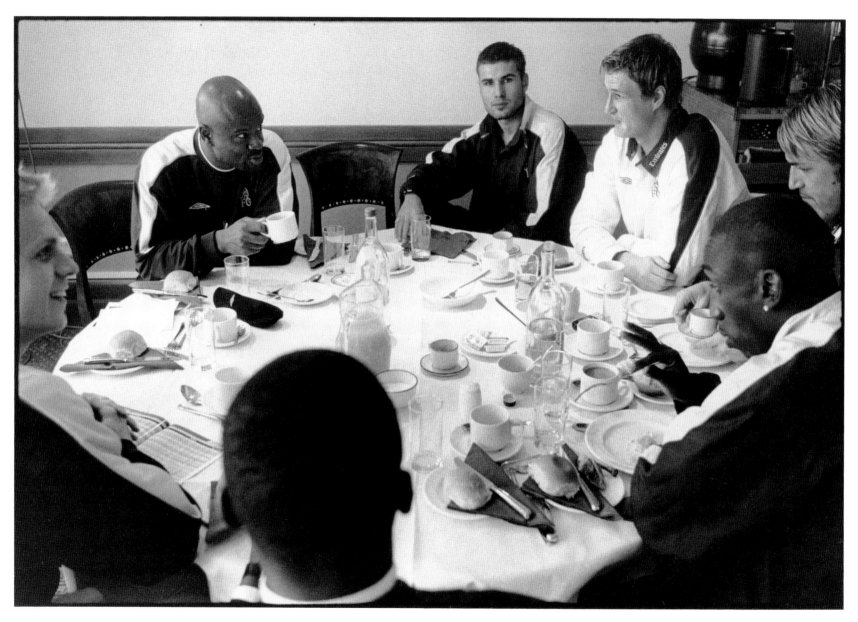

Marcel Desailly, Ade Mafe, Adrian Mutu, Robert Huth, Marco Ambrosio and Jimmy Floyd Hasselbaink have lunch three hours before kick-off against Charlton. East Stand, 2004.

Eddie Niedzwiecki plots Aston Villa's downfall. Harlington canteen,
FA Cup Final week, 2000.

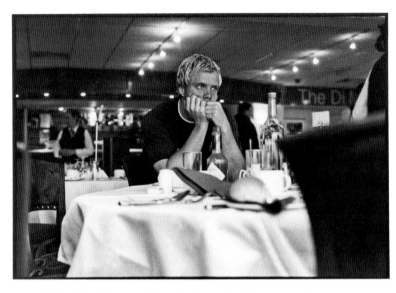

Eidur Gudjohnsen deep in thought after pre-match lunch.
East Stand, 2004.

Peanut seller. Stamford Bridge, 1980.

A big bung. The players bath in
the away dressing room at
Upton Park, 2001.

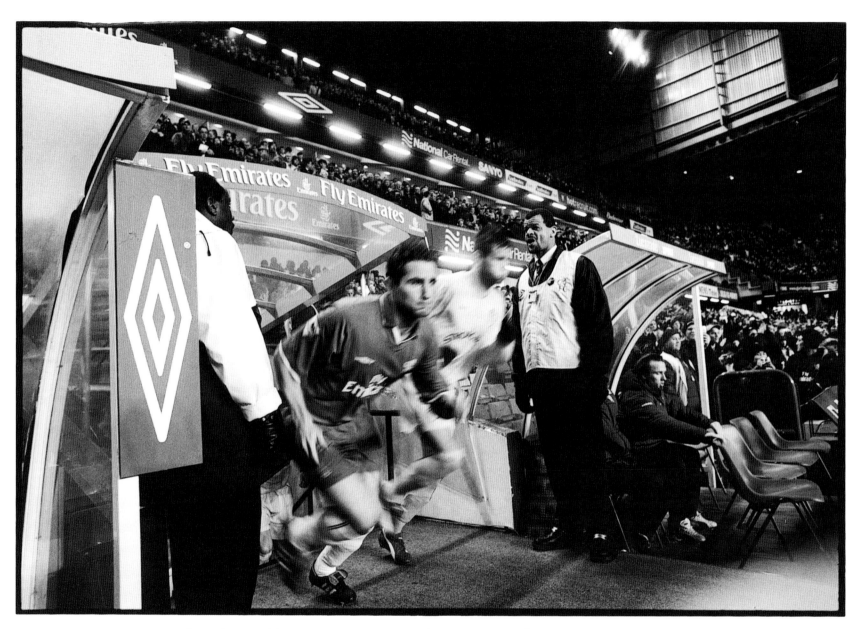

Frank Lampard bursts out of the tunnel at Stamford Bridge. Chelsea 3 – Leeds 1, 2003.

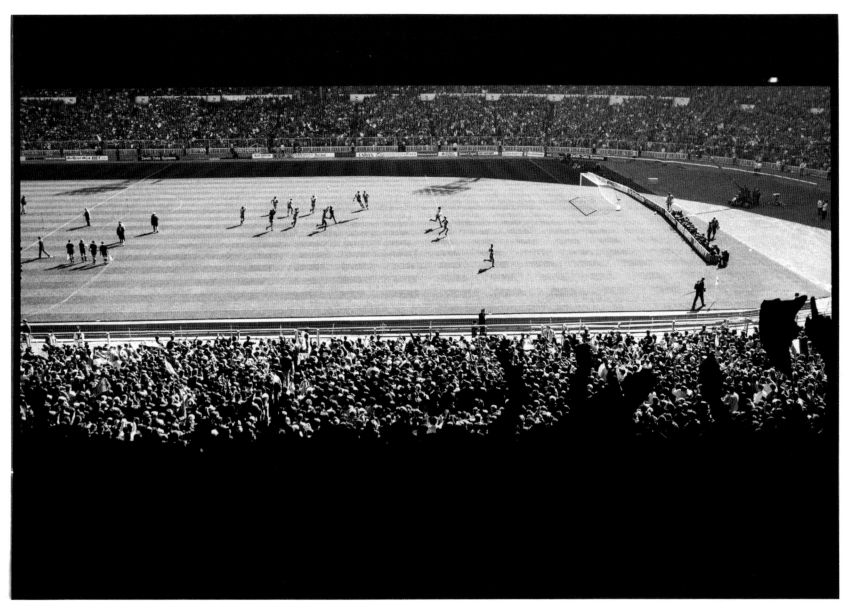

Chelsea takes to the field for the Zenith Data Systems Final. Chelsea 1 – Middlesbrough 0, 1990.

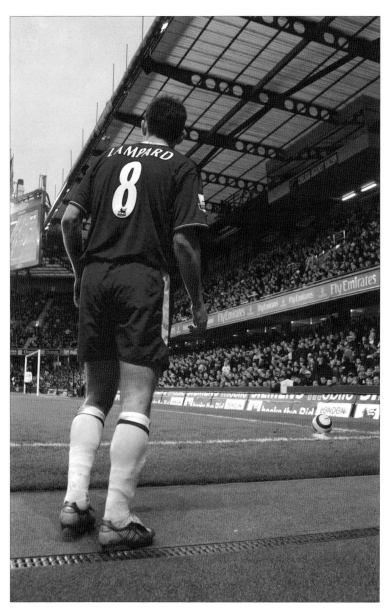

Frank Lampard, 2005.

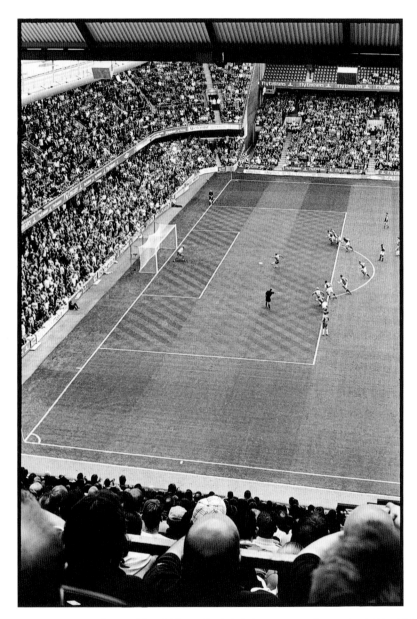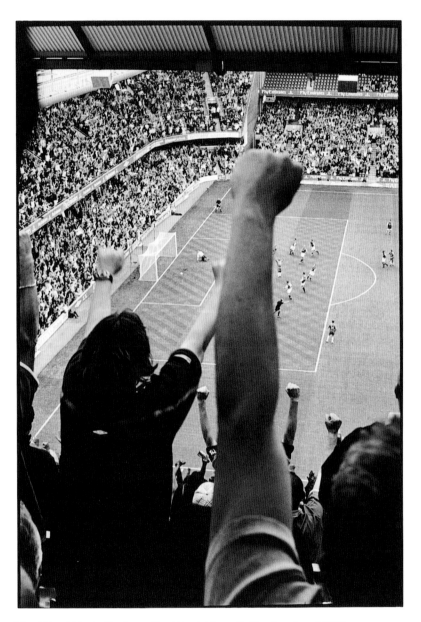

Jimmy Floyd Hasselbaink takes a penalty against West Ham. The Shed End. Chelsea 2 – West Ham 3, September 2002.

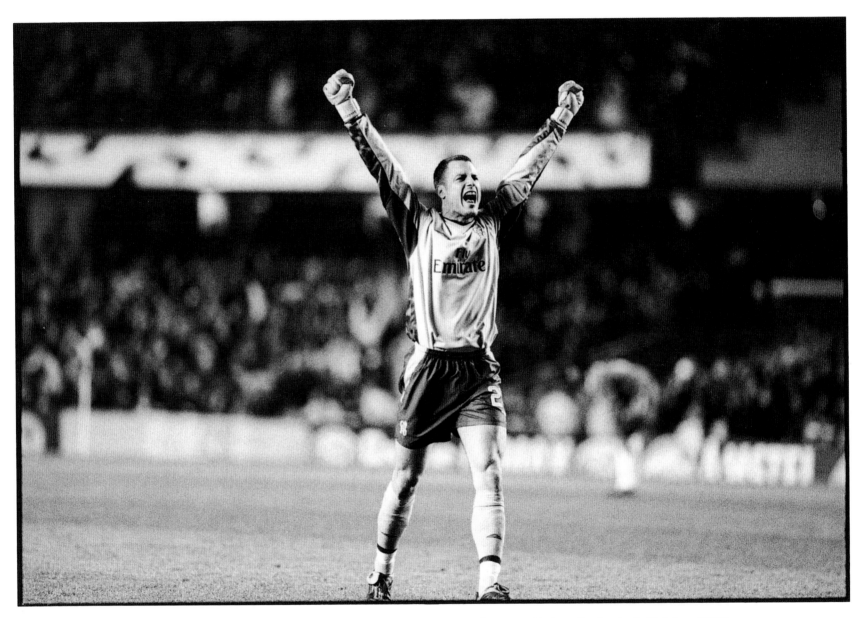

Carlo Cudicini celebrates as Chelsea score in the Champions League. Chelsea 2 – Lazio 0, October, 2003.

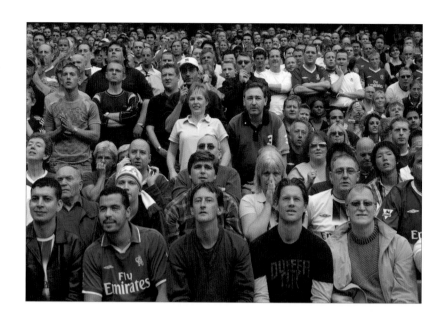
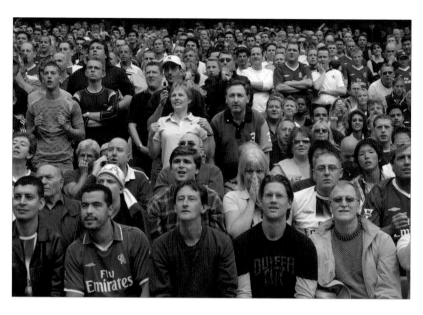
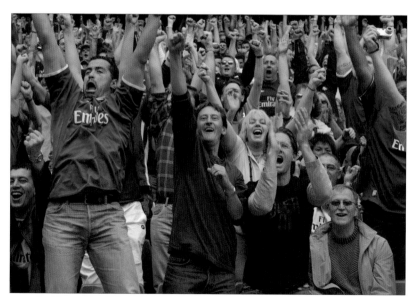
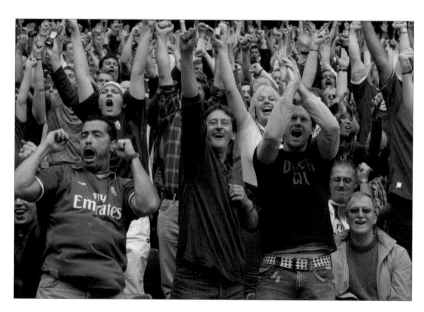

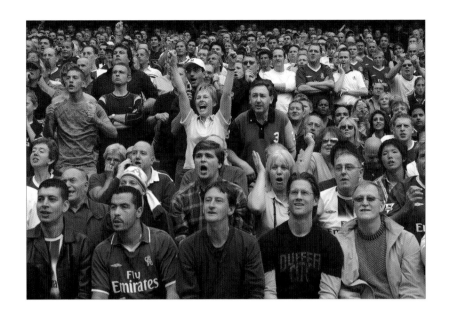
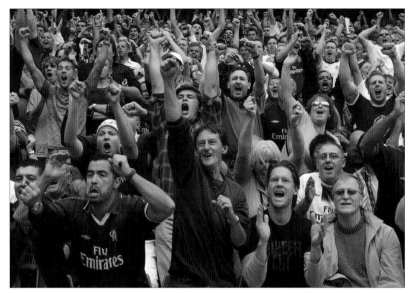
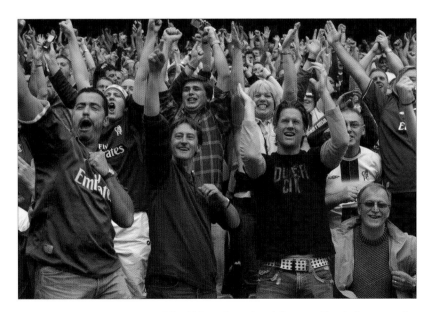
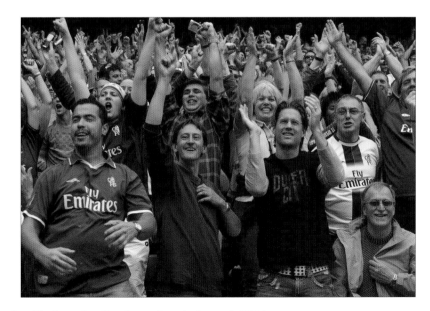

The West Stand celebrates Frank Lampard's penalty. Chelsea 2 – Southampton 1, August 2004.

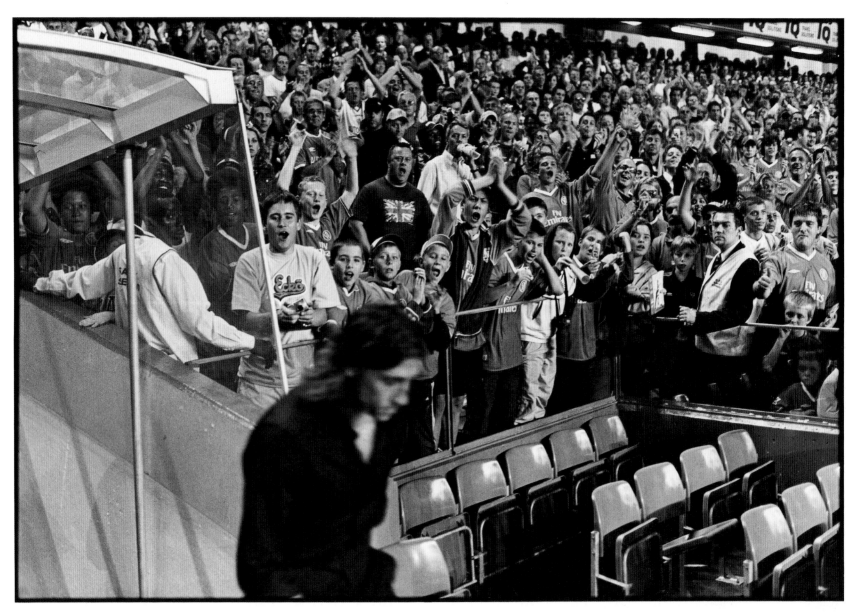

New signing Hernán Crespo walks out to greet fans at half time. Champions League qualifier against MSK Zilina, August 2003.

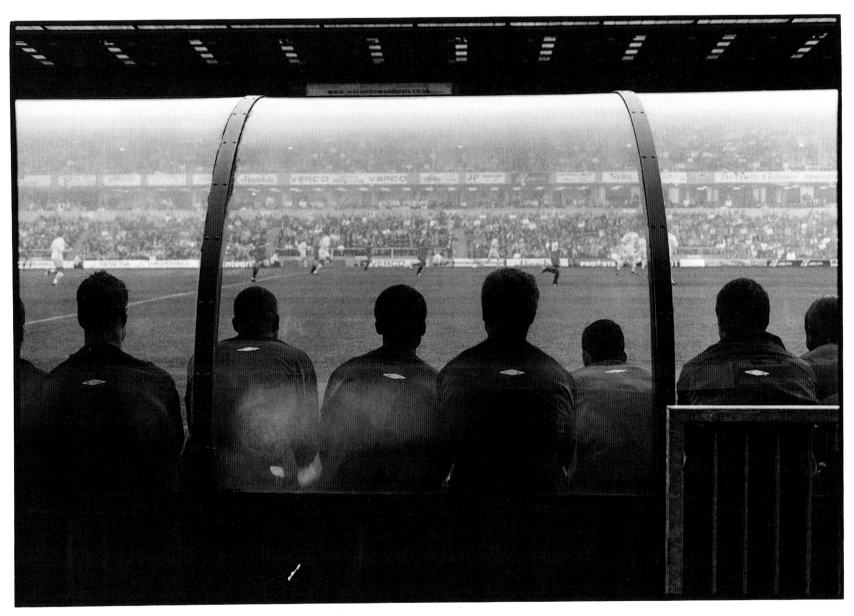

The Chelsea bench during a pre-season friendly against Wycombe Wanderers, July 2002.

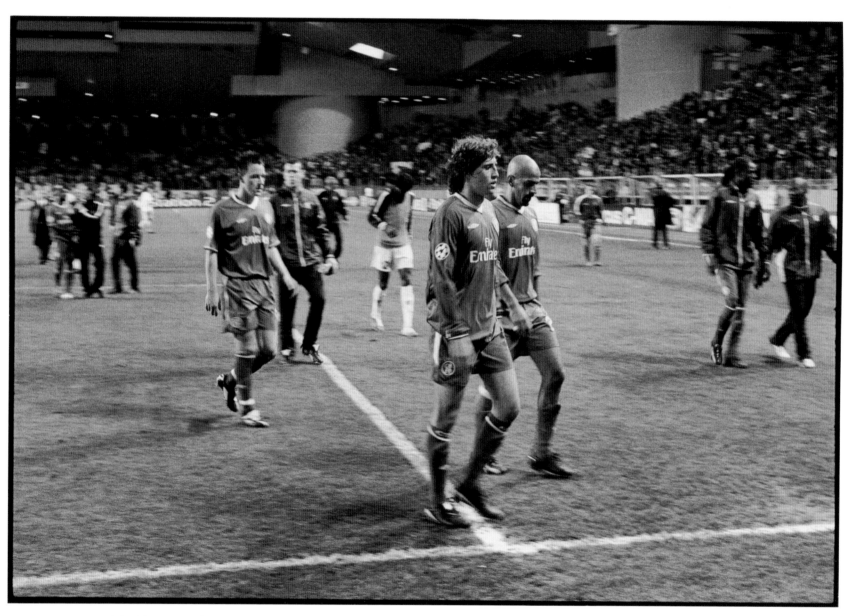

John Terry, Hernán Crespo and Juan Verón trudge off the Stade Louis II pitch. Monaco 3 – Chelsea 1, April 2004.

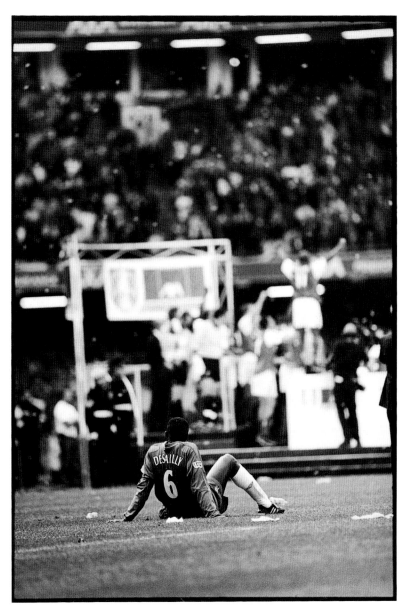

Marcel Desailly watches Arsenal lift the FA Cup. Millennium Stadium, Cardiff. Chelsea 0 – Arsenal 2, May 2002.

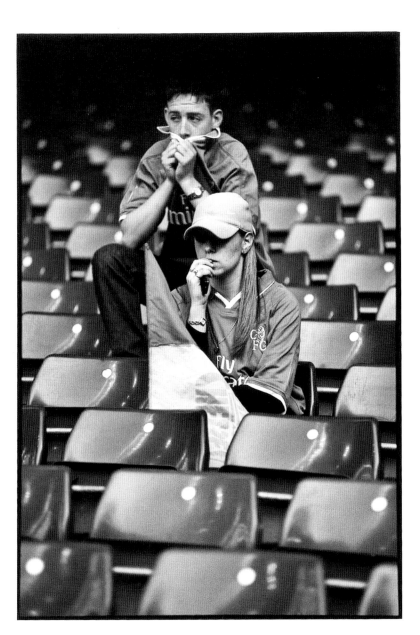

Defeated fans at Cardiff, May 2002.

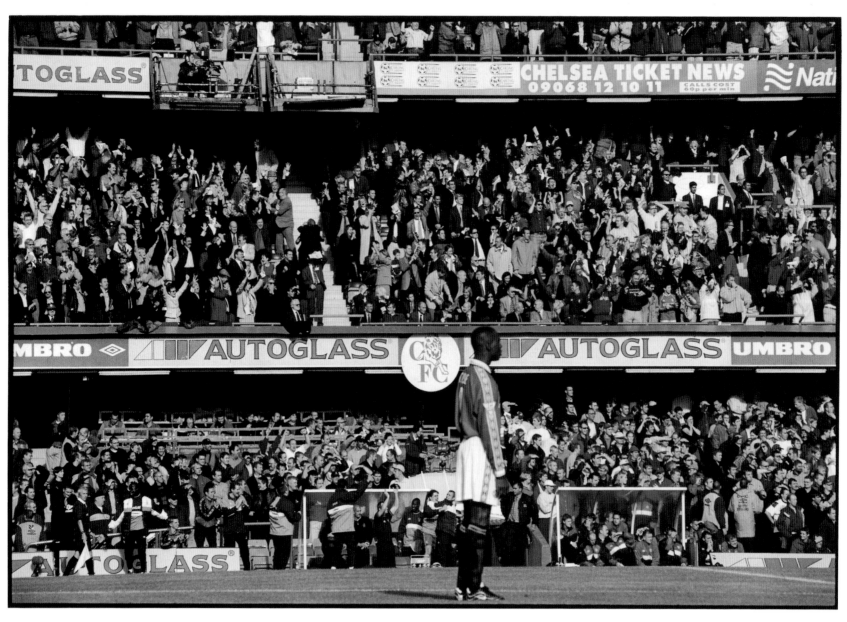

The East Stand erupts as Chelsea score after twenty-six seconds. Chelsea 5 – Manchester United 0, October 1999.

Reflected glory. Carlo Cudicini at The Shed End, 2000.

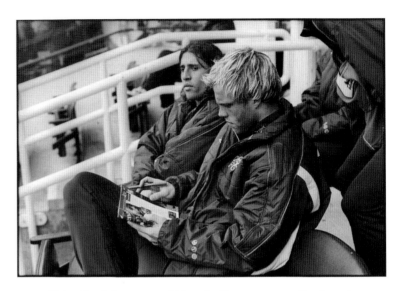

Eidur Gudjohnsen and Hernán Crespo warm the bench before Chelsea's FA Cup fifth-round defeat at Highbury. Arsenal 2 – Chelsea 1, February 2004.

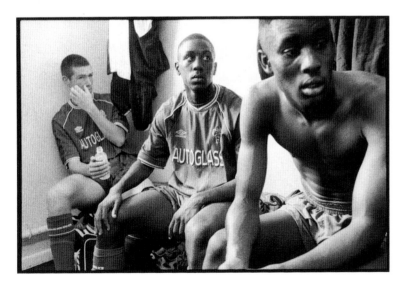

Half-time team talk during a youth team game against Charlton. Harlington, September 2001.

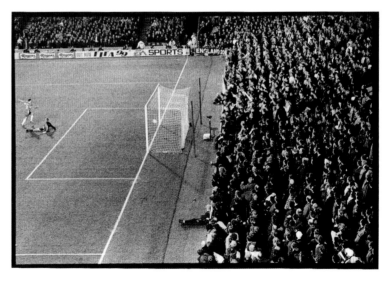

Dennis Wise scores at the Matthew Harding End. European Cup Winners' Cup Quarter Final, first leg. Chelsea 3 – Valerenga 0.

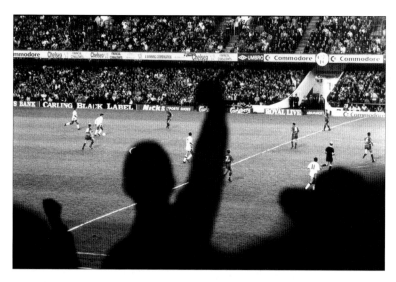

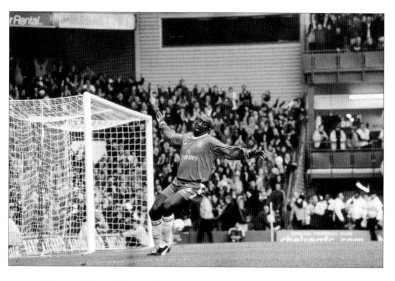

Chelsea vs Tottenham Hotspur. Stamford Bridge, 1990.

Jimmy Floyd Hasselbaink celebrates scoring a hat trick.
Chelsea 5 – Wolverhampton Wanderers 2, March 2004.

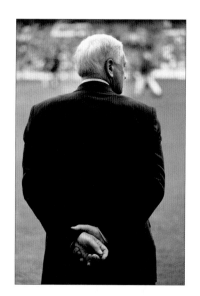

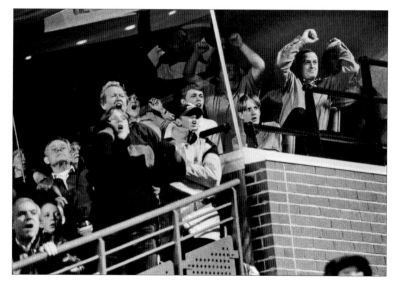

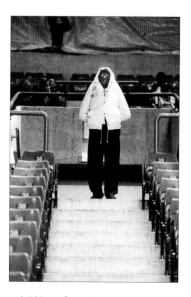

Newcastle Manager Bobby
Robson fiddles nervously with
a golf tee prior to kick-off.
Chelsea 3 – Newcastle United 0,
September 2002.

Tension in the Galleria. European Cup Winners' Cup round one first
leg. Chelsea 1 – Helsingsborgs 0, September 1998.

A West Stand steward gets
drenched. UEFA Cup first
round first leg. Chelsea 1 –
St Gallen 0, September 2000.

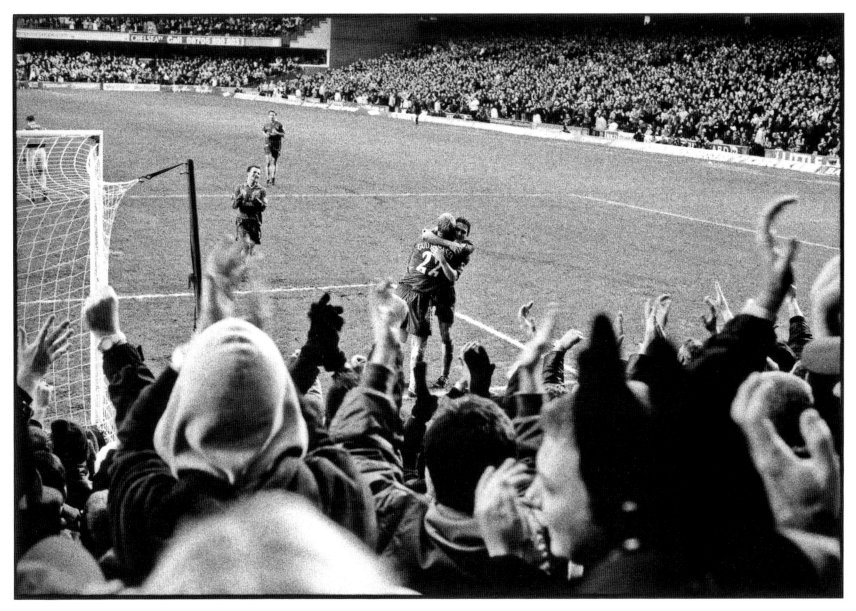

Frank Lampard congratulates Eidur Gudjohnsen after scoring against West Ham in the Premier League. Matthew Harding Stand End.
Chelsea 5 – West Ham 1, January 2002.

# the press

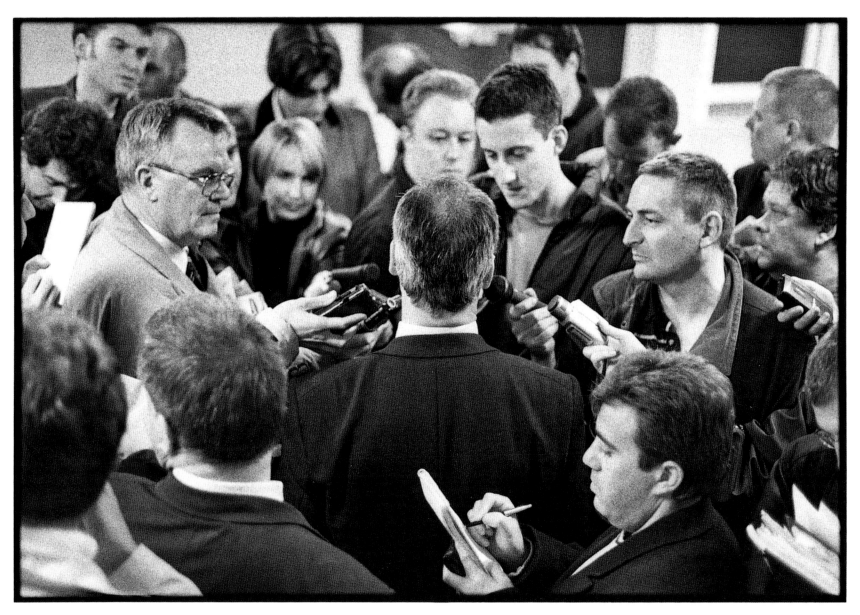

Claudio Ranieri is besieged by the press pack at Upton Park following Chelsea's first defeat of the season. West Ham 2 – Chelsea 1, October 2001.

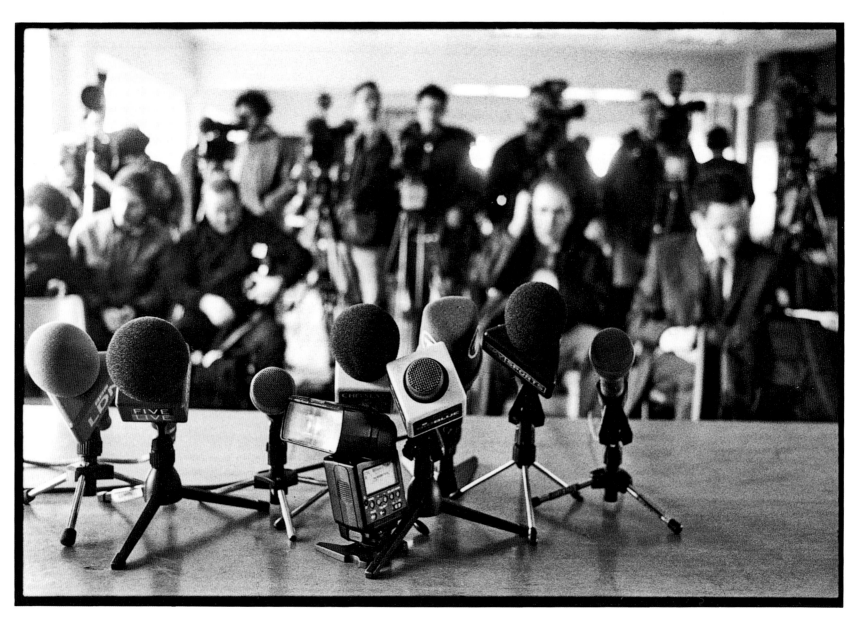

In the hot seat. The view from the manager's chair. Harlington press room, 2002.

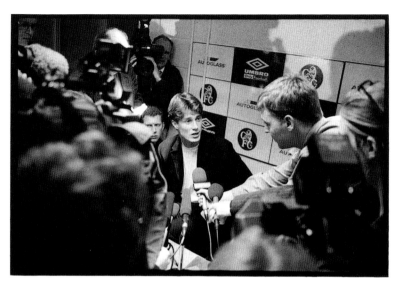

Brian Laudrup announces he is leaving Chelsea. Stamford Bridge press room, November 1998.

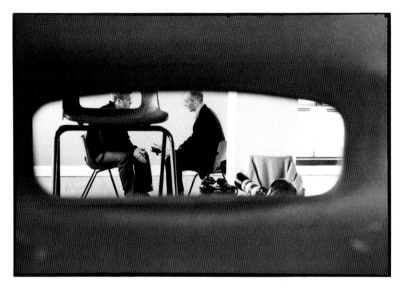

Eidur Gudjohnsen interviewed by a *Times* journalist. Harlington canteen, 2002.

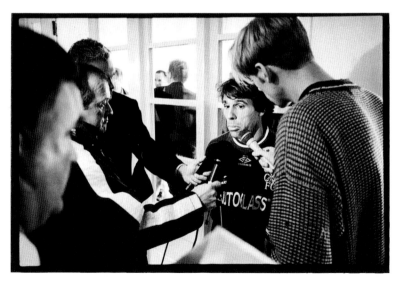

Gianfranco Zola talks to the press. Harlington canteen, 1998.

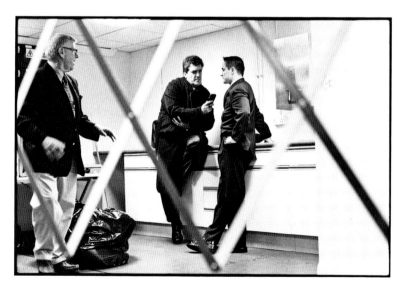

Dennis Wise interviewed by a *Sun* journalist. Stamford Bridge press room, 2000.

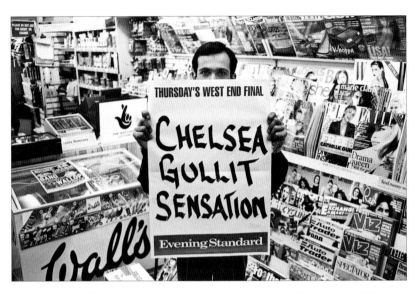

Ruud Gullit sacked. Fulham Road newsagent. February 1998.

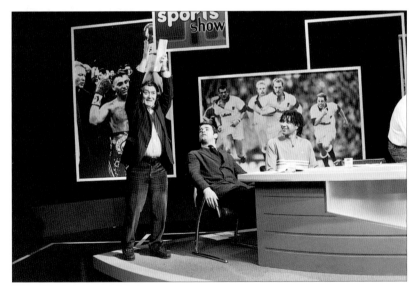

Ruud Gullit appears on Will Carling's *The Sports Show* following his sacking. ITV studios, London, February 1998.

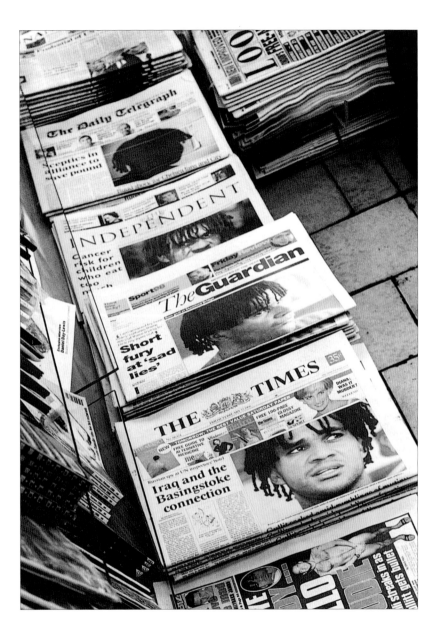

Chelsea – always front page news. February, 1998.

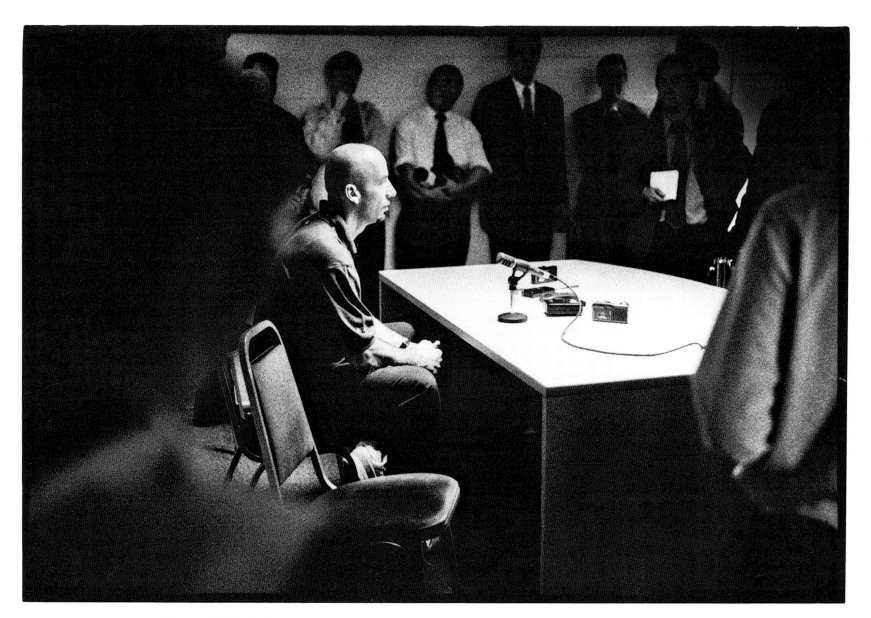

Gianluca Vialli's final press conference at Stamford Bridge. Chelsea 2 – Arsenal 2, September 2000.

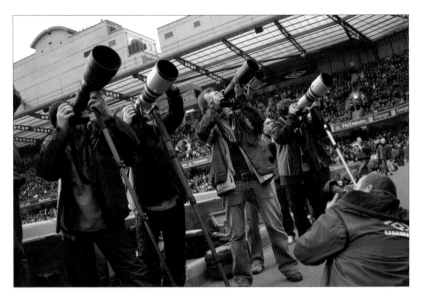

Photographers focus on Chelsea's new owner, 2004.

Roman Abramovich sneaks unnoticed behind the press pack on his way to the dressing room following Chelsea's 0 – 0 draw with Stuttgart, March 2004.

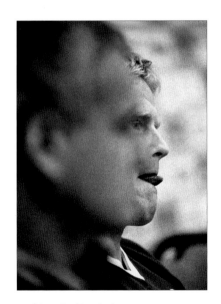

Claudio Ranieri presents new £7million signing Damien Duff to the press. Pankhurst Suite, West Stand, July 2003.

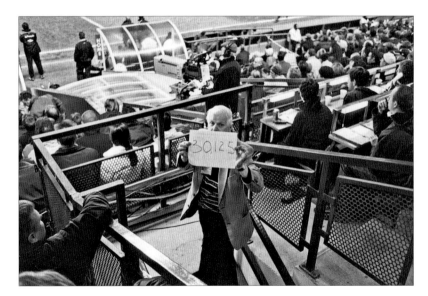

Press room steward Brian Pullman holds up the attendance figures for journalists in the press box.
Chelsea 2 – Nottingham Forest 0, January 2000.

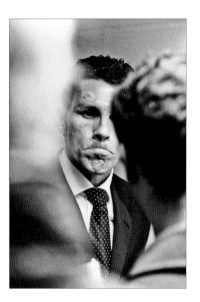

Black and blue. Gustavo Poyet interviewed after Champions League win. Stamford Bridge press room. Chelsea 3 – Feyenoord 1, November 1999.

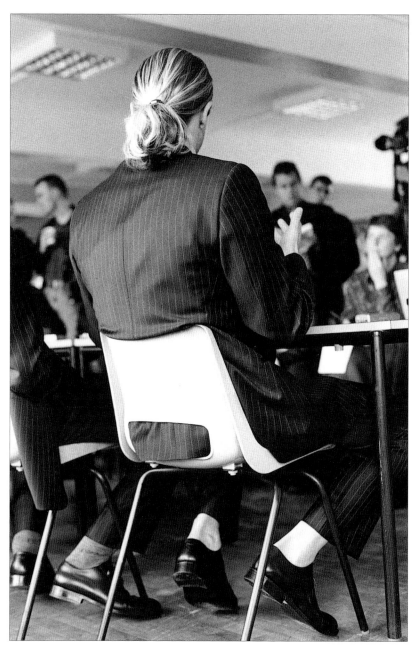

Players wear their Cup Final suits for press interviews in the Harlington canteen. FA Cup Final week, May 2002.

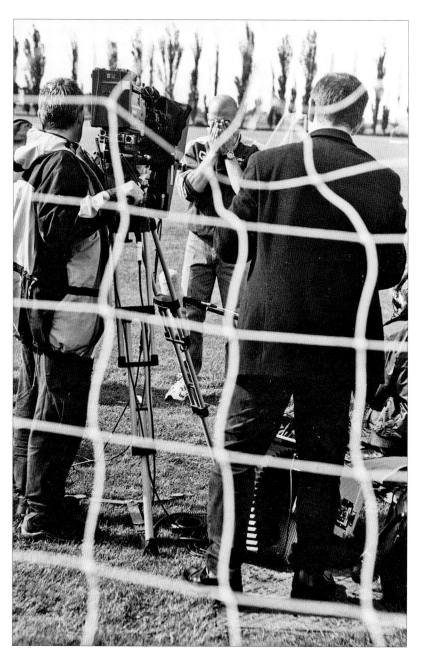

Gianluca Vialli prepares for a Sky TV interview. Harlington, 2000.

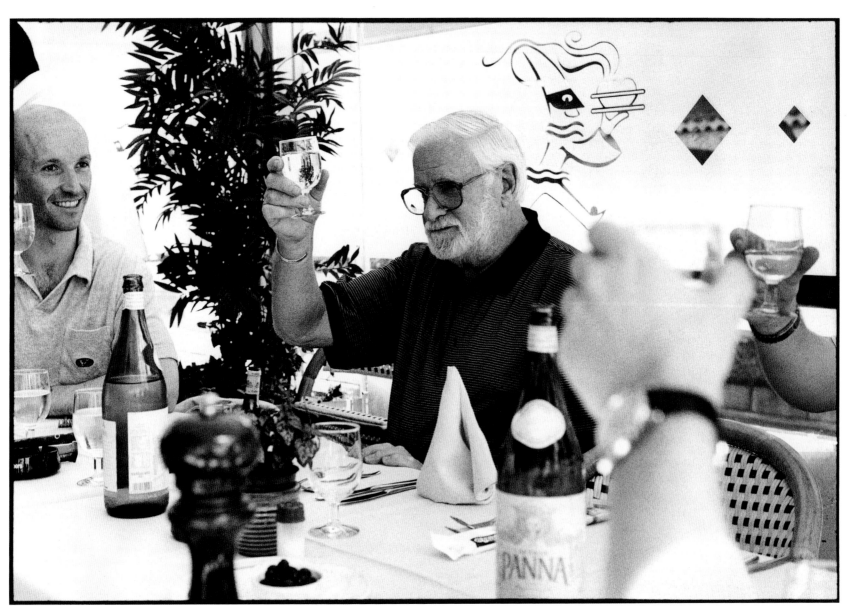

Ken Bates entertains the press before the Champions League game in Monaco, 2004.

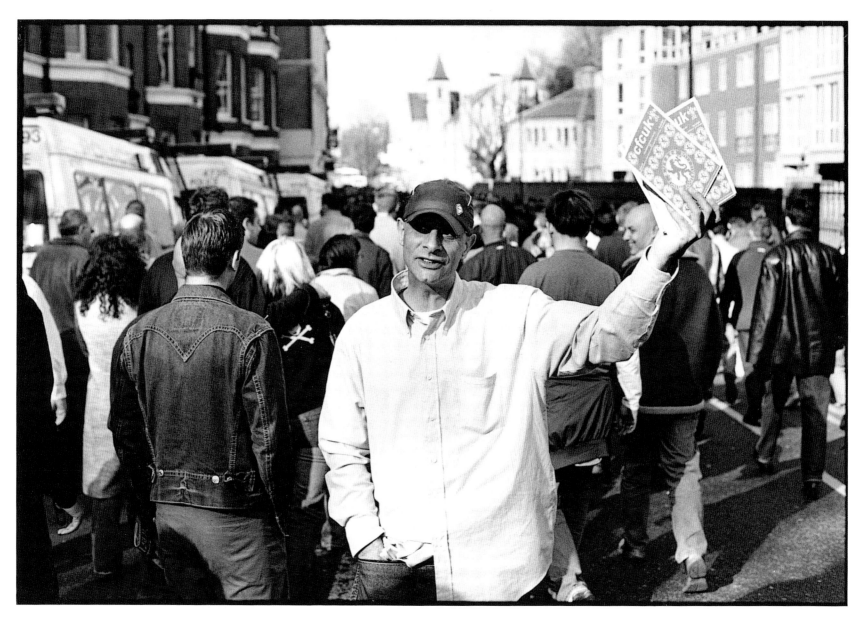

Fanzine seller. Fulham Road, 2004.

# champions

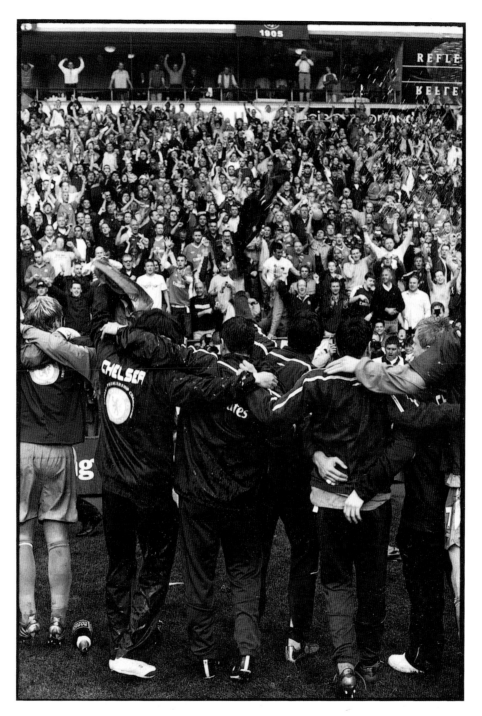

Players celebrate with fans after winning the Championship at the Reebok
Stadium. Bolton 0 – Chelsea 2, April 2005.

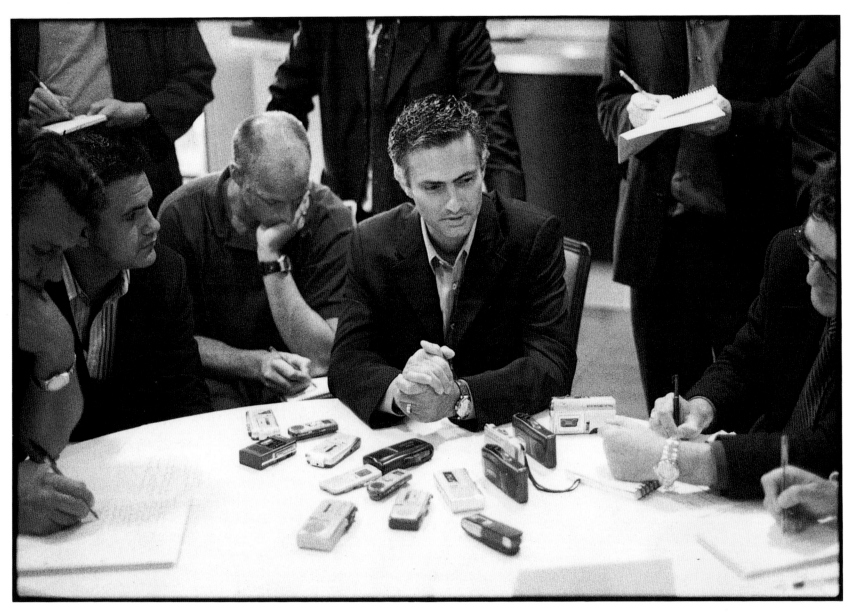

José Mourinho meets the press at his first press conference and reveals he is 'The Special One', July 2004.

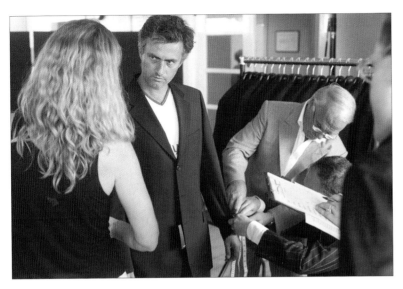

José Mourinho is fitted for his new Boss suit.
Harlington canteen, July 04.

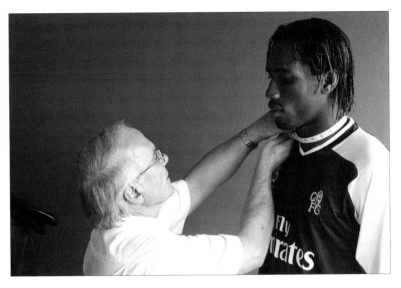

Didier Drogba is measured for his suit. Harlington canteen, July 2004.

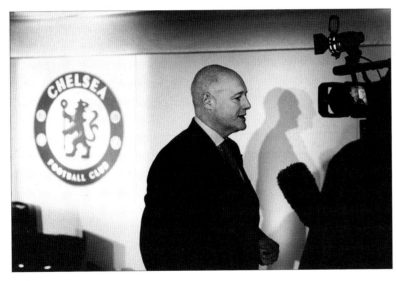

Chief Executive Peter Kenyon at the launch of the new club badge.
West Stand, December 2004.

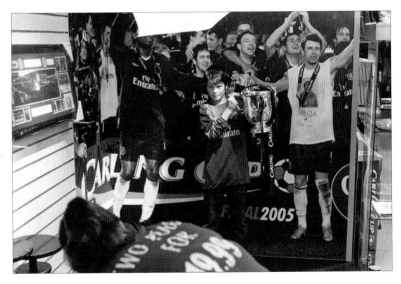

A fan poses with the Carling Cup. The Chelsea Megastore,
March 2005.

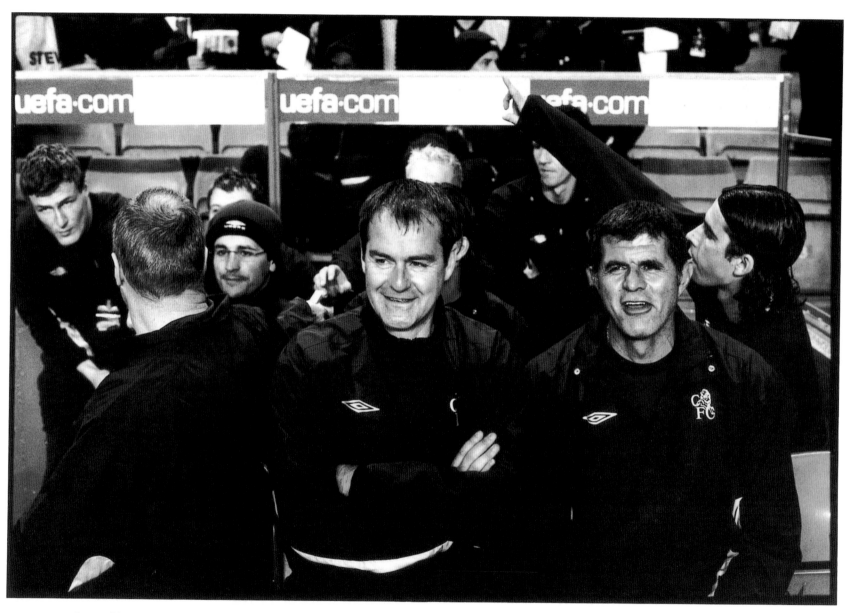

Steve Clarke takes charge after José Mourinho is banned from the Chelsea bench. Champions League Quarter Final first leg.
Chelsea 4 – Bayern Munich 2, April 2005.

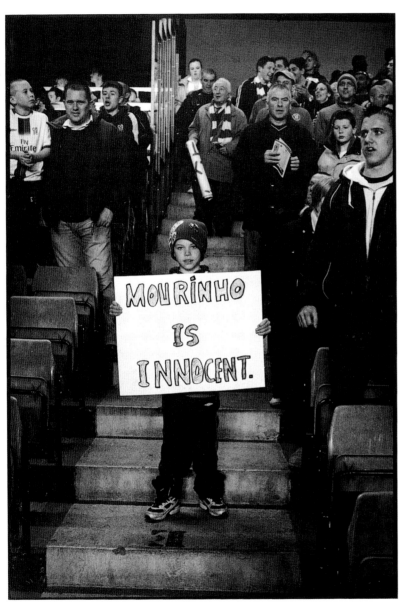

A fan in the East Stand shows his support for Mourinho.
Chelsea 1 – West Bromwich Albion 0, March 2005.

José Mourinho. Cheslea 4 – Crystal Palace 1, March 2005.

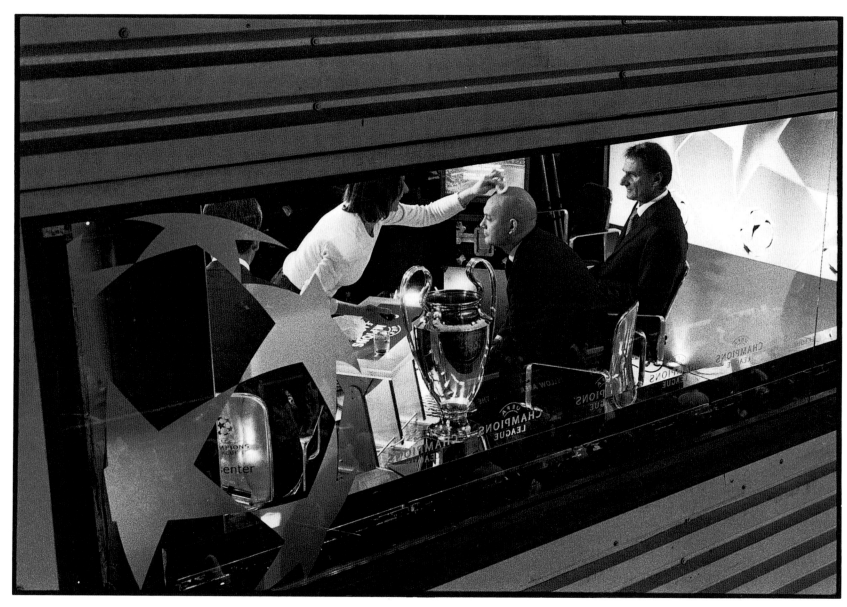

As close as it got. The European Cup comes to Stamford Bridge. Ray Wilkins in the Sky TV studio. Champions League Semi Final first leg. Chelsea 0 – Liverpool 0, April 2005.

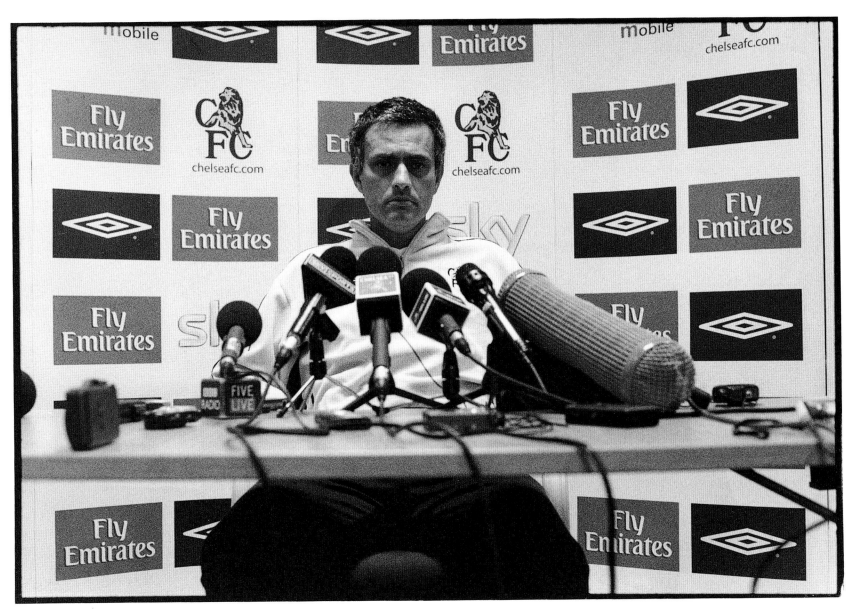

José Mourinho. Cobham press room, February 2005.

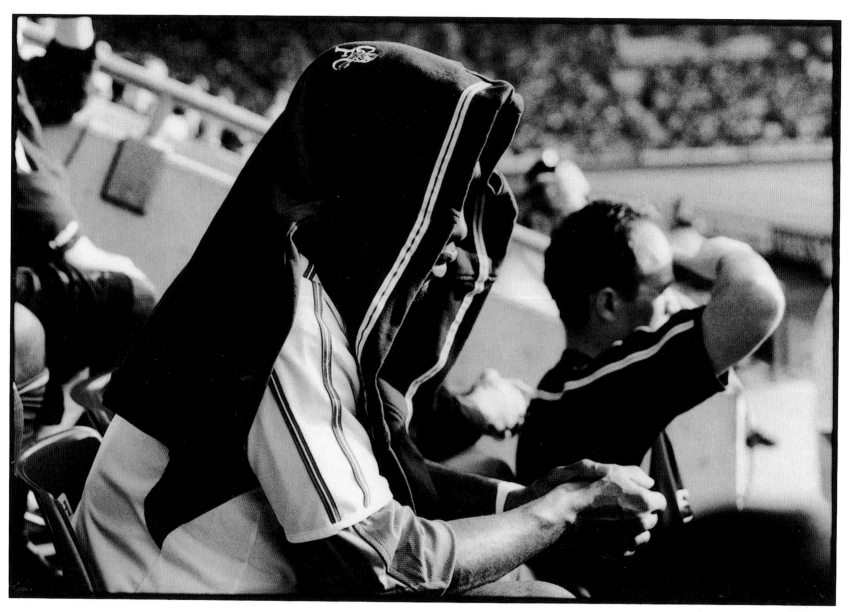

Didier Drogba on the bench at St Mary's stadium, April 2005.

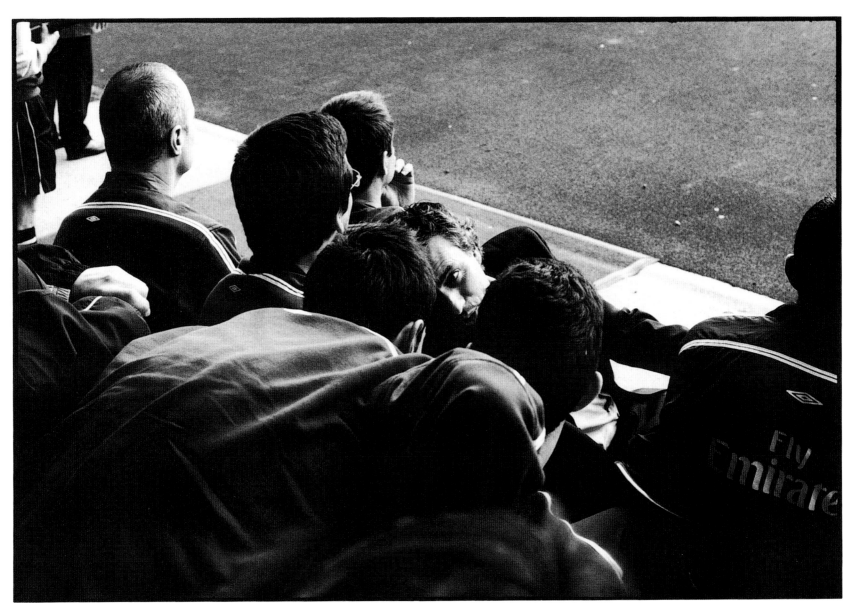

José Mourinho gives instructions to Matiaz Kezman. Southampton 1 – Chelsea 3. Chelsea go thirteen points clear with seven games to go.

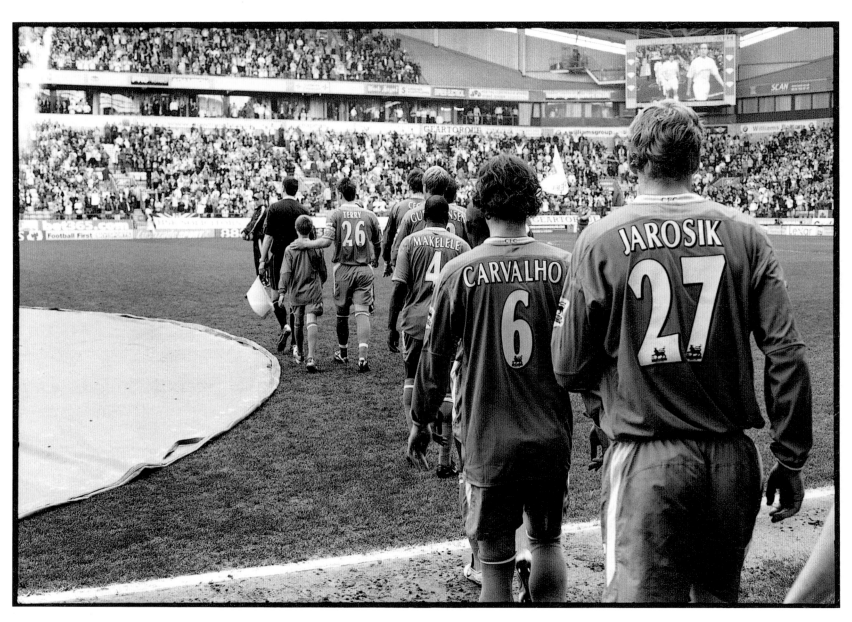

Chelsea players take to the field at the Reebok Stadium. 5.15pm, 30 April 2005.

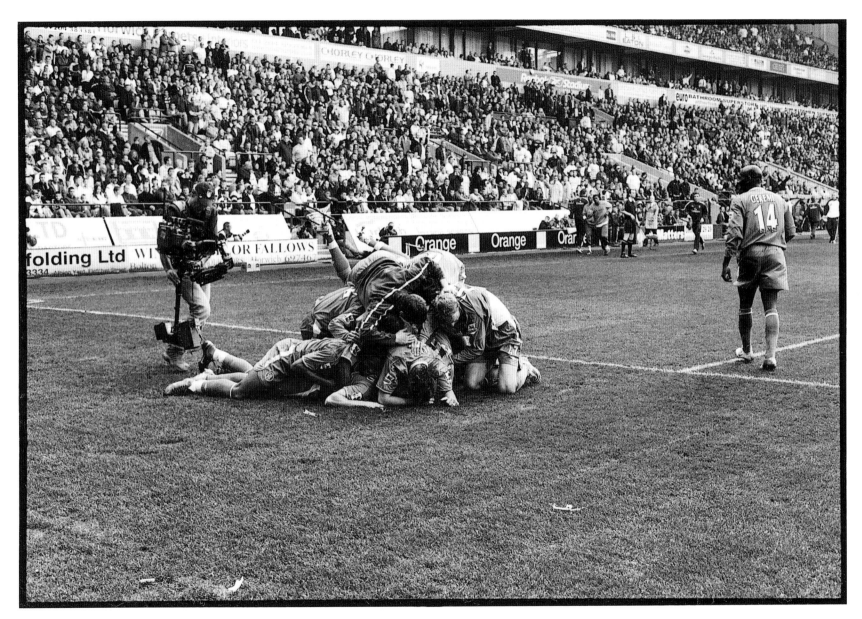

Frank Lampard scores in the sixtieth minute.

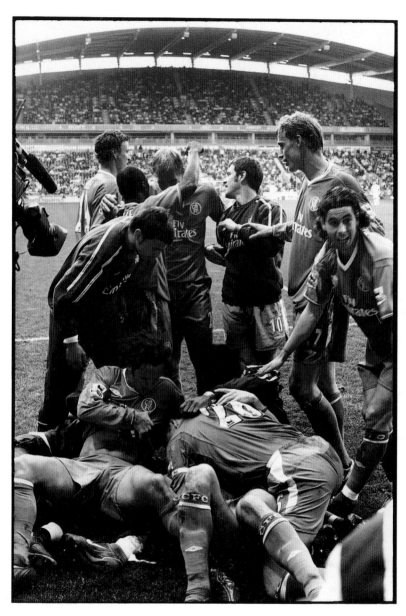

The players celebrate Frank Lampard's second goal. Bolton Wanderers 0 – Chelsea 2.

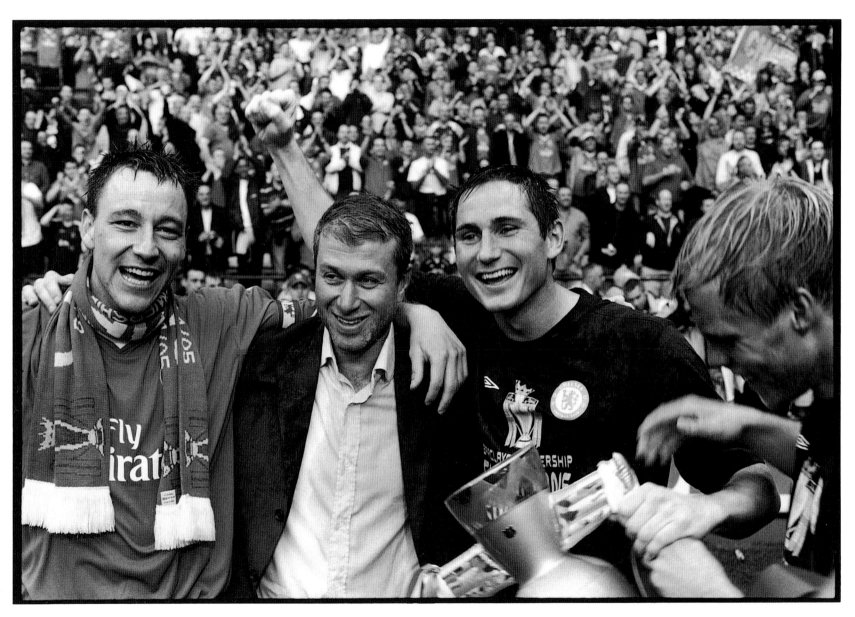

John Terry, Roman Abramovich, Frank Lampard and Eidur Gudjohnsen celebrate winning the Championship at Bolton.
The 50-year wait is over. 7.00pm 30 April 2005.

# Acknowledgements

Thanks to John Blake and Clive Hebard who commissioned and edited this book and to Graeme Andrew and Jon Sloane for design.

Thanks are due to the following current and former CFC staff – Aaron Lincoln, Terry Byrne, Ade Mafe, George Price, Alex Nairn, Gary Staker, Mick McGiven, Carina Dell, Stewart Bannister, Frank Steer, John Kelly, Andy Rolls, Mike Banks, Chris Fraser, Bob Spencer, Billy McCulloch, Gwyn Williams, Theresa Conneely, Jonathan Beck, Gary Taphouse, Gill and Brian Pullman, John Shewend, Pippa Hancock, Paul Smith, Bill Crane, Gena Repton, Jack Manfield, Tony Stewart, Dave Utal, Nicky Perruccio, Giorgio Pellizzaro, Mick the grounds-man, Carl Chapman, Helen Wood, Gerry Harvey and Jack Manthorpe.

Thanks also to *Chelsea* magazine editors Lee Berry, Alex Leith, Ryan Herman, Clive Batty, Dan Davies, Neil Barnett and Andy Winter, Jason Cowley at the *Observer Sports Monthly*, Moira Ashcroft, Christine Lee, Francis Glibbery, Steev Burgess, Marcello Pozzetti, Scott Heavey, Pete Guest, Stuart Taylor, Adrian Ensor and to Blues fans Giles Smith, Kevin Jones, Simon Jones, Ben Thornton, Georgi Donnell, Jim Drewett, Graham Wray, Leigh Davies, Adrian Wells, Martin Wells, Jack Birney, Pat Dibben, Sam Lovejoy, Mark Wyeth, Arthur Miller and Joe Boylan.

Prints from this book are available at
www.chelseabluesinblackandwhite.com

For EJ, D, O and DR

See you at the Bridge